# THE ENCHANTED WORLD OF
# JESSICA GALBRETH

CHIMERA PUBLISHING

HAMILTON, NEW JERSEY
2006

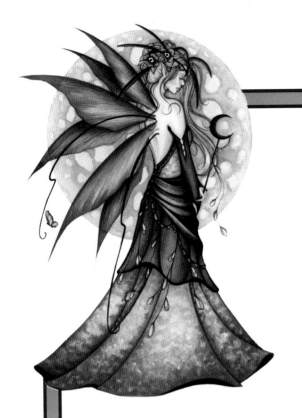

# THE ENCHANTED WORLD
# OF JESSICA GALBRETH

**Art:** Copyright © Jessica Galbreth 2006
**First Edition:** Copyright ©
Chimera Publishing, 2006. All Rights Reserved

**Editors:** Norman Hood and E. Leta Davis
**Design and Layout:** McNabb Studios
for Chikara Entertainment, Inc.

**Limited Edition**
**ISBN 0-9779749-2-8**
**Hard Cover**
**ISBN 0-9779749-1-X**
**Paperback**
**ISBN 0-9779749-0-1**

Chimera Publishing
Hamilton, New Jersey

Visit our website at
www.chimerapublishing.com
E-mail: norm@chimerapublishing.com

First Printing: July 2006
10 9 8 7 6 5 4 3 2 1

Printed in China by Regent Publishing Services Limited.For printing information, contact Robert V. Conte at 212-779-3346.

For Josh, Julia Rose & Little Joe…
thank you for being my inspiration

### Aine

This is one of my very early works, back when I was doing only Celtic mythology. Aine was a Celtic deity, a faery queen to be exact, celebrated for her beauty.

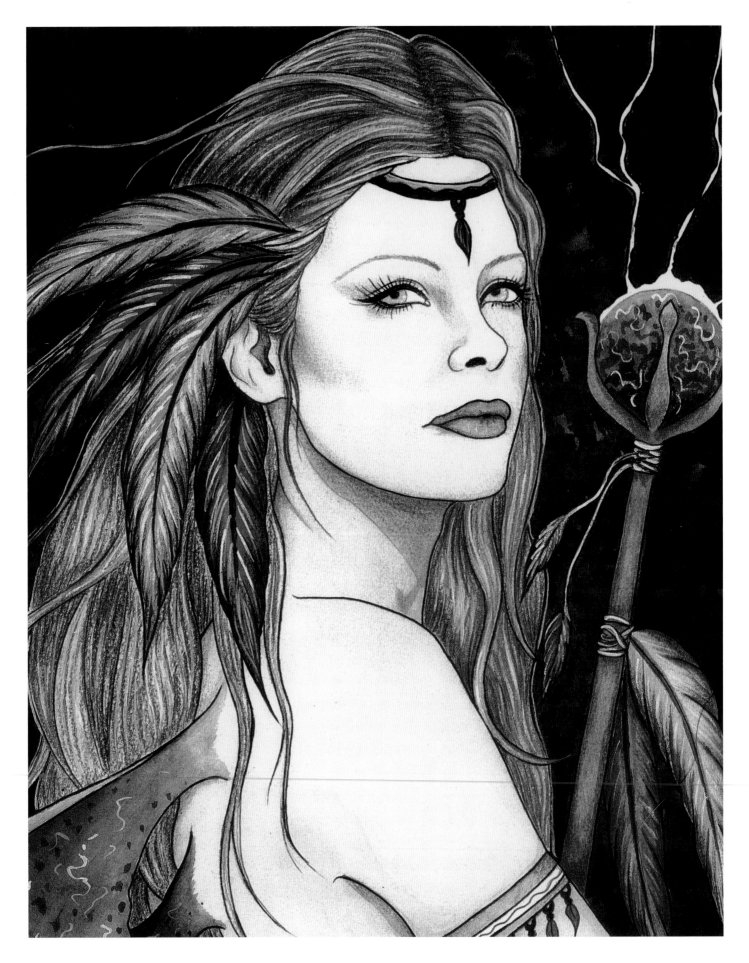

### Airmid

This is one of the first paintings that I ever sold in print form. Another Celtic Goddess, Airmid was known as a healer. I've shown her here with her feather adorned magic wand.

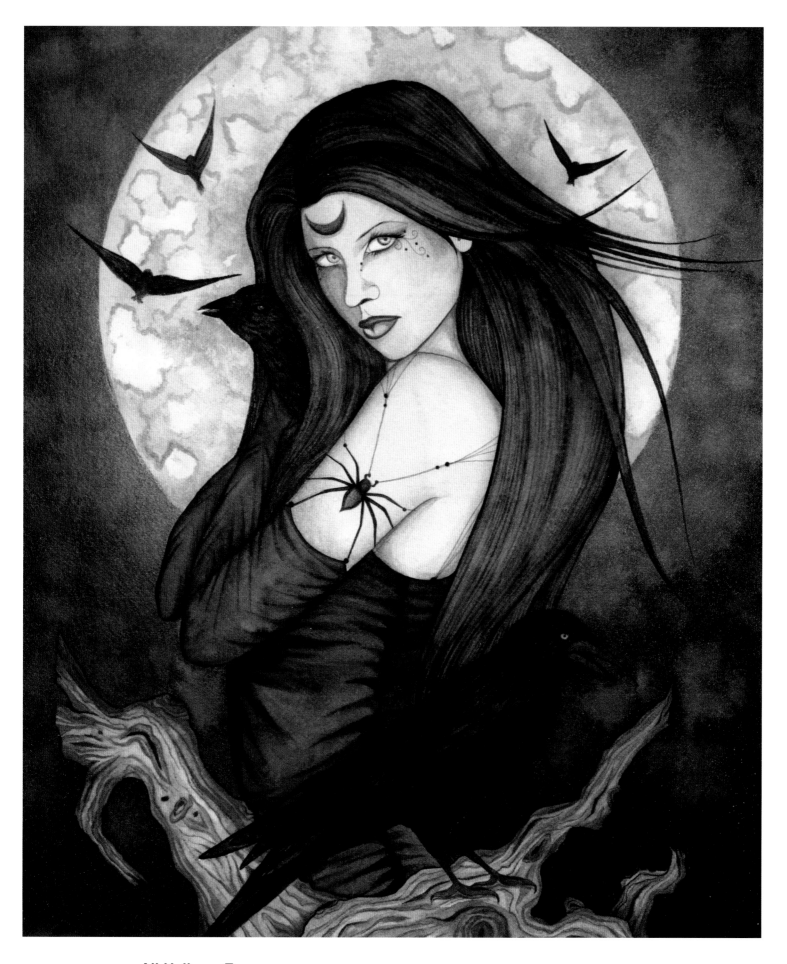

### All Hallows Eve

All Hallows Eve is the ancient Celtic holiday from which we derived our modern-day Halloween. This time of year has always been a favorite of mine, so I really wanted to do something special to represent it. This dark, enchanted maiden with her raven familiars beneath a full moon was the result.

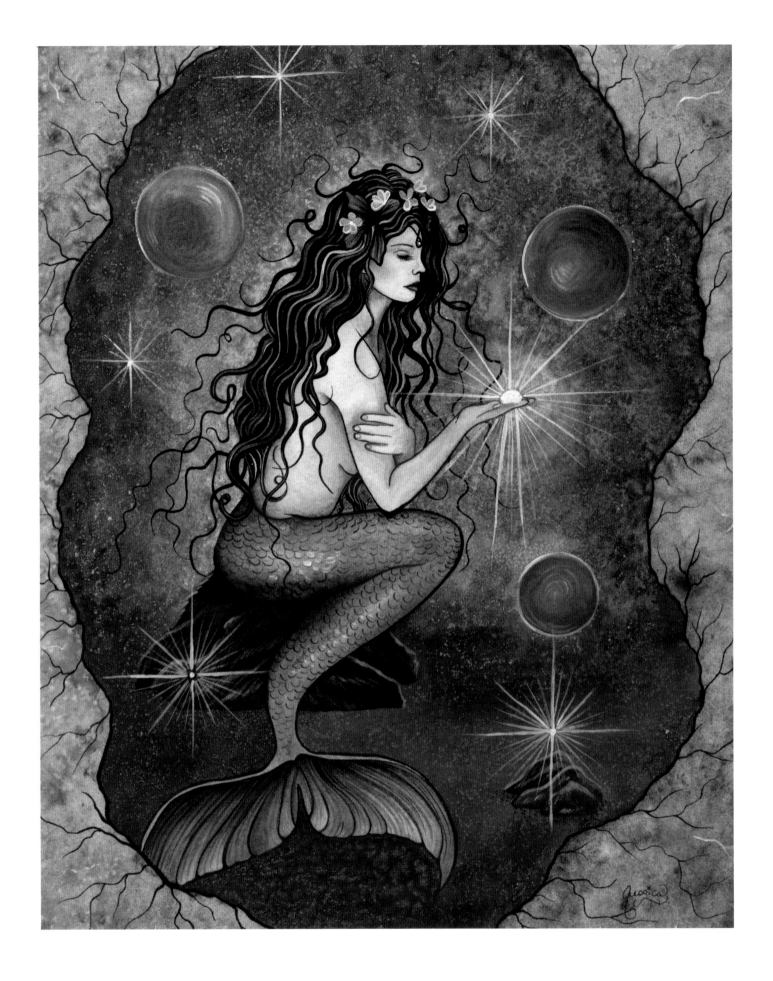

### A Mermaid's Wish

I always enjoy painting mermaids, though I don't seem to paint them often enough. This was one of my first mermaid paintings, I wanted to paint a mermaid making a wish upon a magical stone.

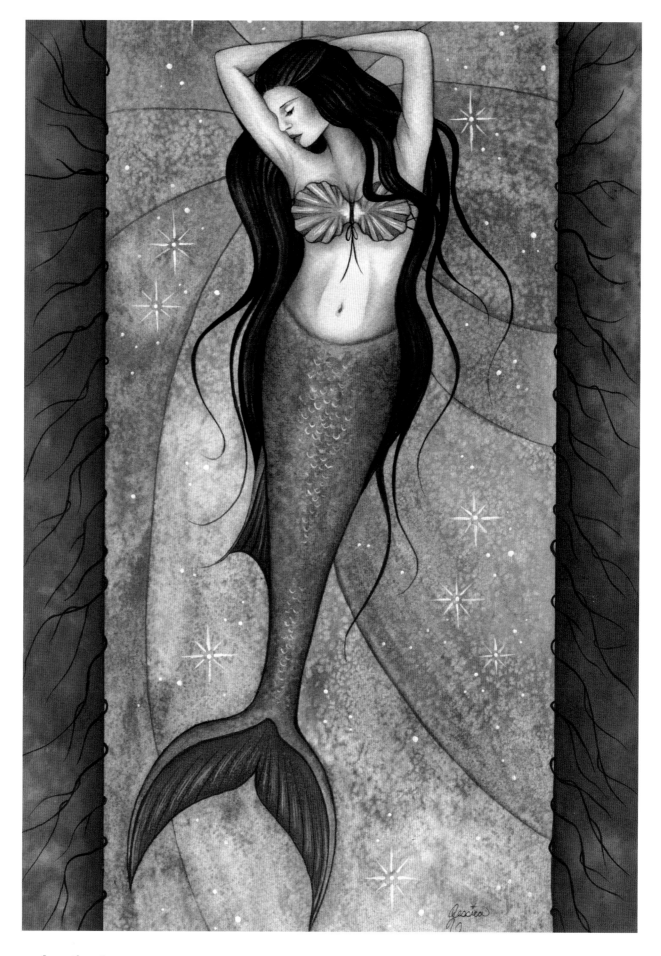

### *Amethyst*

This purple mermaid, aptly named Amethyst, rises to the surface as her long hair flows in the current.

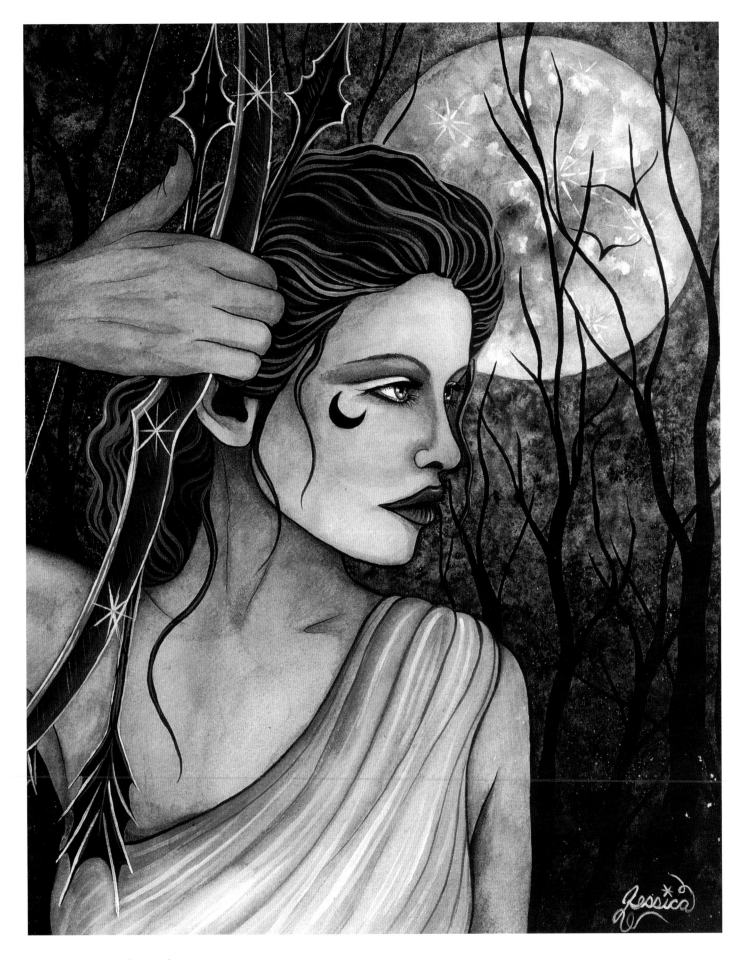

### Artemis

This is one of my goddess images and features the huntress goddess holding her golden bow and arrows.

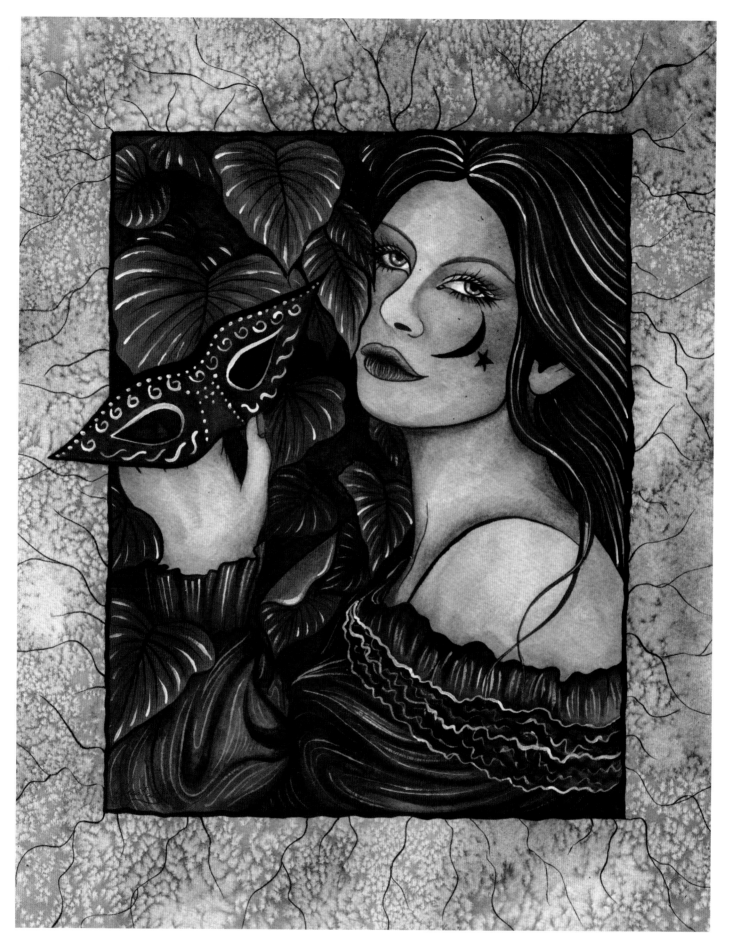

**Autumn Enchantment**

A beautiful maiden is on her way to an enchanted autumn masquerade.

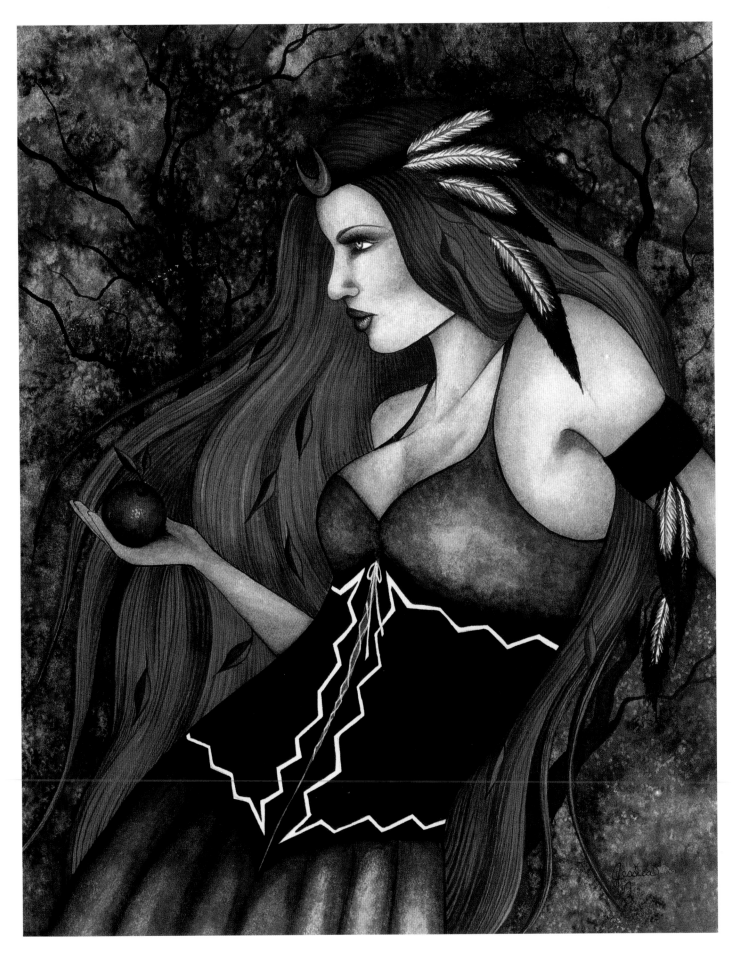

### *Autumn Equinox*
Another autumn-themed piece. Can you ever really have too many of those? This one is in celebration of the autumn equinox.

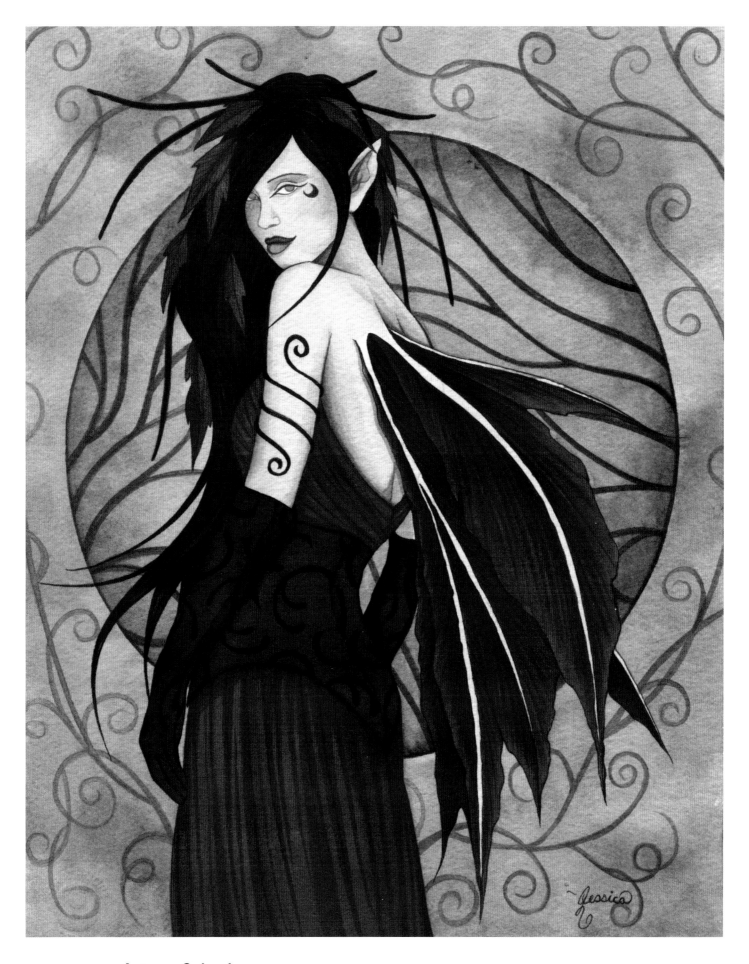

### *Autumn Splendor*

This autumn faery is one of my newer paintings and remains one of my more popular images. I used varied tones and hues of red on this decadent enchantress.

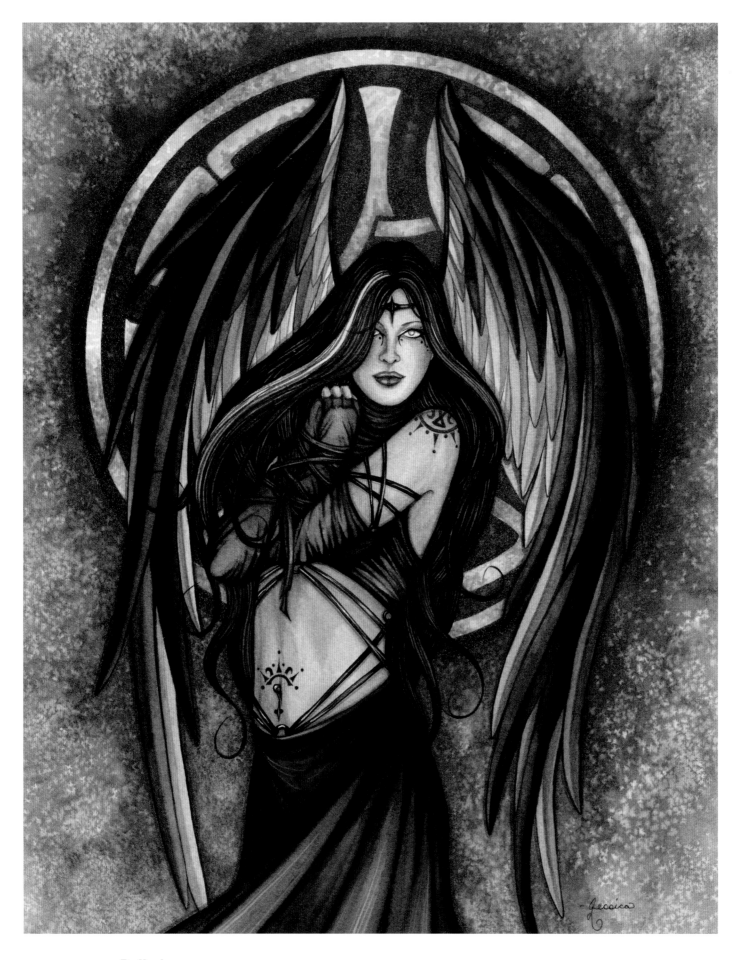

### Belladonna
A dark winged angel stands before a symbolic backdrop. She wears an elaborate costume and her wrists are loosely bound by a red tie, allowing her to free herself at anytime. A shock of white hair sprouts from her otherwise long, raven locks.

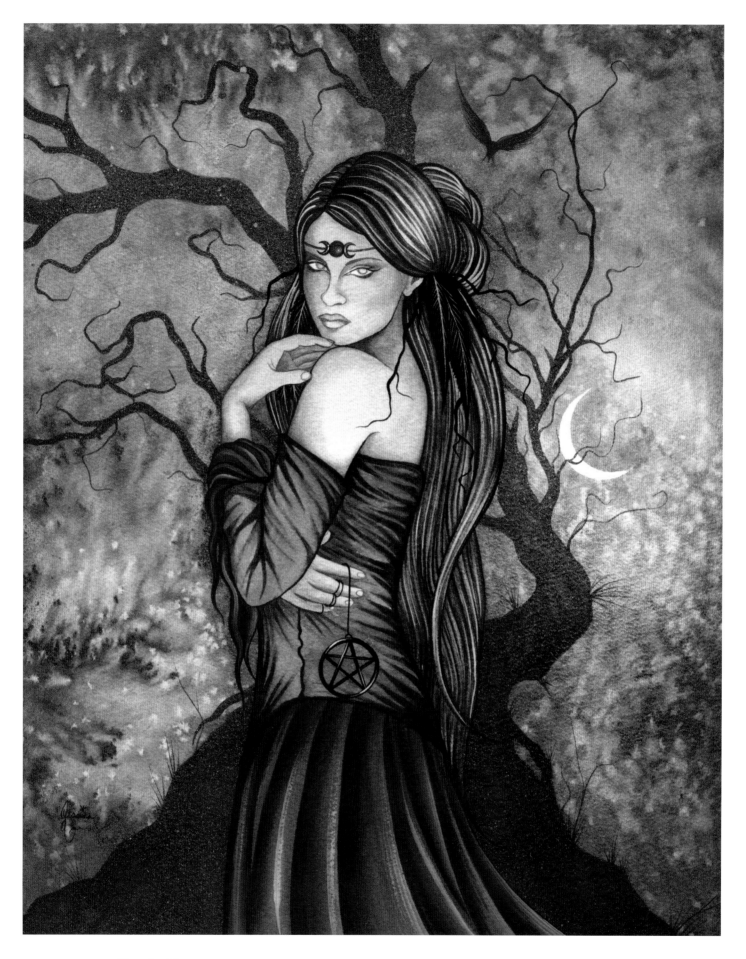

### *Bewitching*

An enchanted maiden stands before an old twisted tree with a crescent moon in the night sky. She holds a pentacle and has raven feathers adorning her long brown hair.

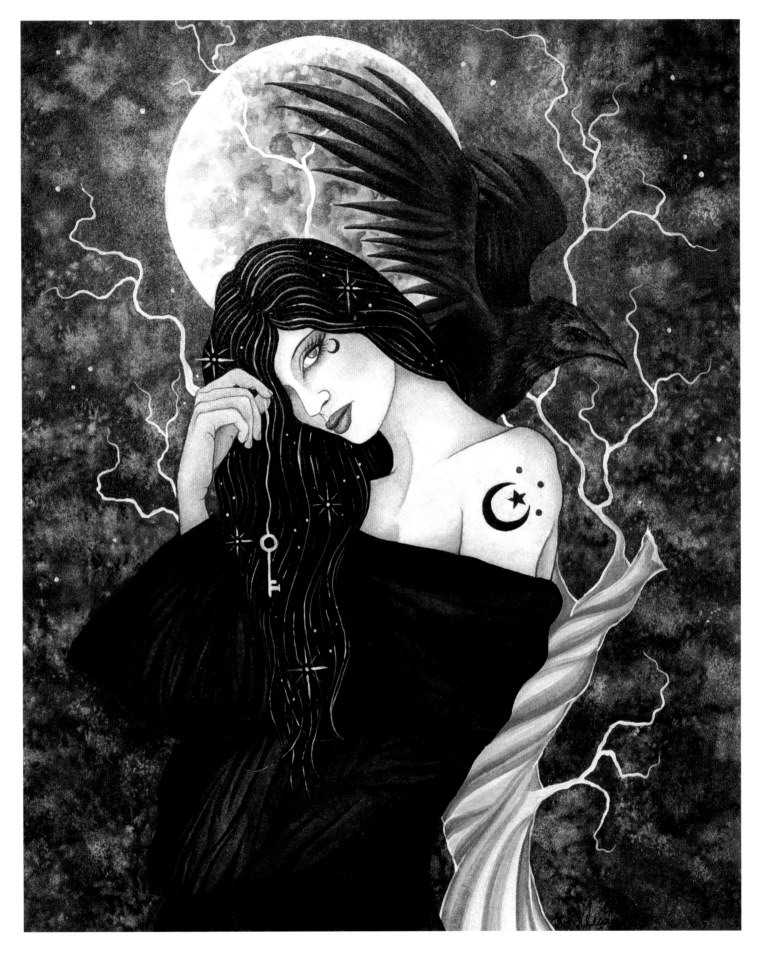

### Black Magick

Black Magick was one of my first endeavors to create a dark, gothic maiden with a raven. She quickly became one of my best selling images and so I've expanded on this subject over the years.

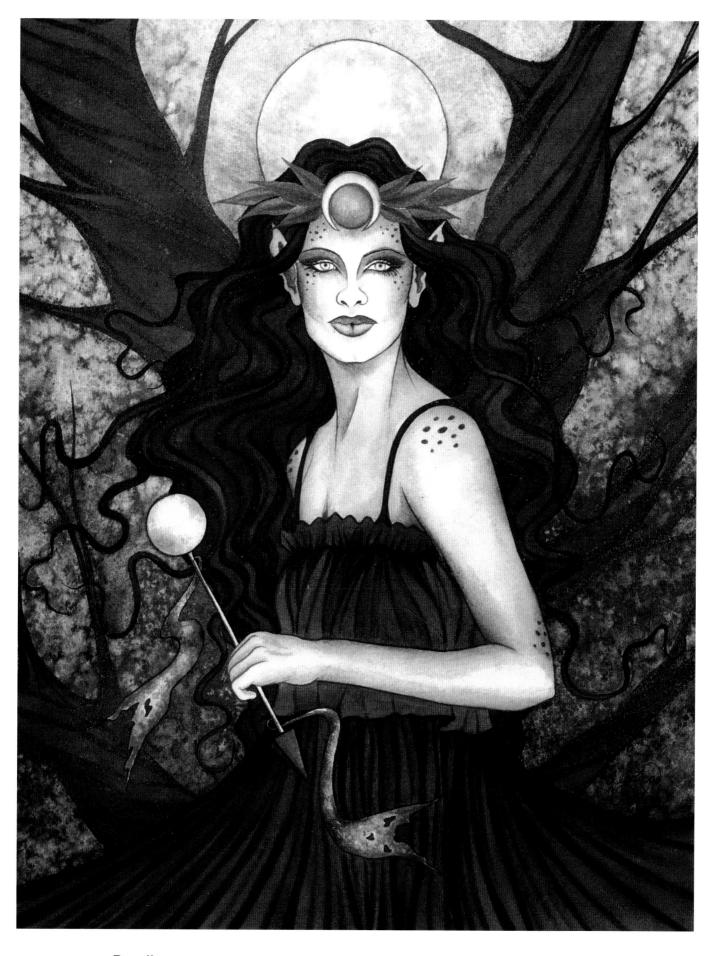

### *Boudiccea*
This is my portrayal of Boudiccea, a Celtic warrior queen famed for her deep red hair.

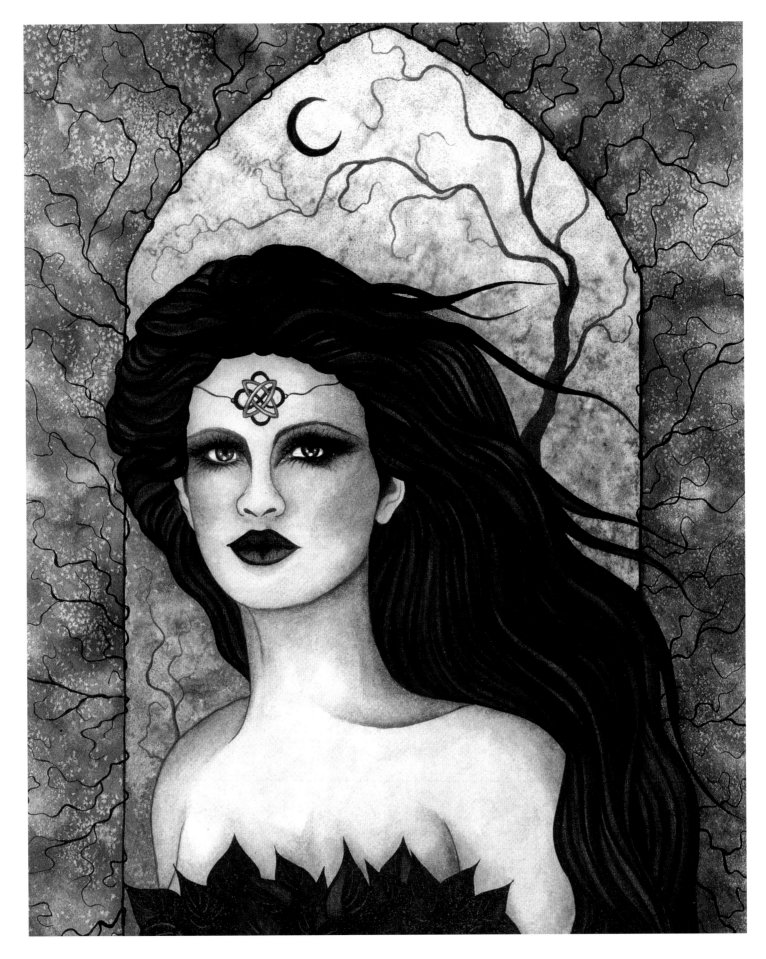

### Brid

Brid is perhaps the most widely known Celtic goddess, also known as Brigid, Brig, etc. I've shown her in portrait form, wearing a Celtic knot work headband.

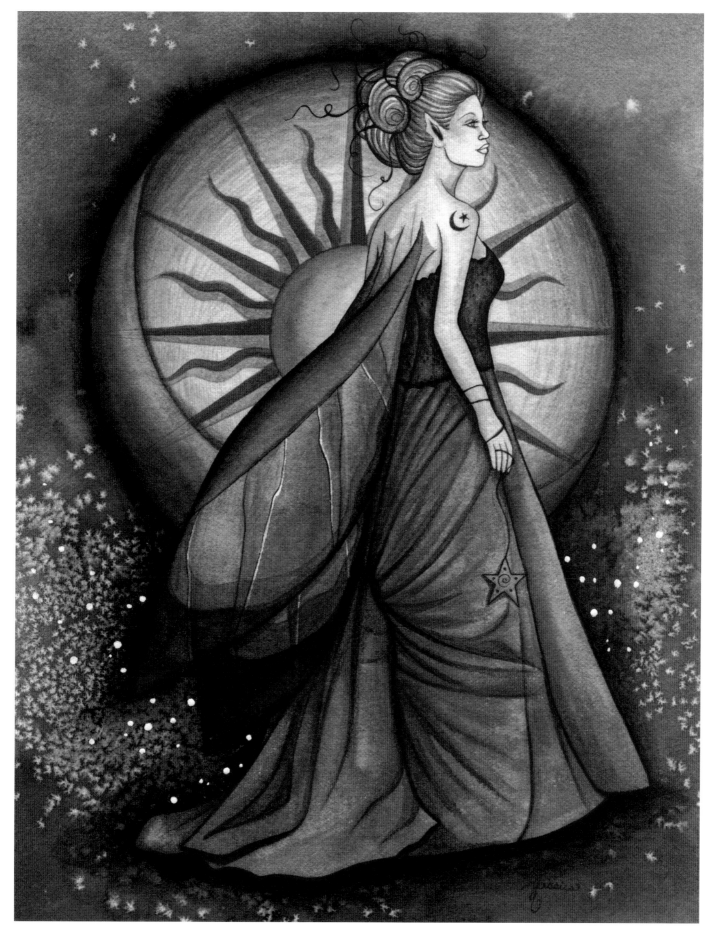

## Celestia

Celestia is a faery in a long, romantic gown set against a moon and sun backdrop.

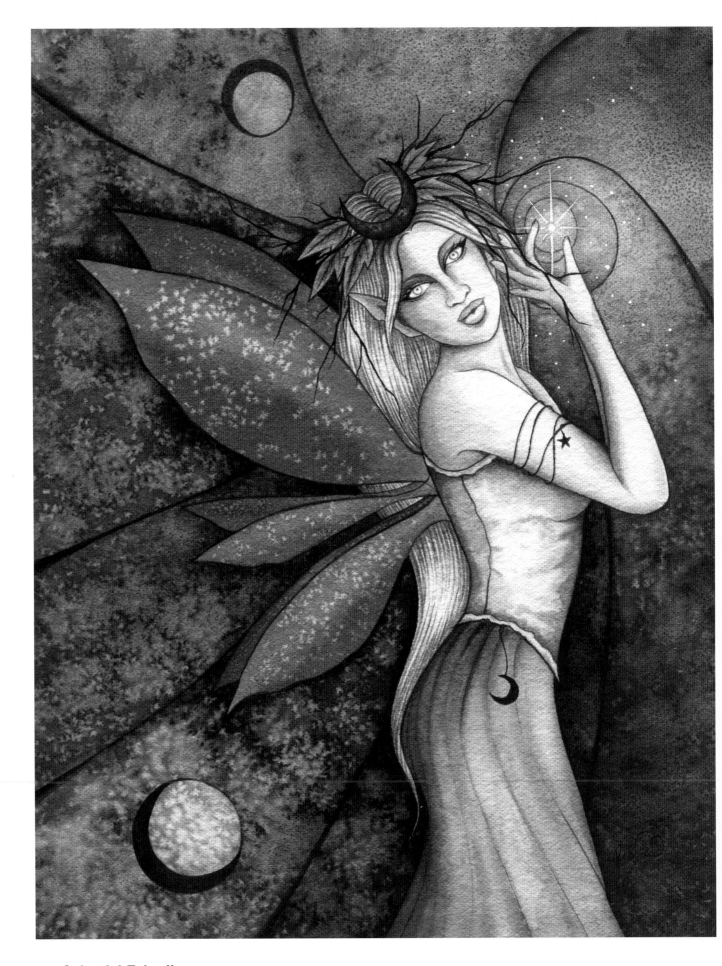

### *Celestial Fairy II*
I did this brightly colored faery painting for a step-by-step instruction book on how to paint fairies.

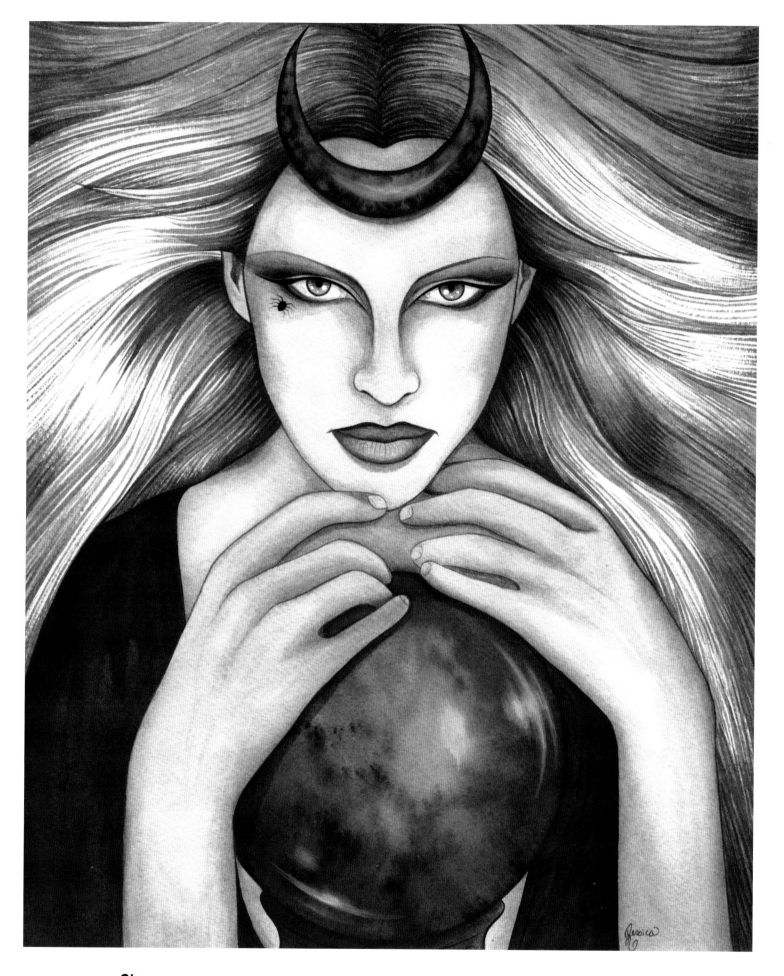

### *Circe*

I've always loved the story of Circe, the powerful sorceress. I portrayed her as a haunting enchantress with a crystal gazing ball and moon crown.

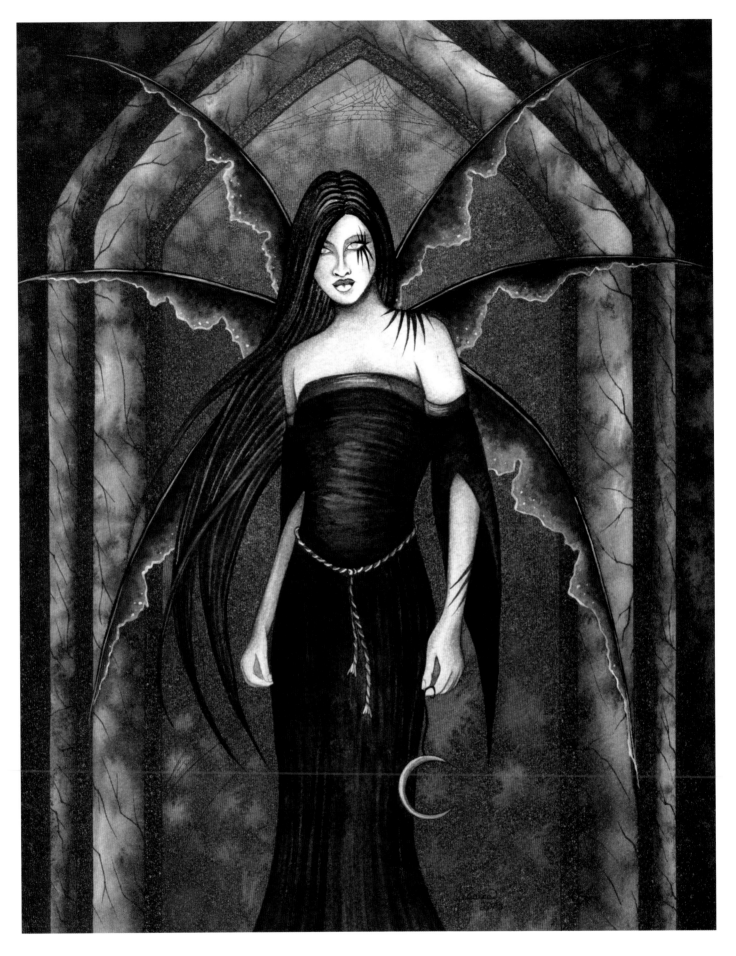

### The Countess

This is one of my darker pieces, depicting a gothic female vampire.

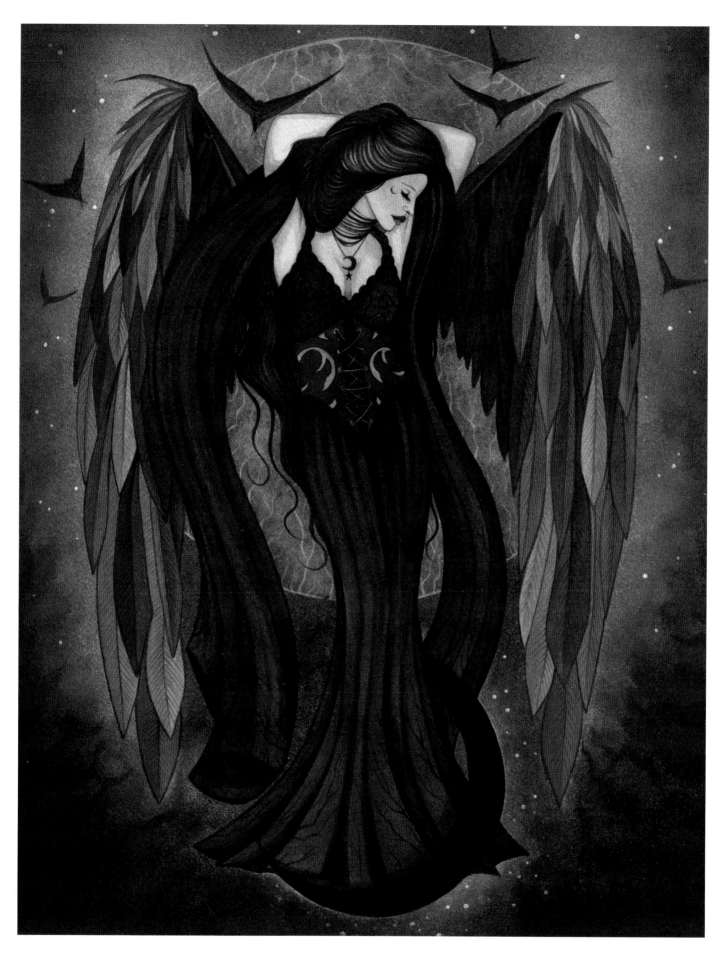

### Dark Angel

Despite her name, I think this dark angel has a sweet, almost shy countenance. She rides through the night sky on a crescent moon with her wings outstretched.

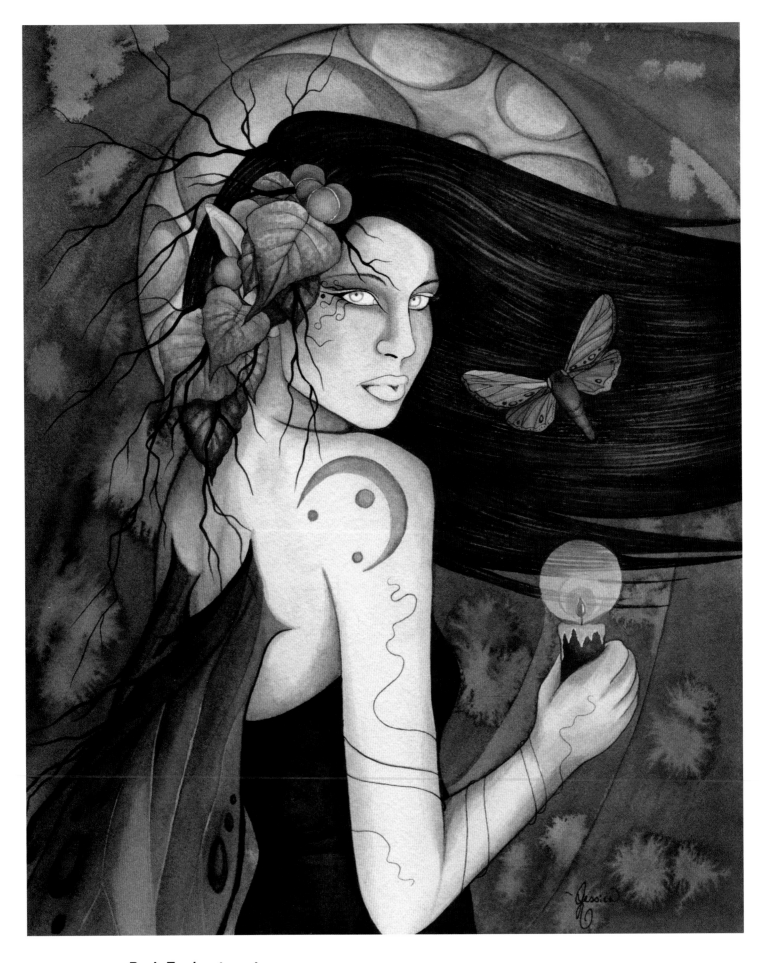

### Dark Enchantment

In this painting, a mysterious faery leads us into her shadowy realm, with only a candle to light our way. A moth rests in her long raven locks. I especially like how the eyes came out on this one; they are a bit spooky and bewitching.

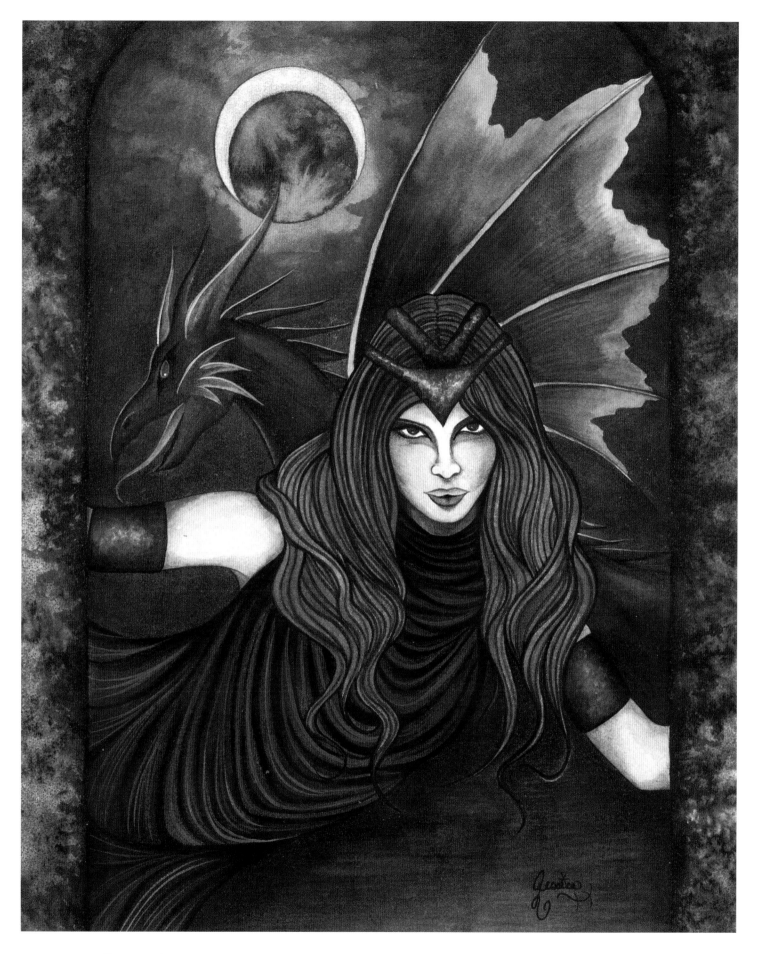

### Dragon Keeper

A dark maiden rests between the columns of her temple accompanied by her dragon familiar.

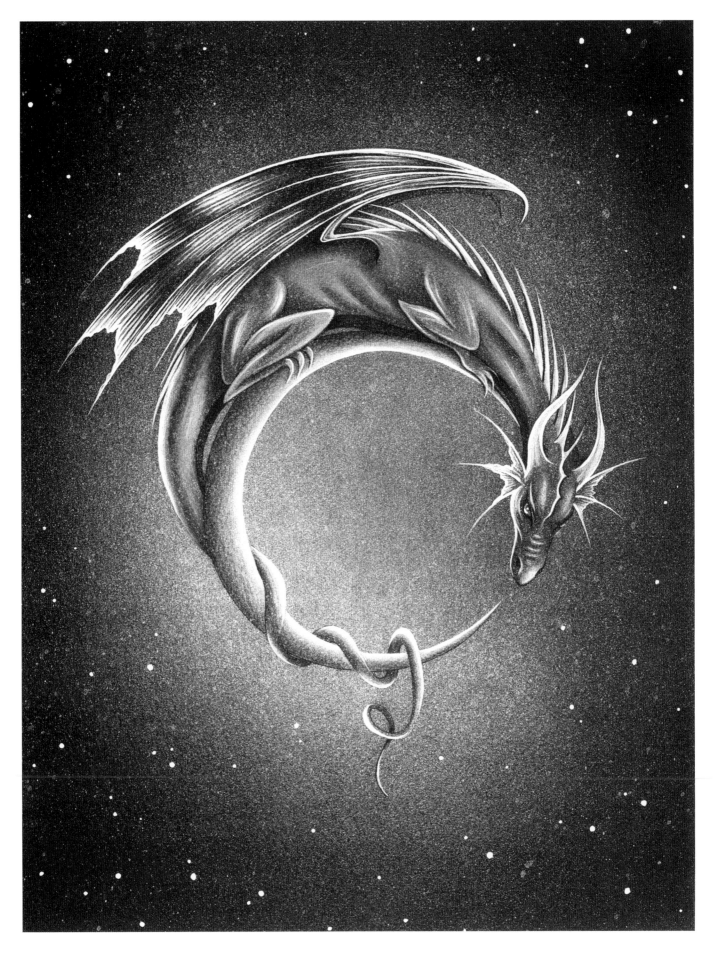

### Dragon Moon

In addition to my usual watercolors, I like to experiment with air brushing. This is one of my dragons done using an airbrush and pencil technique. It features a silvery dragon wrapped around a crescent moon.

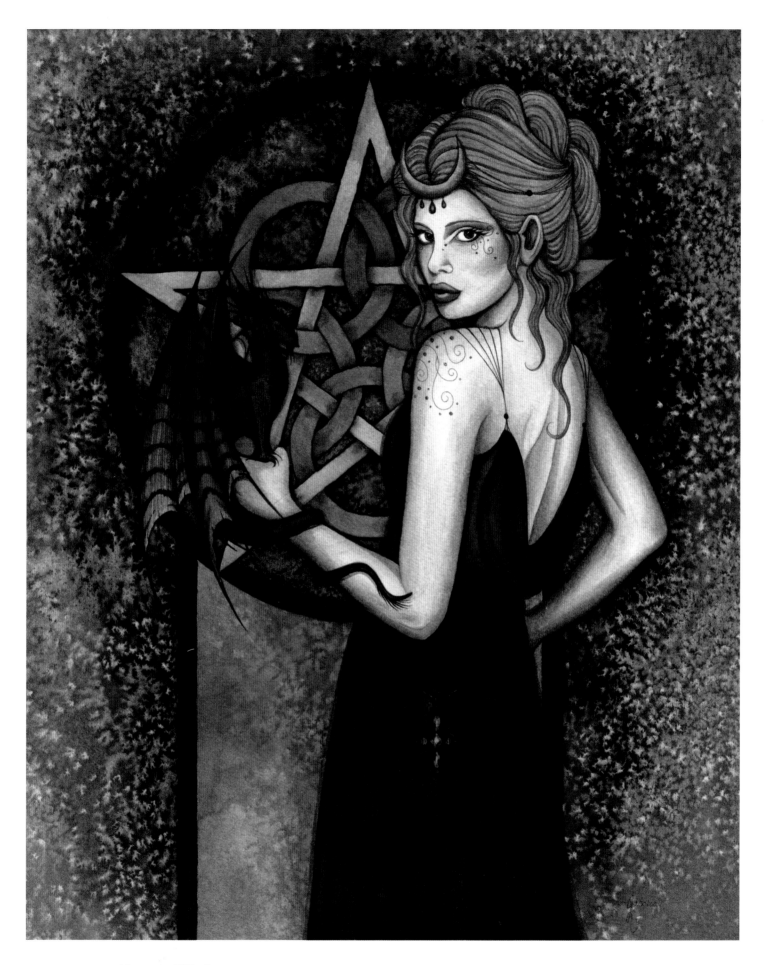

### *Dragon Witch*
This piece was the cover for my 2006 Night Magick calendar. It features an enchantress with her dragon familiar perched on her hand. She wears a deep red gown and stands in front of a decorative Celtic pentagram symbol.

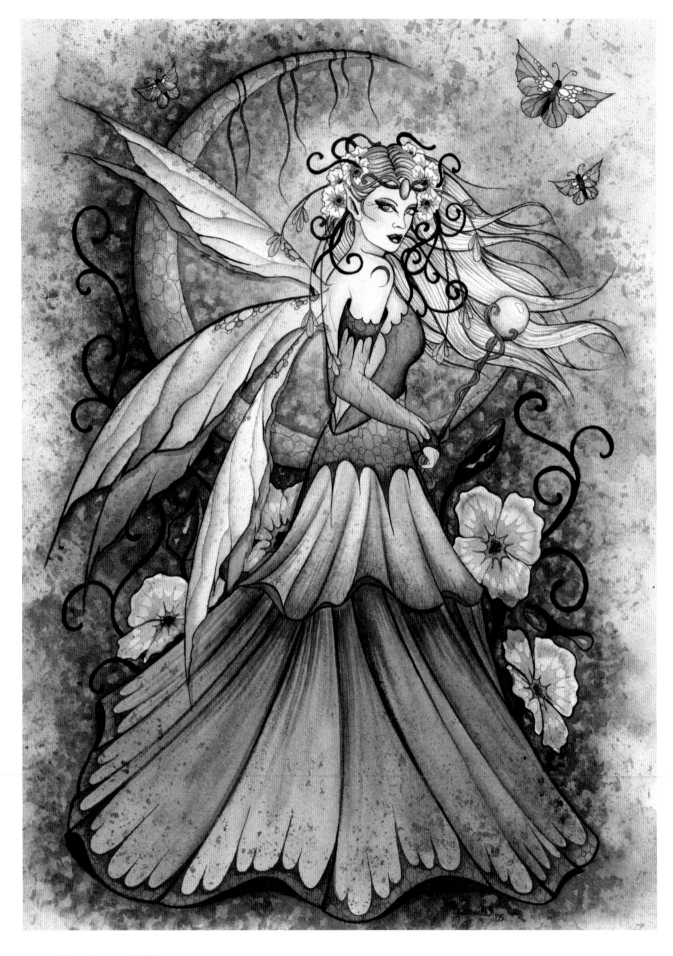

### Enchanted Moon

This faery painting was a play on using a variety of colors. She's just bursting with the hues of a twilight sunset.

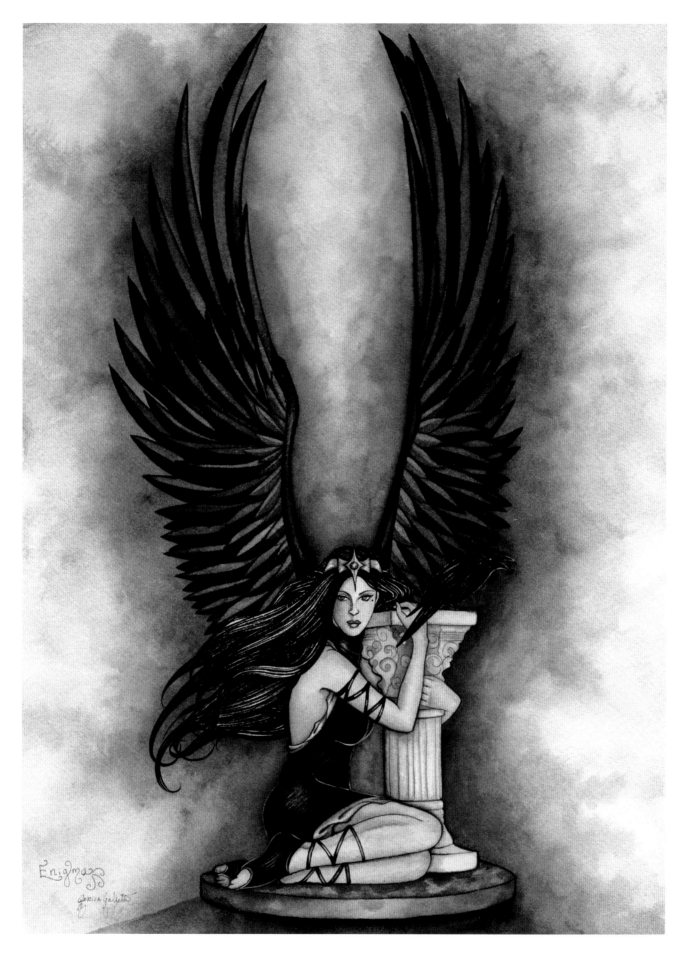

## Enigma

The word enigma means mystery, and I thought it was the perfect title for this raven winged angel seated next to a pedestal.

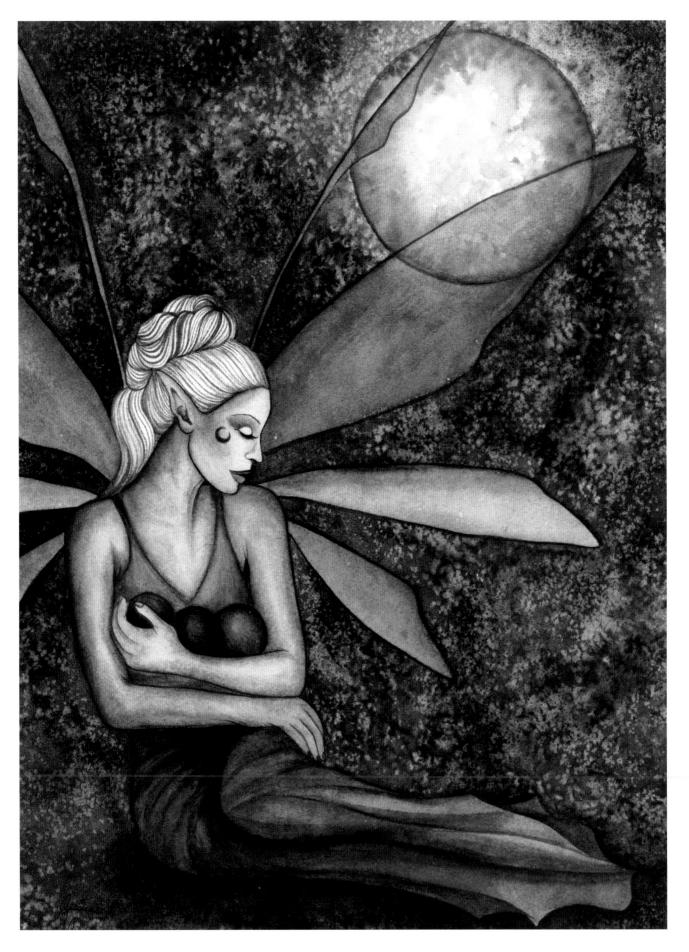

### *Fairy Moon*

Here we have a serene lunar faery clutching several magical moonstones surrounded by indigo and deep blue hues.

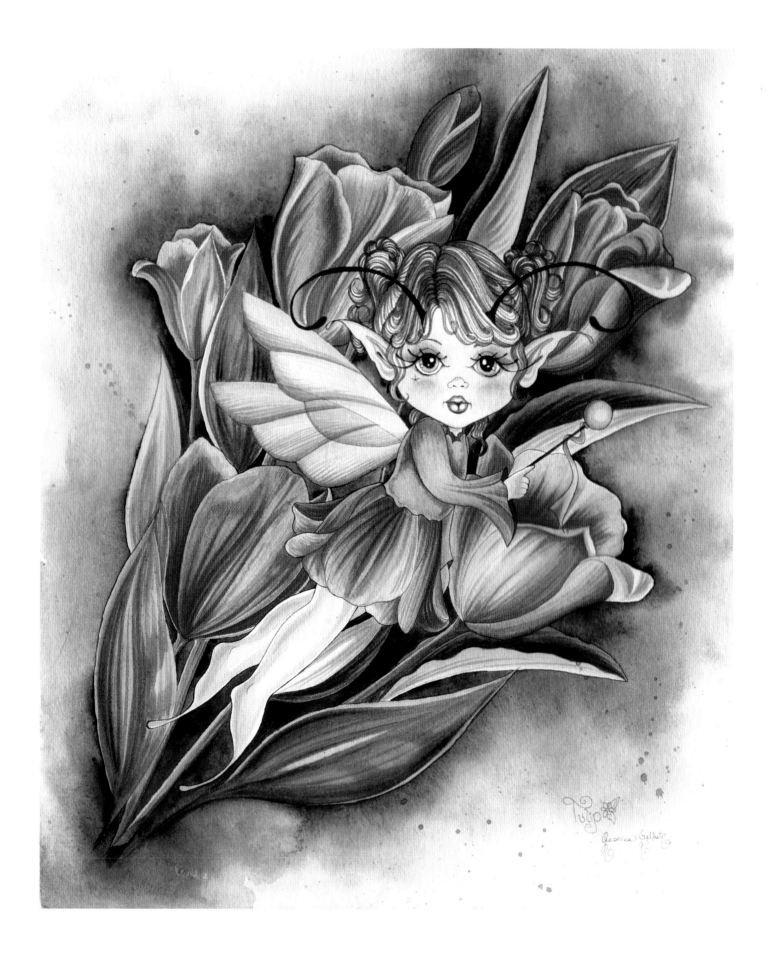

### *Fairy Petal Tulip*

I actually painted this for my little daughter, Julia Rose. I hadn't ever painted a little one as a faery, so it was quite different from what I was used to. I think she came out looking a bit mischievous!

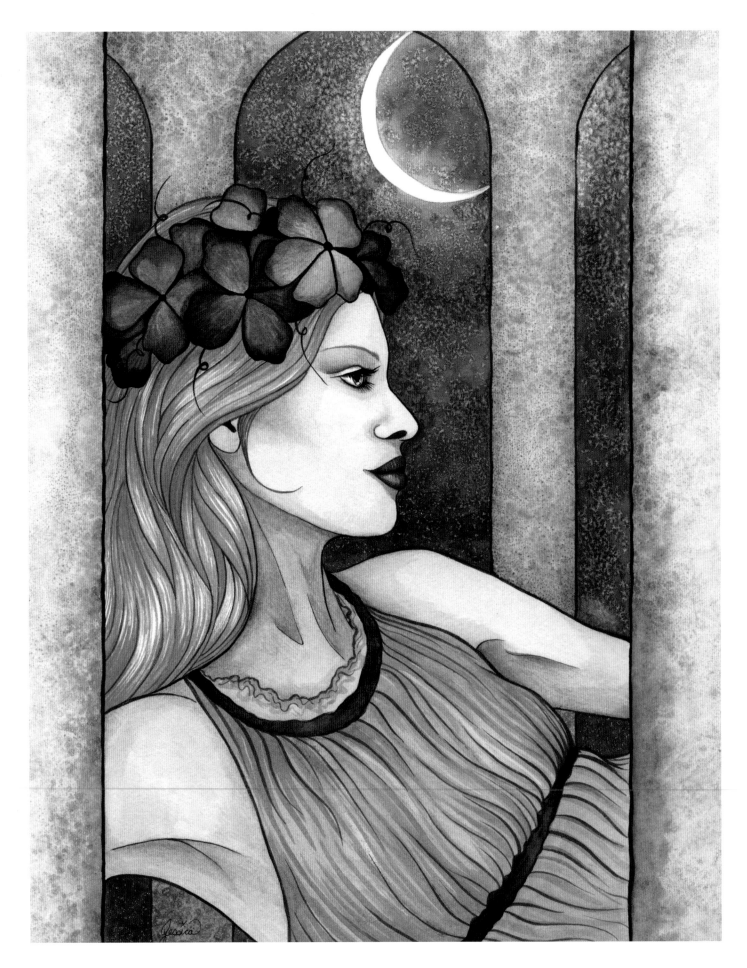

### Freya

This is my rendition of the Norse goddess of love and beauty. Freya was renown for her beautiful blonde hair and blue eyes.

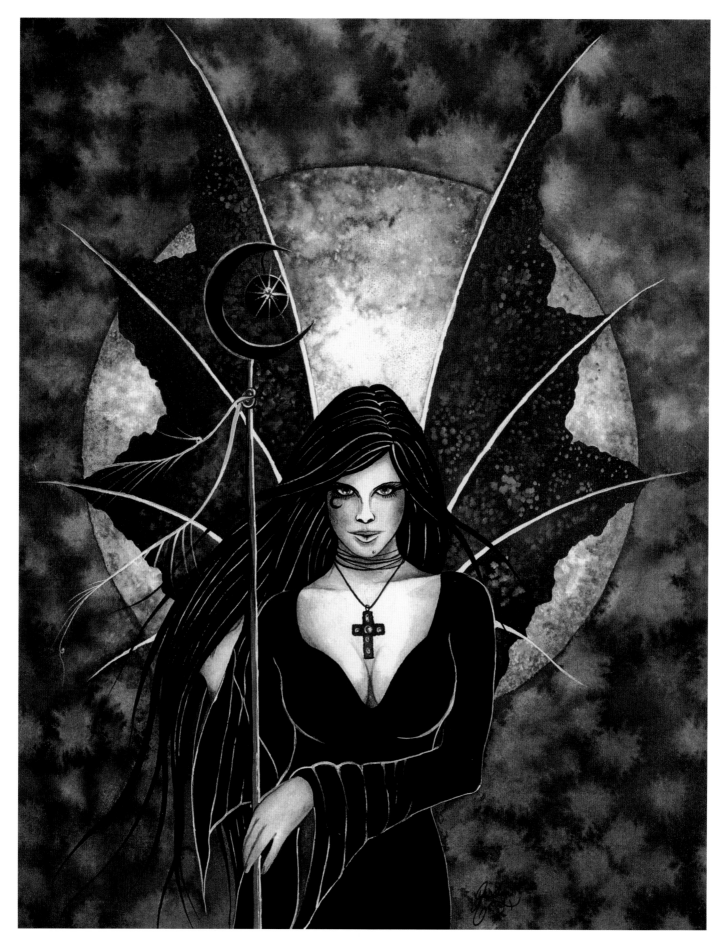

## Gothic Faery

This was my very first painting done in a gothic style. I remember being pleasantly surprised at the interest in this piece and went on to elaborate on this theme.

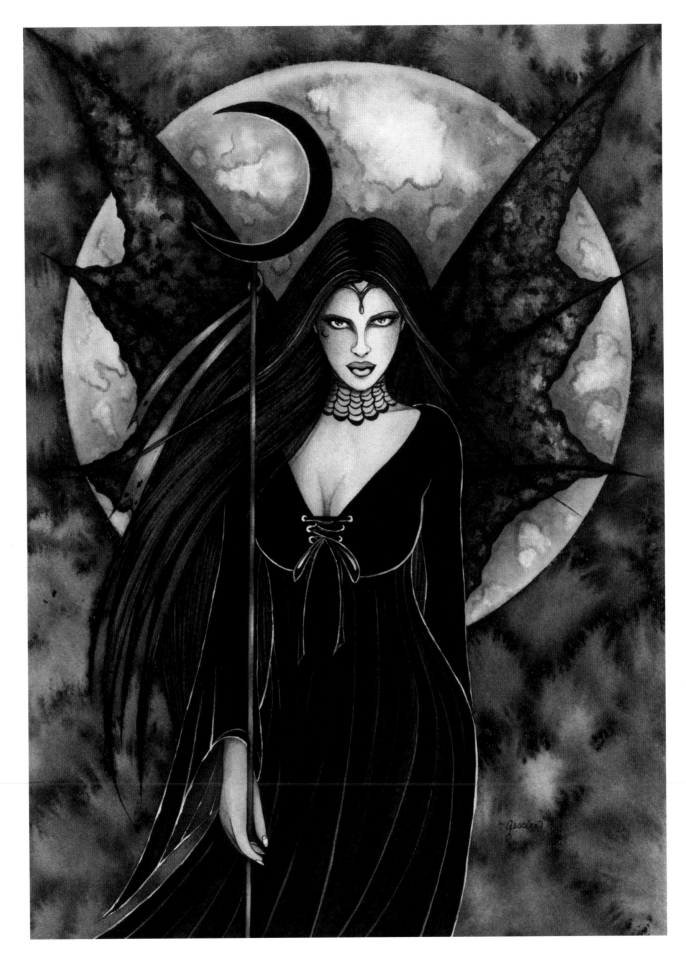

### *Gothique*
My gothic style paintings have always been popular with my collectors. This one is a different take on my original Gothic Faery painting. I don't know that I'd want to meet this faery on a dark and stormy night.

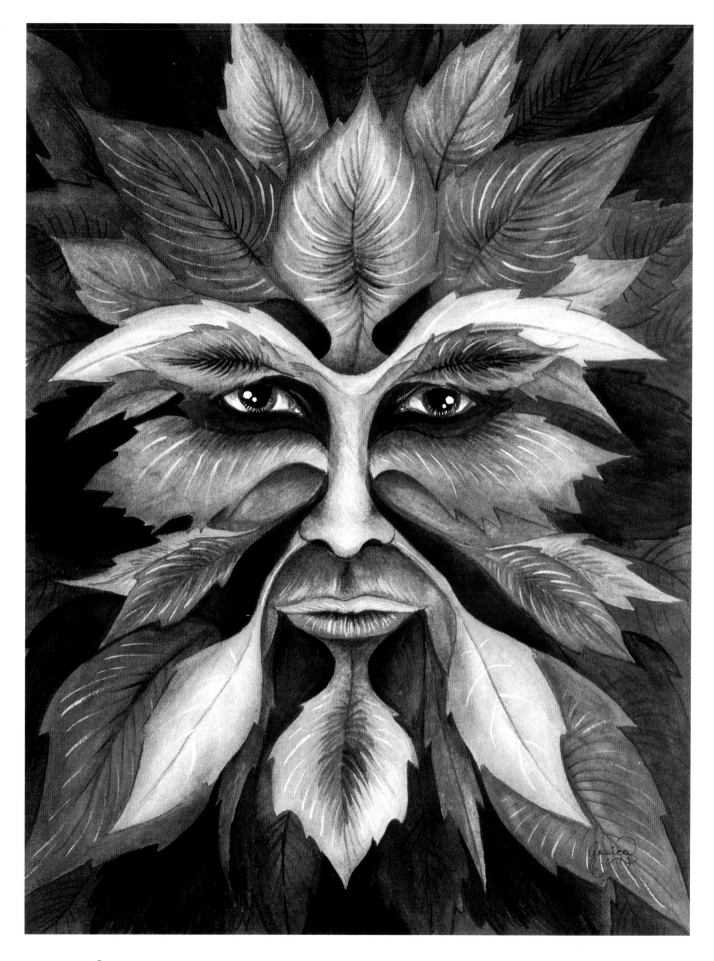

## *Greenman*

This painting remains one of my personal favorites, and is also one of the very few males I've ever attempted. The Green Man is a popular Celtic figure representing the Earth, fertility and the mysteries of nature.

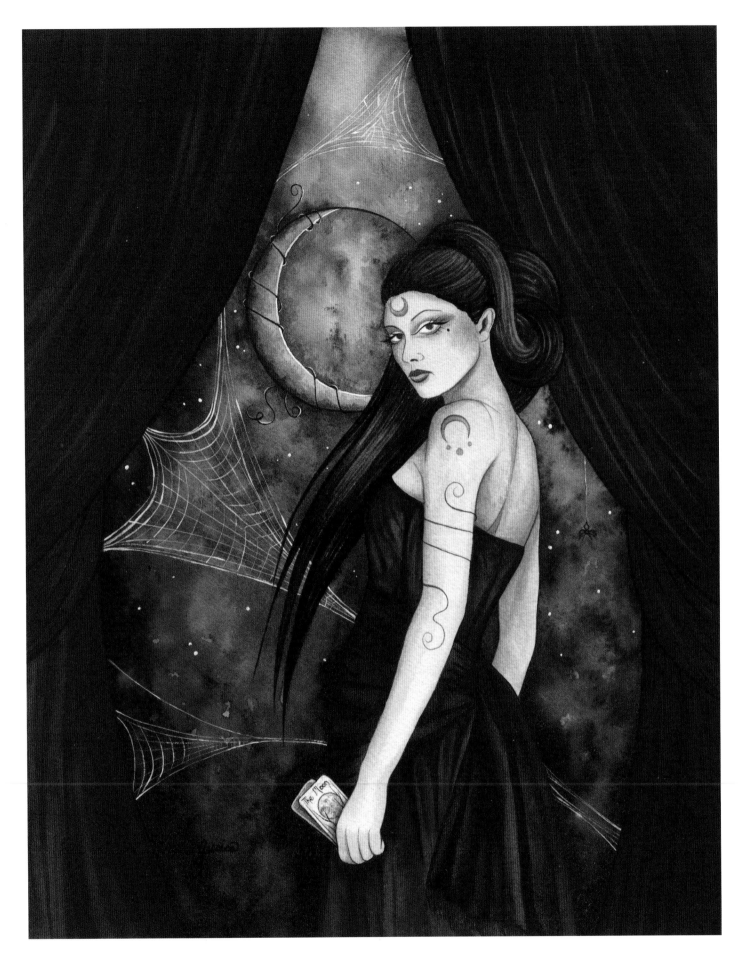

### *Gypsy*

I'm always fascinated by the real life Gypsy fortunetellers at the Renaissance Festivals, this piece was inspired by them. It features a mysterious Gypsy maiden beckoning, her tarot cards are ready in her hand.

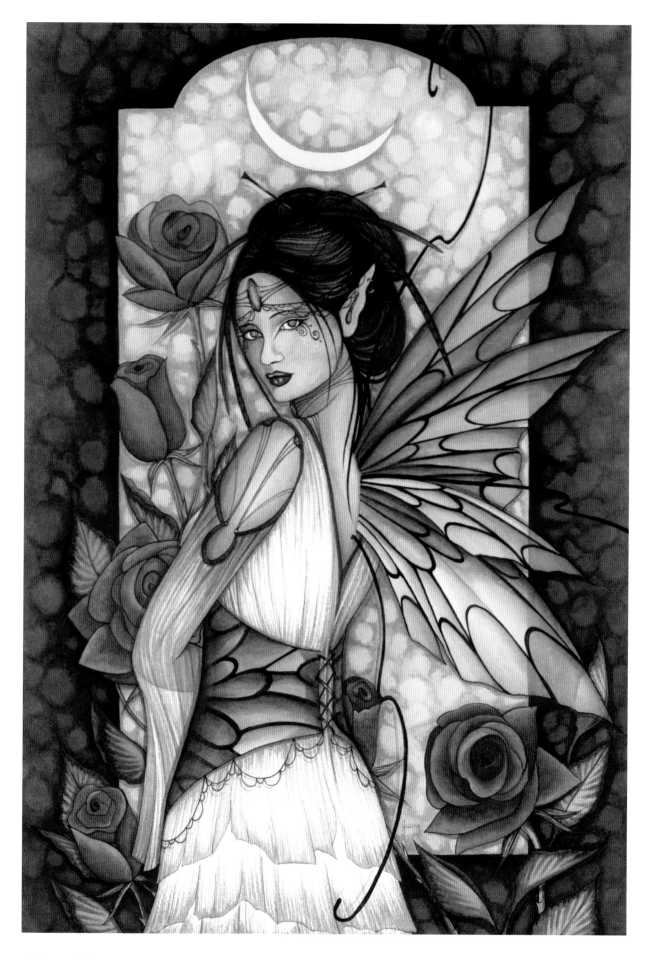

## *Gypsy Rose*

Dressed in all her finery, a gypsy faery stands before a decorative window as autumn colored roses bloom around her.

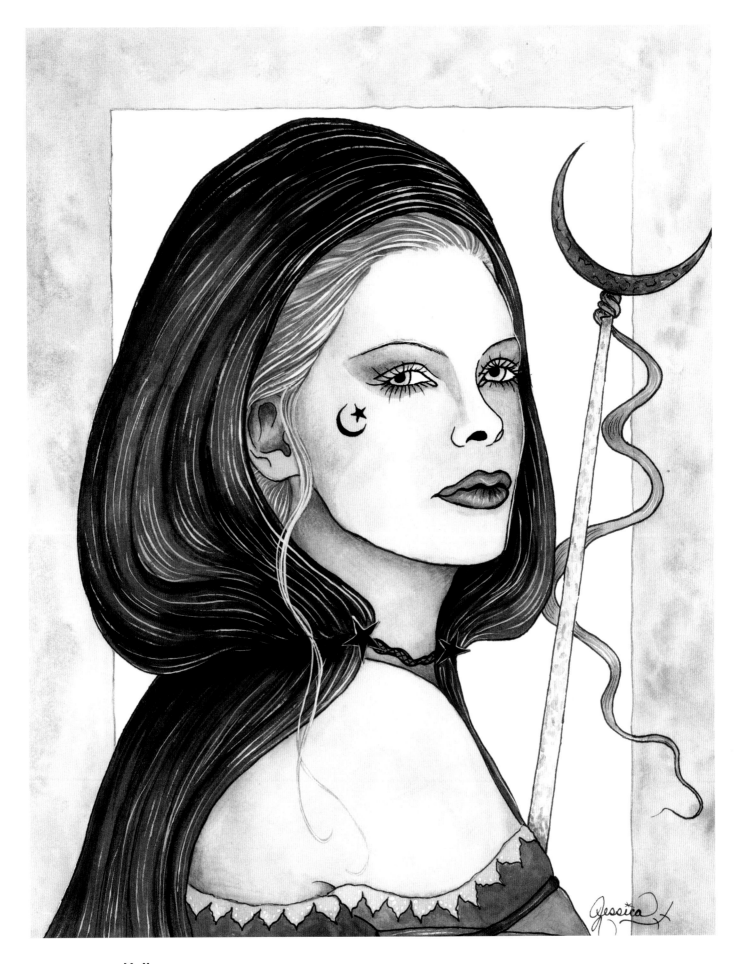

### *Hallewes*

This is another of my very early works. Hallewes is a sorceress from ancient Celtic mythology.

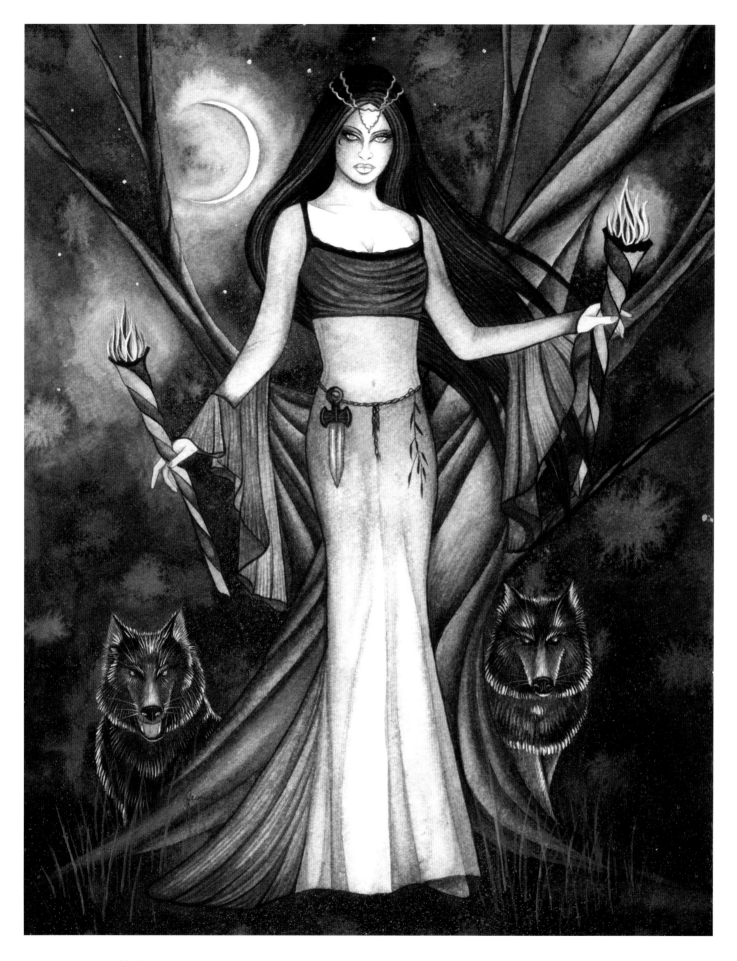

### *Hekate*

I've always enjoyed painting goddesses, and this is my rendition of the goddess Hekate. I've shown her with her traditional mythological symbols, including two large black dogs, an athame on her belt, and a torch in each hand. She is often times pictured as an old woman, but I wanted to put a different spin on that and showed her a bit younger.

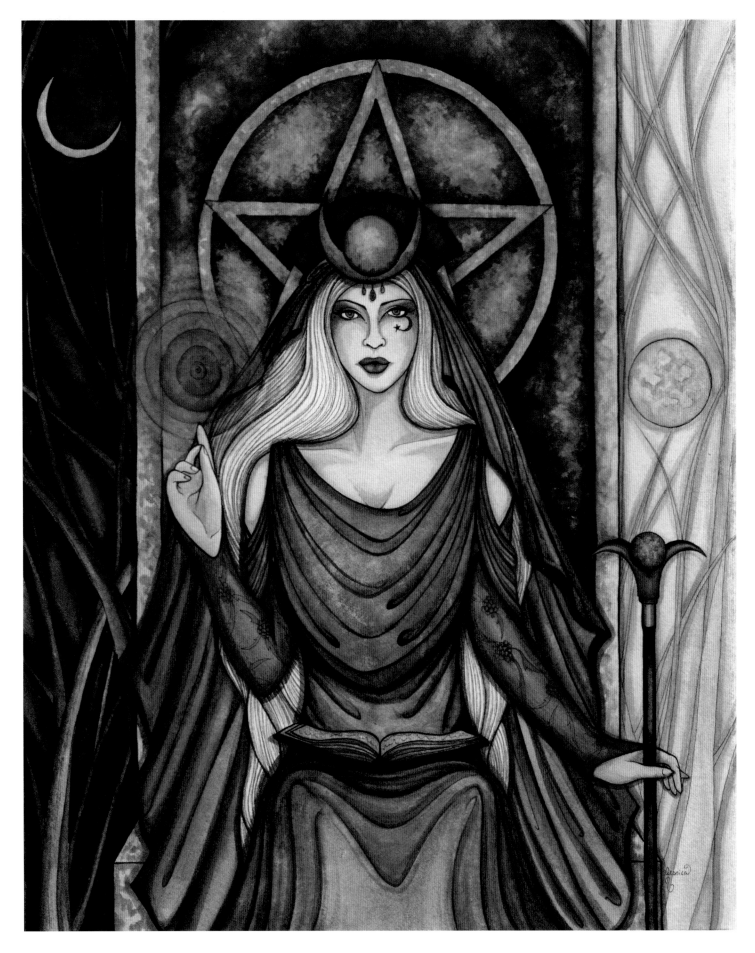

### High Priestess
This is my take on the High Priestess image found in most tarot decks. Sitting on her throne, she wears her traditional headdress and robes.

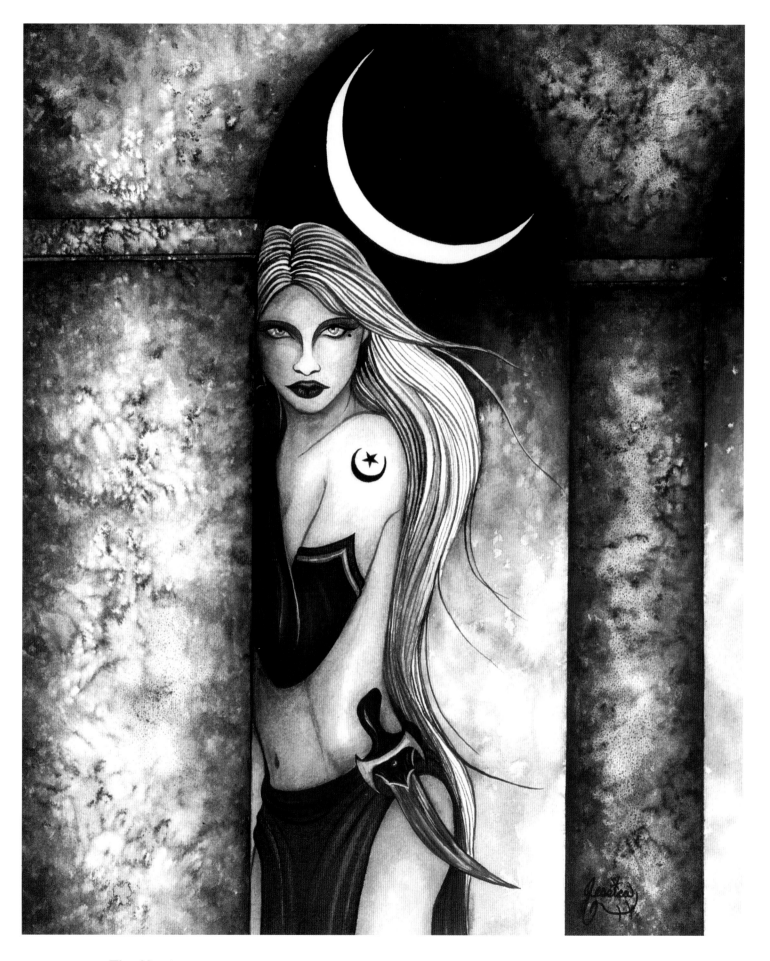

### *The Huntress*

I painted this piece for my Night Magick calendar. This was an experiment in using contrasting shades of black and white, adding a bit of red for interest.

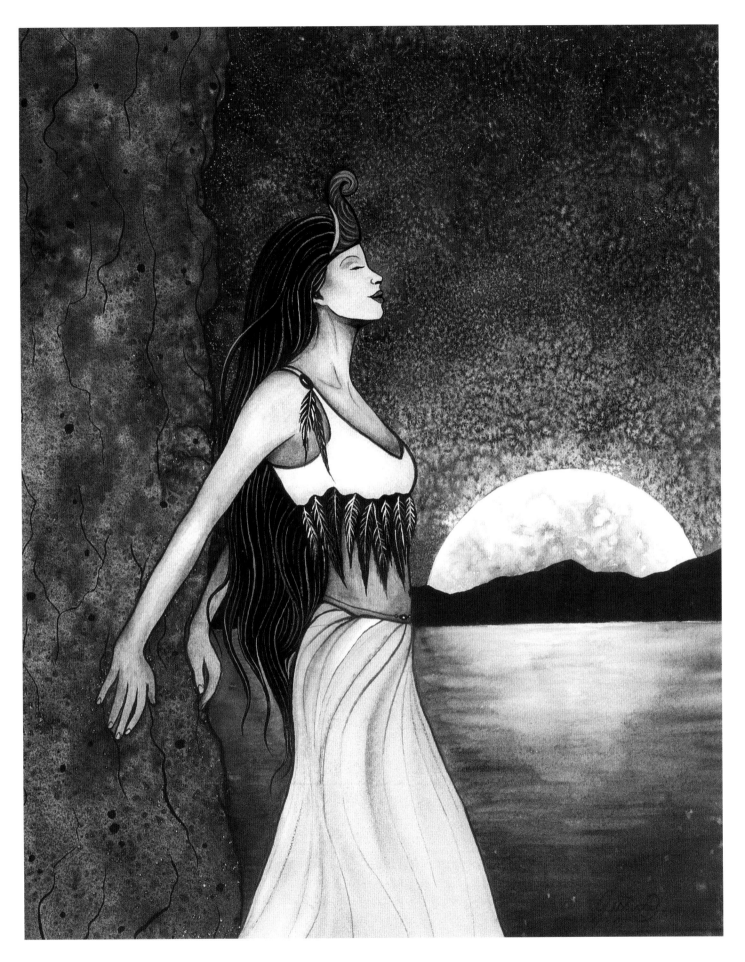

### *Inanna*

Inanna is a Sumerian goddess. Their mythology considered her to be the mother of creation, presiding over the birth of the Universe. The unusual headdress I've portrayed her in was taken from an ancient reference of this goddess.

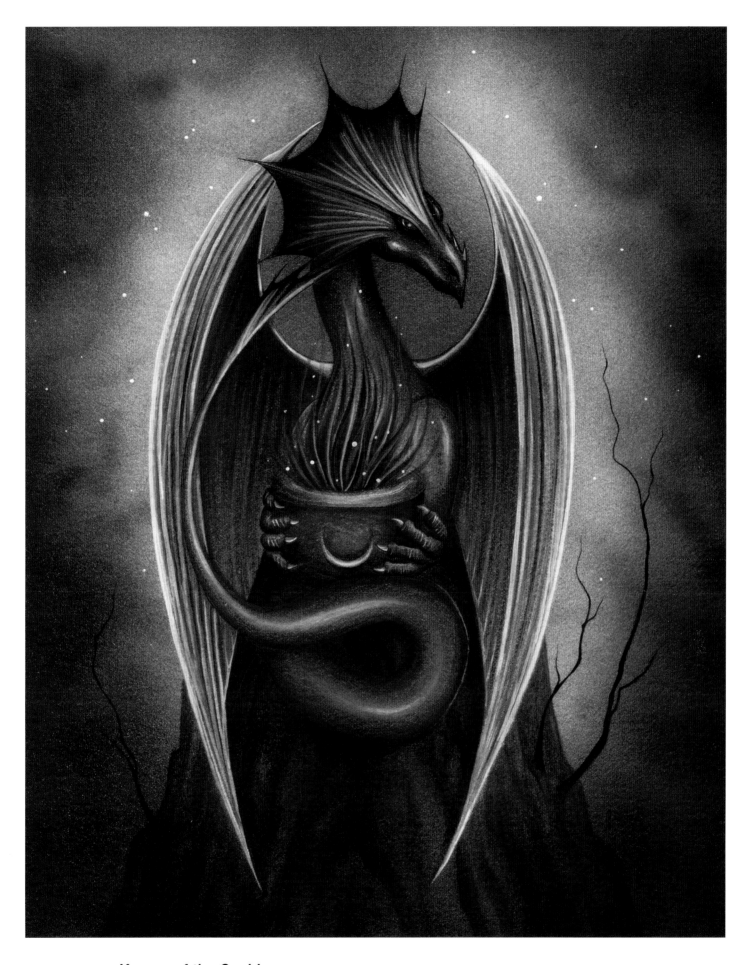

### *Keeper of the Cauldron*

This is another one of my airbrushed dragons. This dragon is a bit on the darker side, and clutches a cauldron between his mighty claws.

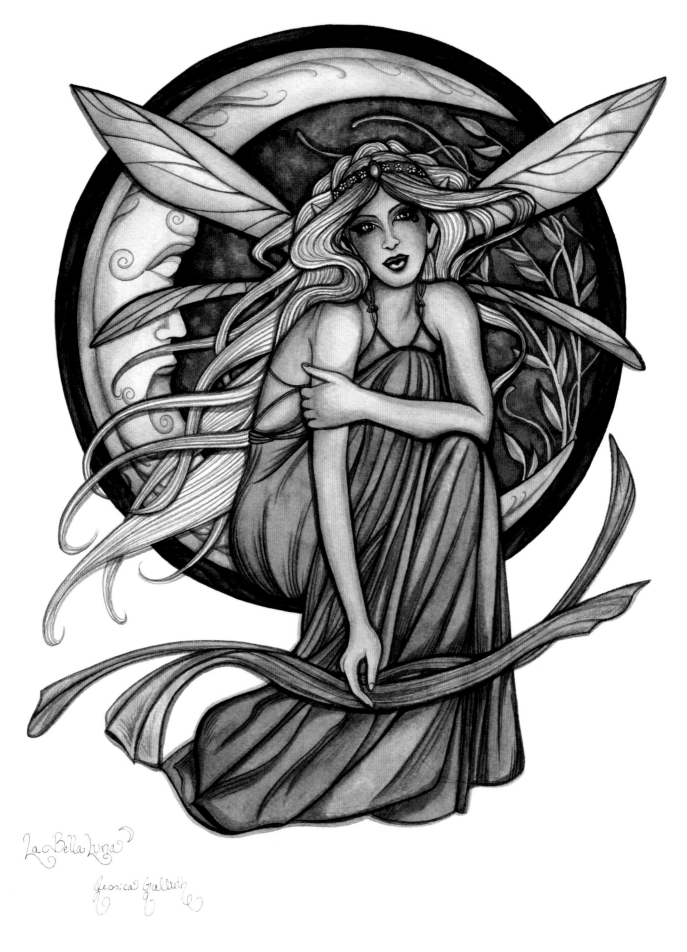

*La Bella Luna*

Jessica Galbreth

### *La Bella Luna*
I've had an interest lately in the Art Nouveau movement and this is my take on a faery done in that decorative style. Her name translates to "The Beautiful Moon".

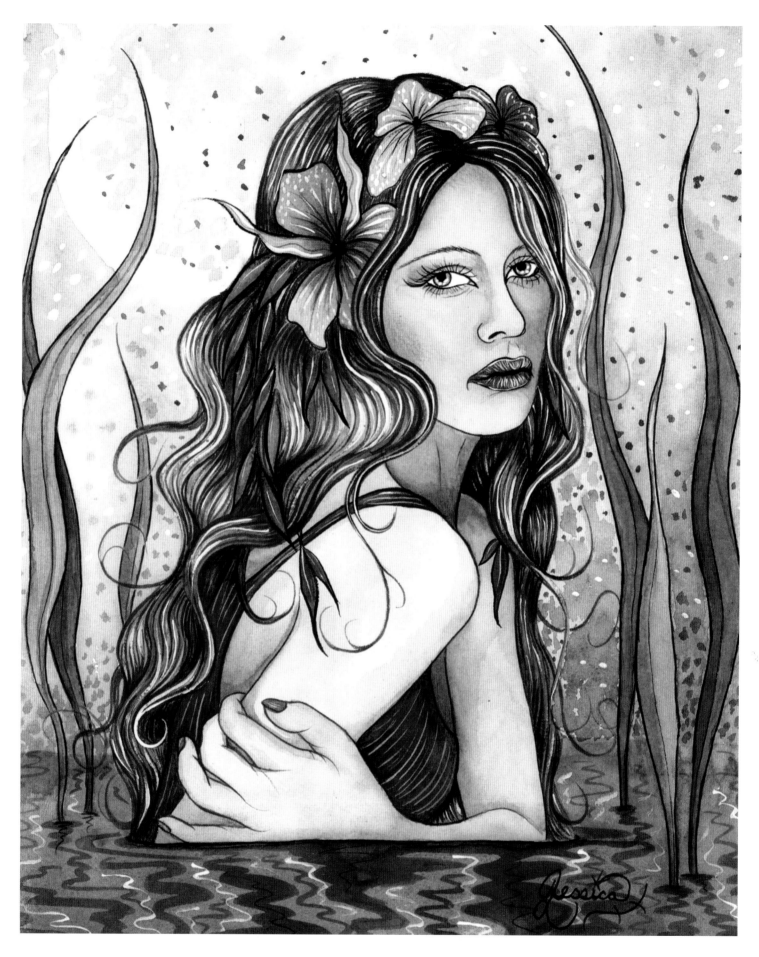

### *Lady of the Lake*

Lady of the Lake is one of my very earliest pieces. I was very much into Earth tones during this phase of my career.

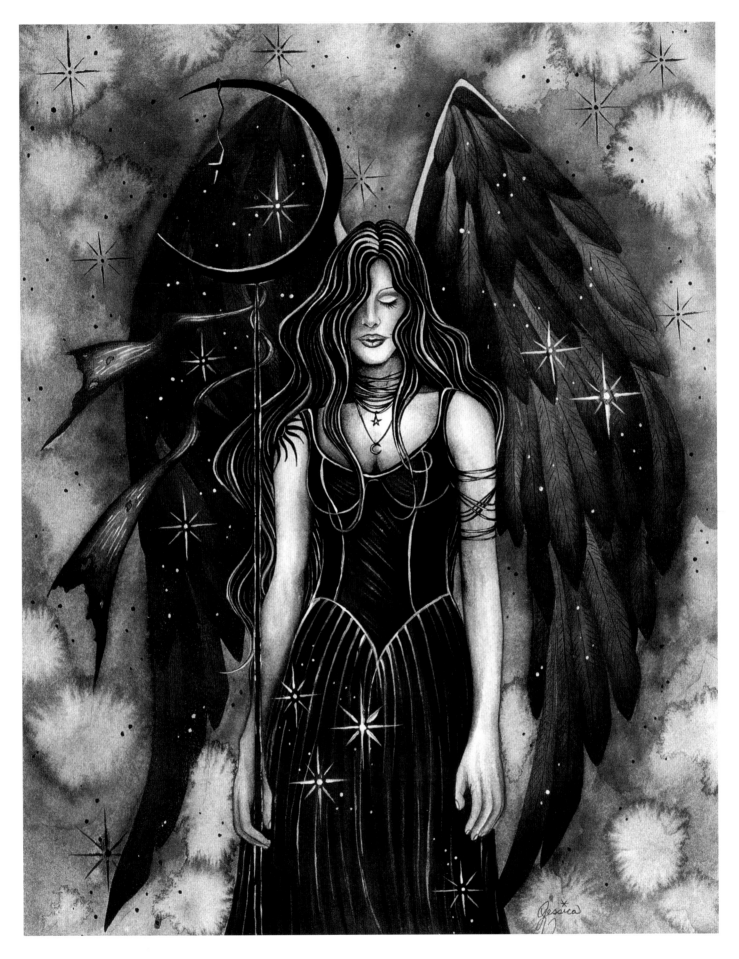

### Lady Raven
Another dark winged angel with an elaborate costume and long flowing hair.

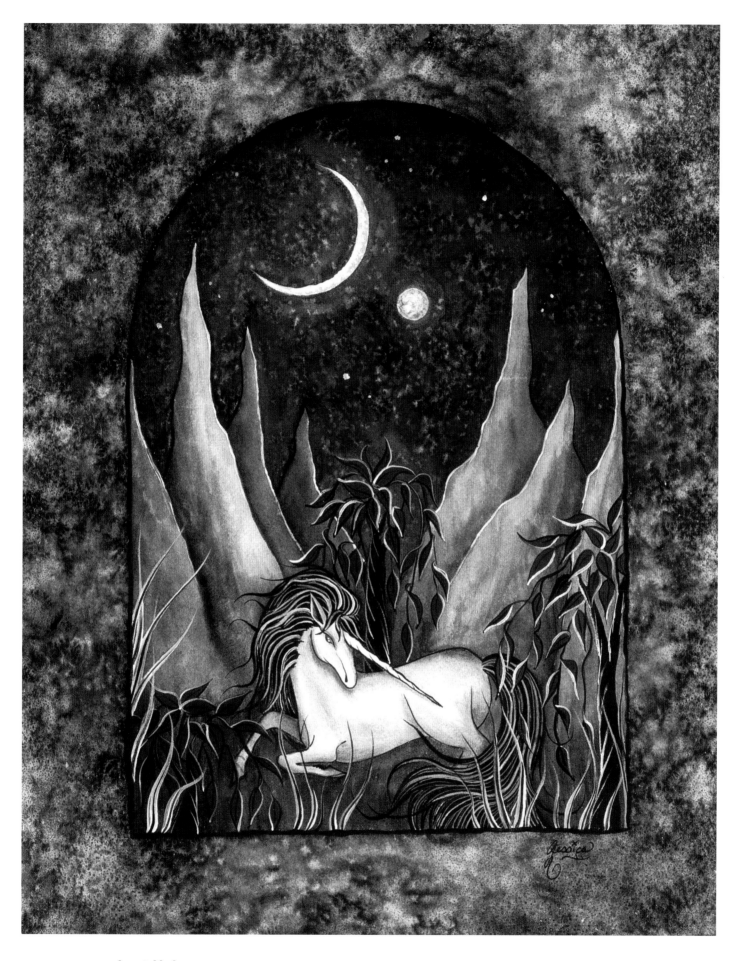

## *Last Unicorn*

This piece was inspired by the beautiful work of Susan Seddon Boulet. To me, this unicorn is the very last of its kind and has its head bowed in mourning.

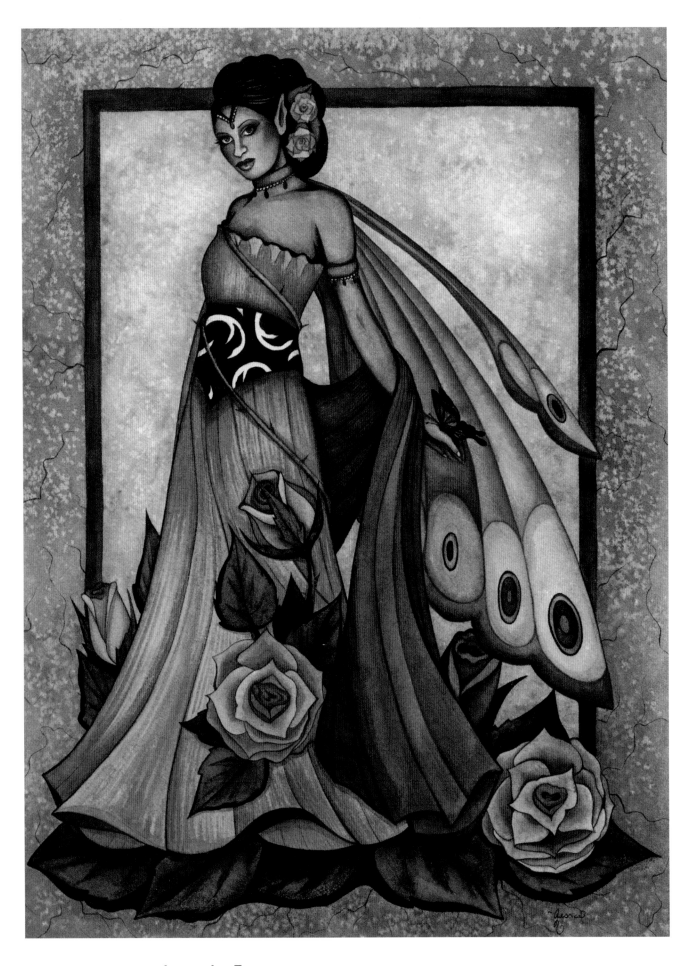

### Lavender Rose

I painted this faery when one of my figurine manufacturers requested a dark skinned faery in a long elaborate gown. Roses are my favorite flower so I took the liberty of adorning her in lavender blooms.

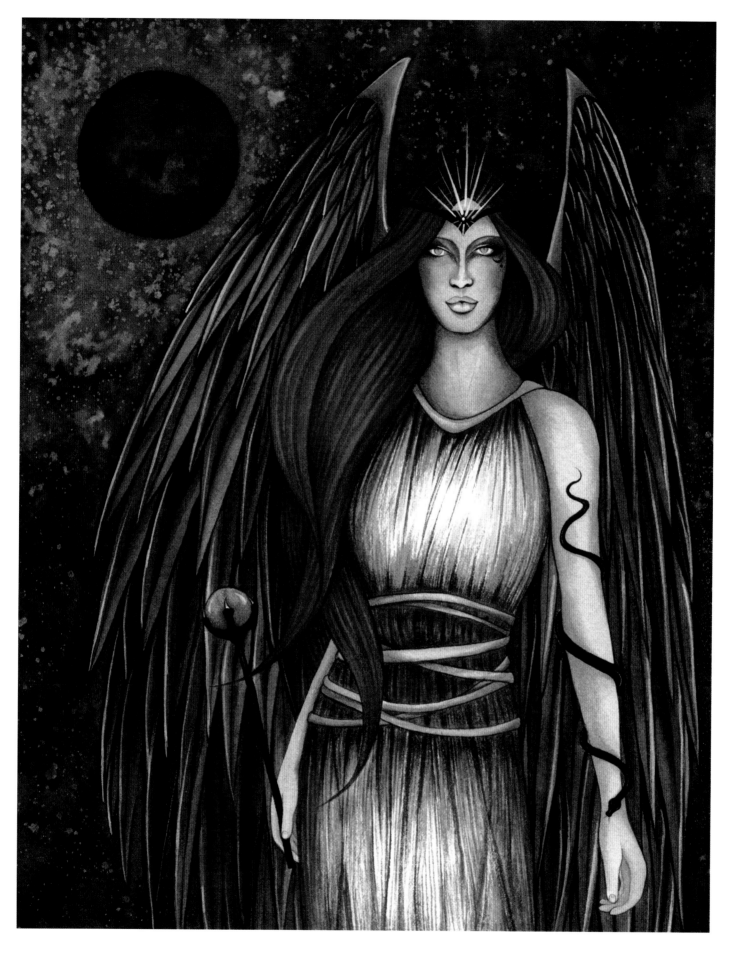

### Lilith

Lilith is a dark goddess from Hebrew mythology. I've shown her here with her magical scepter and symbolic serpent.

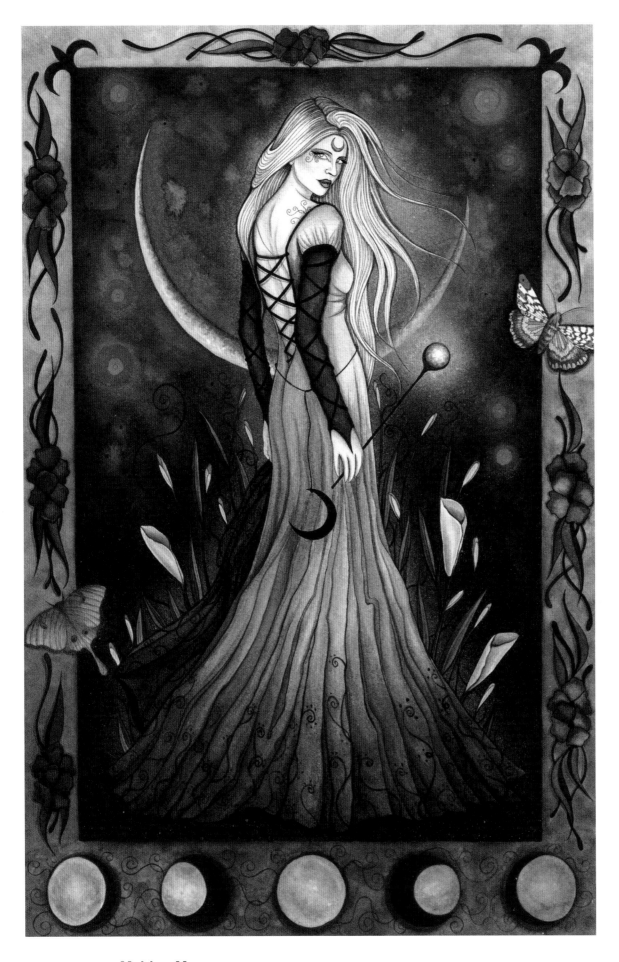

### *Maiden Moon*

This is a companion piece to my Mother Earth painting, which appears later in this book. Using soft, deep hues and the moon phases, I sought to create an image of the female personification of the moon.

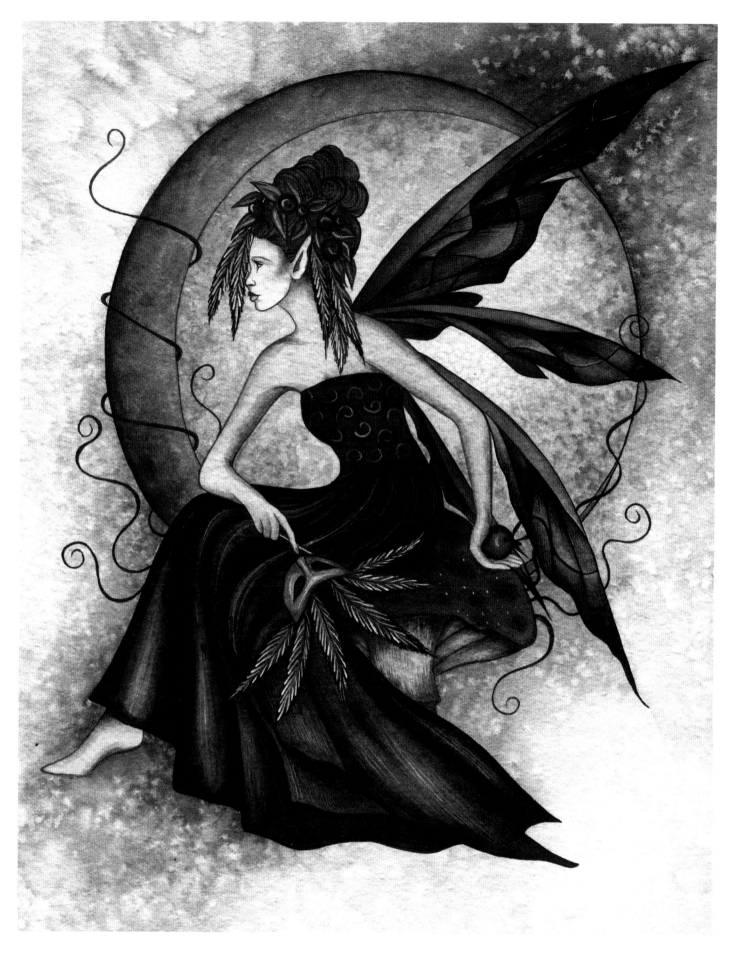

### Masquerade
Ready for a masquerade, this faery seated on a toadstool is dressed in all her finery. I absolutely love fantasy masks and they find their way into many of my paintings.

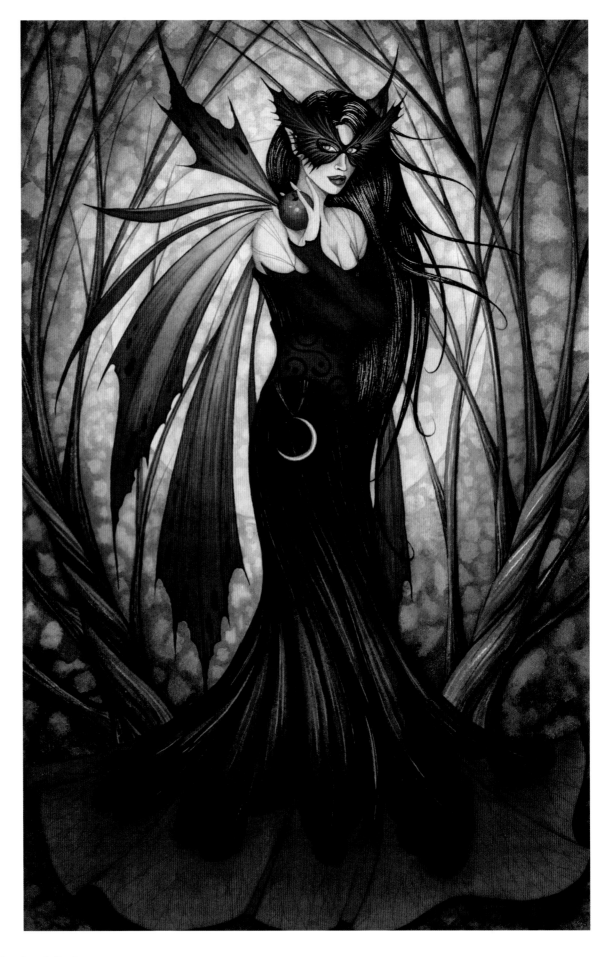

### *Mask of Autumn*

I painted this image of a decadent, striking autumn faery wearing a fantasy mask just for the cover of this book. I wanted something very special, that had never been seen before.

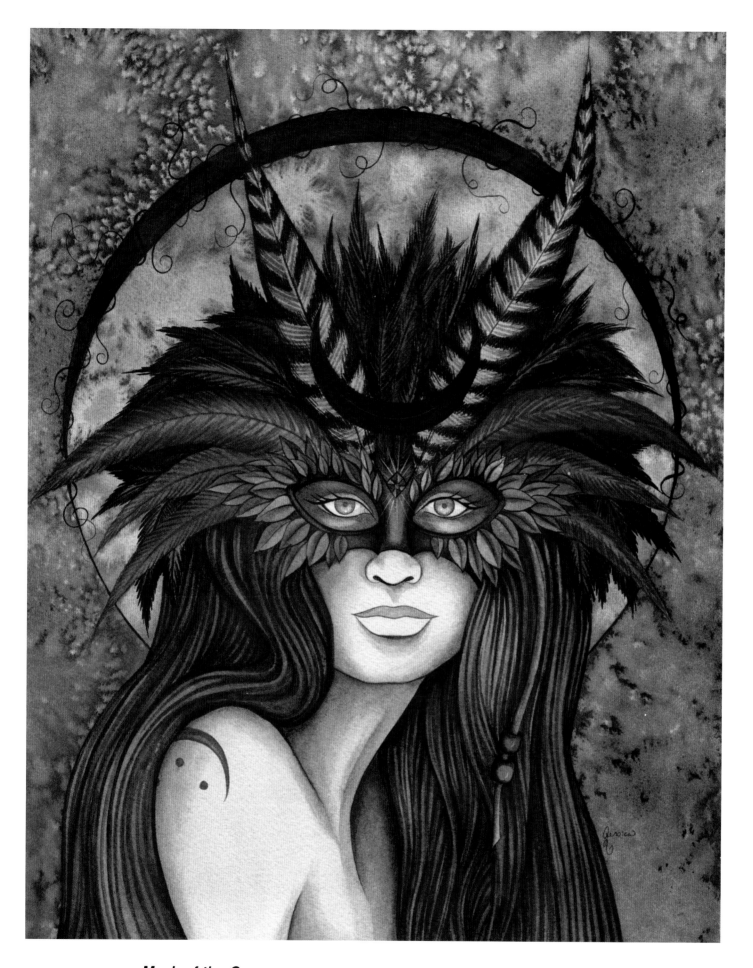

### *Mask of the Greenwoman*

This is the female companion to my Greenman painting. She remains one of my more popular images. I was inspired to create her enchanting mask after seeing beautiful fantasy masks in this style at a show I do in Michigan.

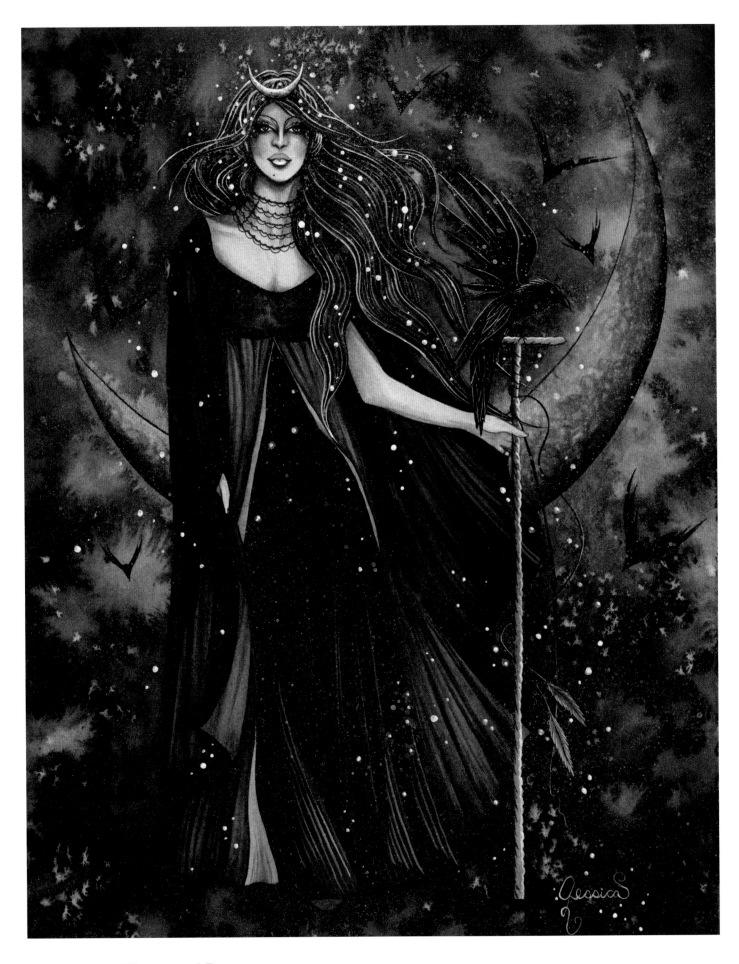

### Mistress of Ravens
A dark mistress stands with her staff as her raven familiars take flight all around her. I especially like the dress in this piece, it was inspired by a beautiful wedding gown I saw in a magazine.

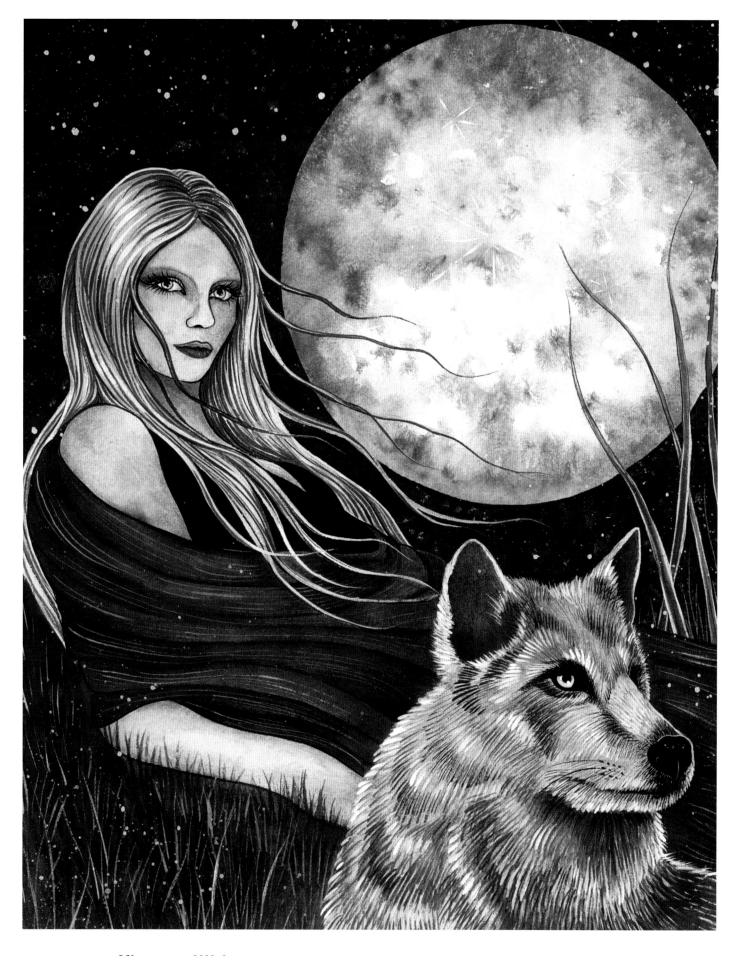

### *Mistress of Wolves*
One of my older pieces featuring a woman with a silver wolf and a full moon. This is popular scene that I've revisited with other paintings.

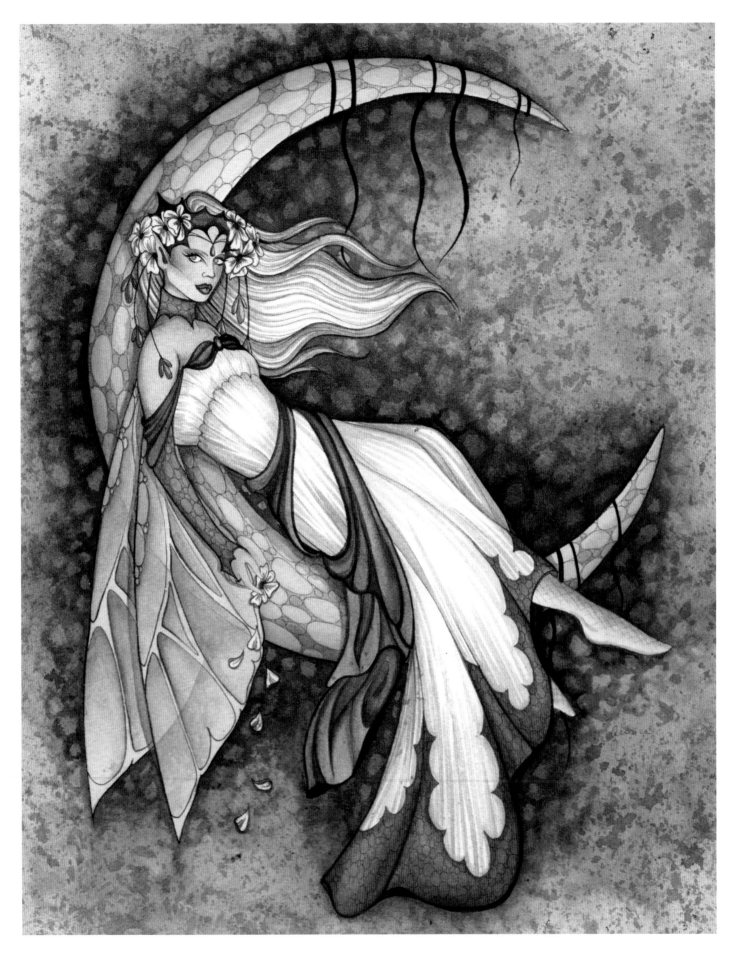

### *Moon Dreaming*
My take on the popular theme of a faery resting on a crescent moon. She is lazily dropping flower petals down into the night sky.

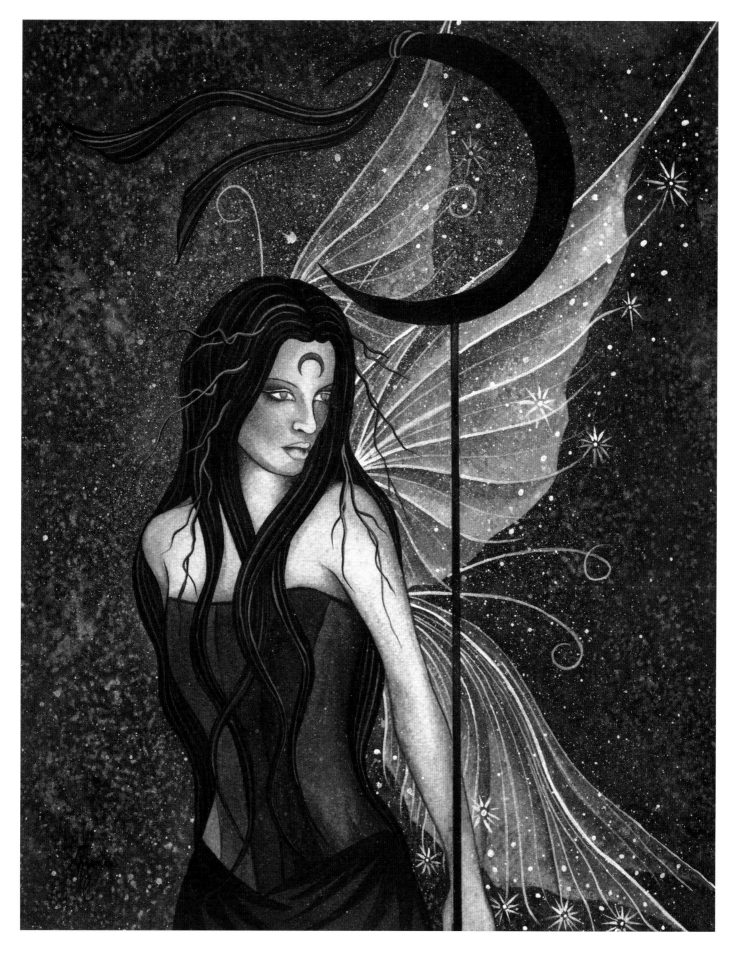

## Morgaine

One of my early attempts at a darker, gothic faery. I also wanted to try an entirely black and white watercolor painting, concentrating on tonal shades of gray.

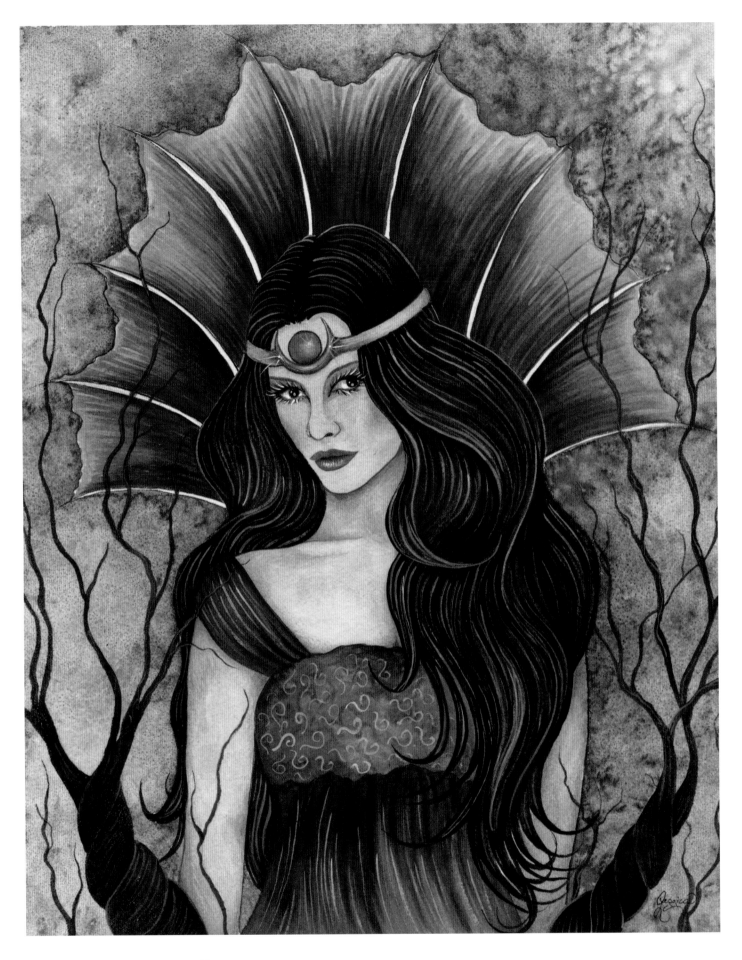

### Morgan Le Fey

This is my rendition of the infamous sorceress and dark faery queen from Arthurian legend. I plan to revisit this theme again.

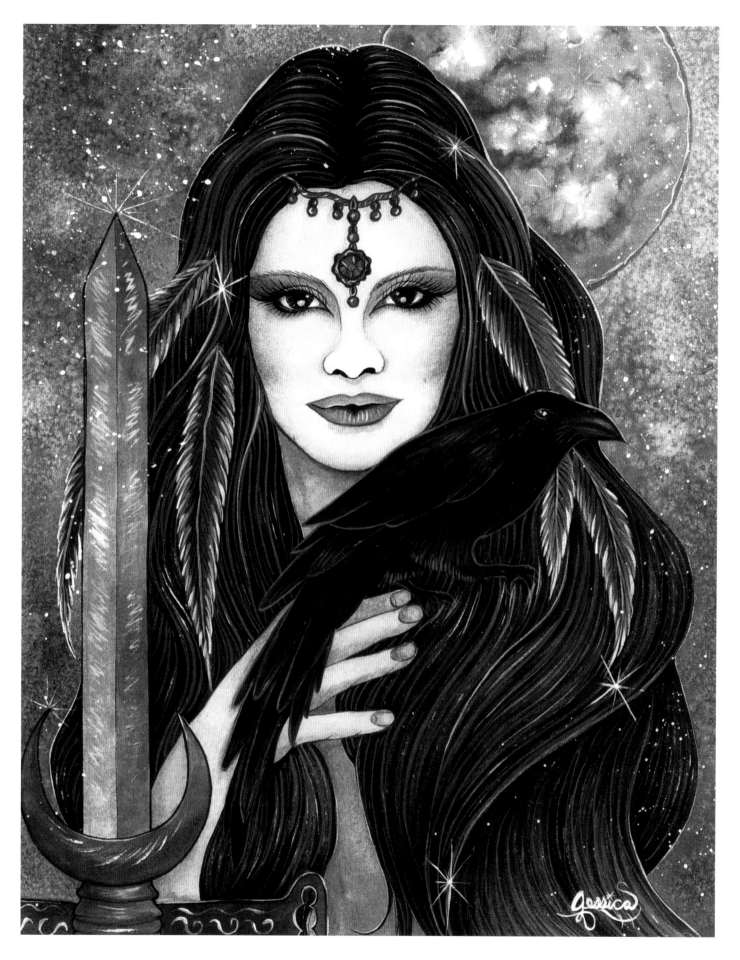

### *The Morrigan*

This piece remains one of my most popular goddess paintings. The Morrigan is a war goddess from Celtic mythology. Her symbol is the raven.

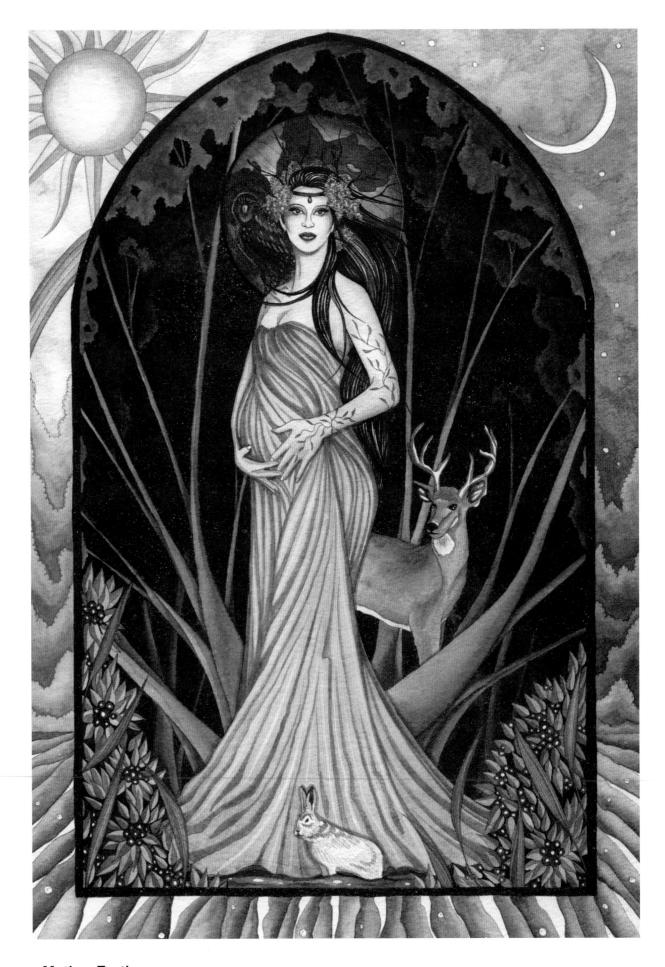

### *Mother Earth*

This piece is my rendition of the female personification of the Earth and Mother Nature. The elements of this piece are intended to remind us of the beauty and power of nature, which is present in all aspects of our world.

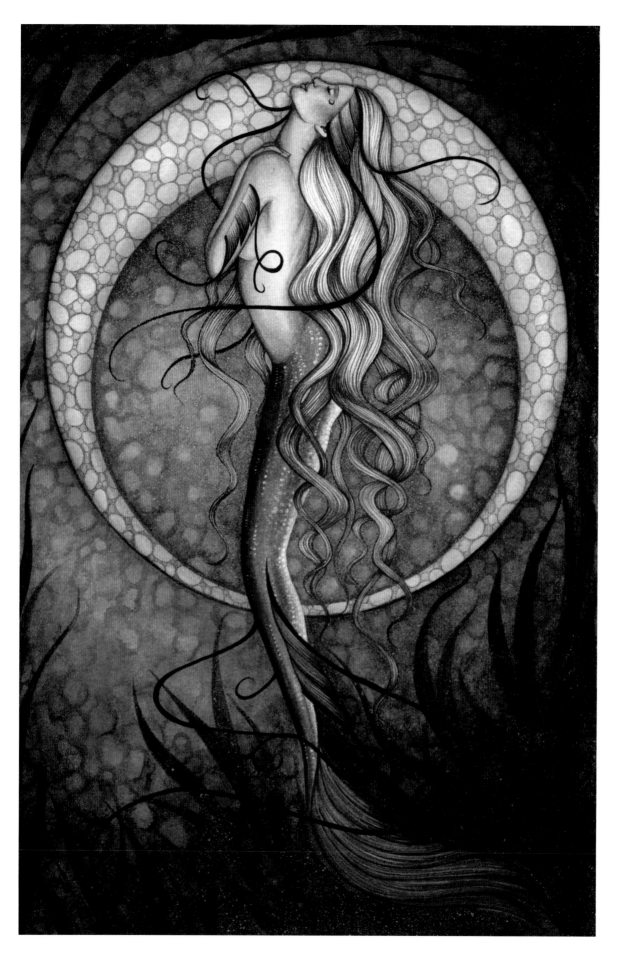

### *Mystic Mermaid*
This is one of my more recent mermaid paintings. This beautiful mermaid is drifting softly under the sea against a mystical moon backdrop.

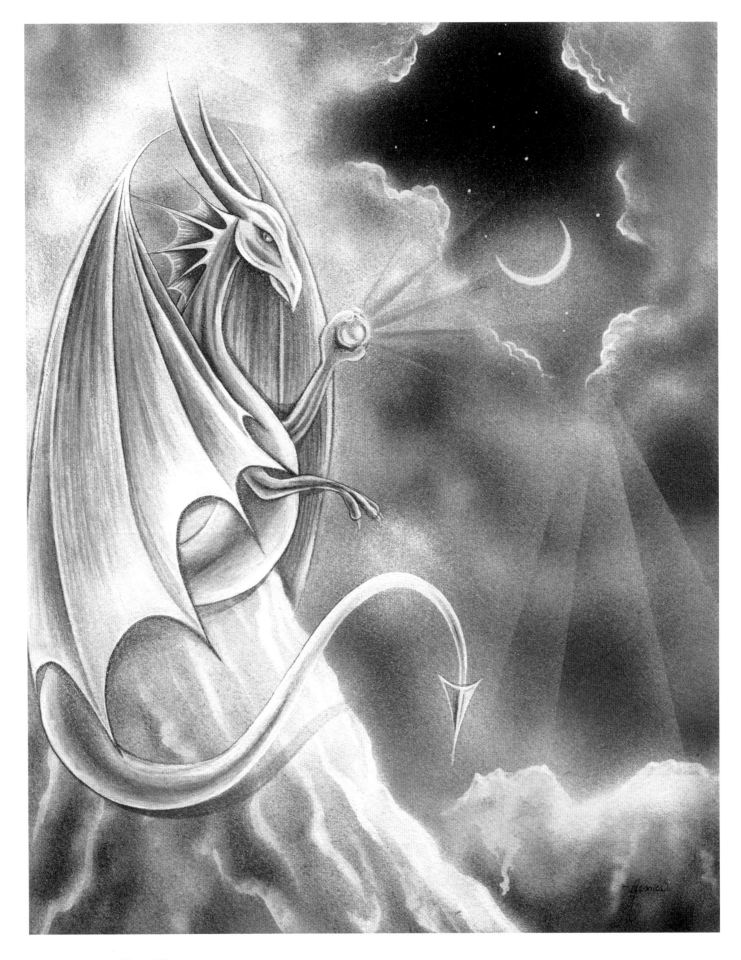

### *New Moon*

One of my more recent airbrushed dragons. This one has a sort of otherworldly, mystical quality.

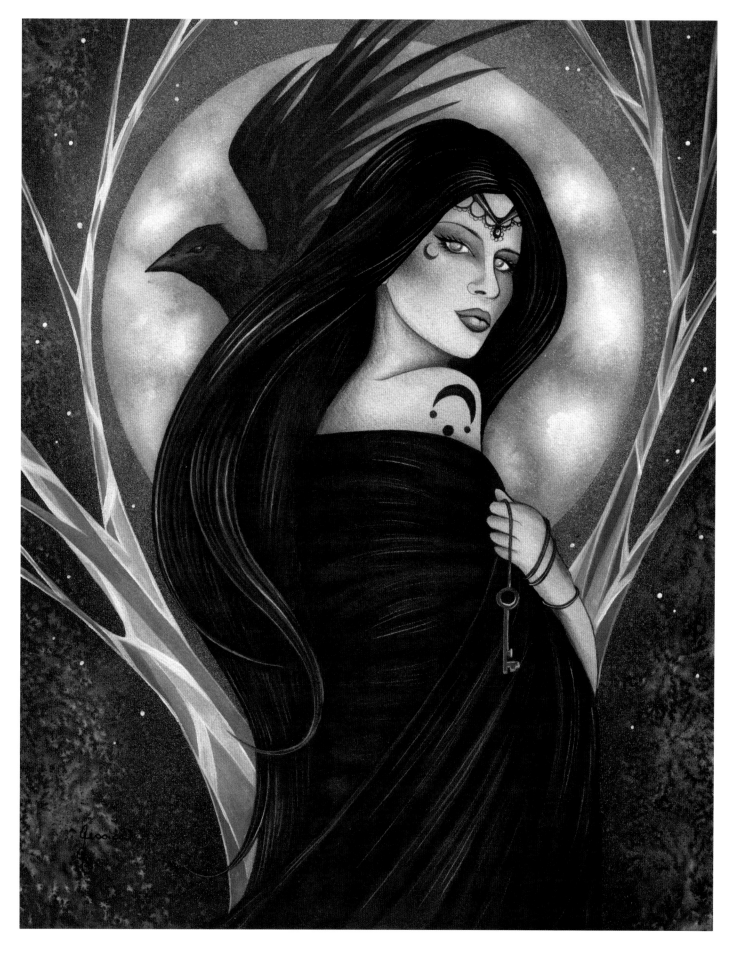

### Night Queen

Night Queen is a different take on my earlier painting Black Magick. Another dark enchantress stands beneath a full moon with a raven on her shoulder.

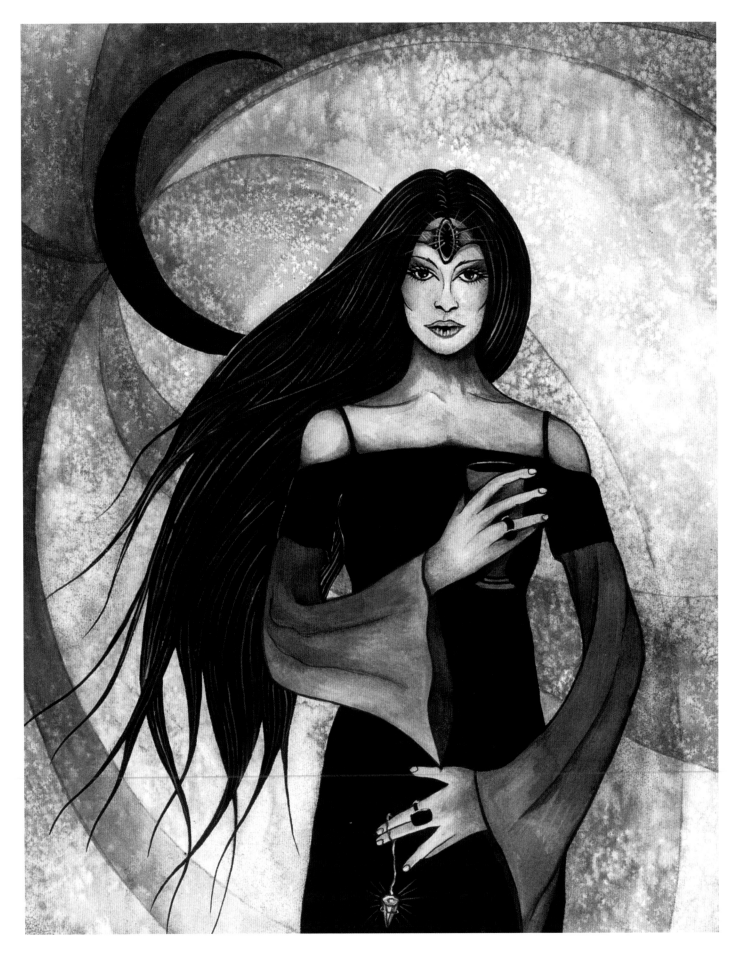

### Nyx

This is another one of my goddess paintings, featuring my rendition of Nyx, the goddess of night from Greek mythology. She's a bit on the gothic side and features a dark moon in the background.

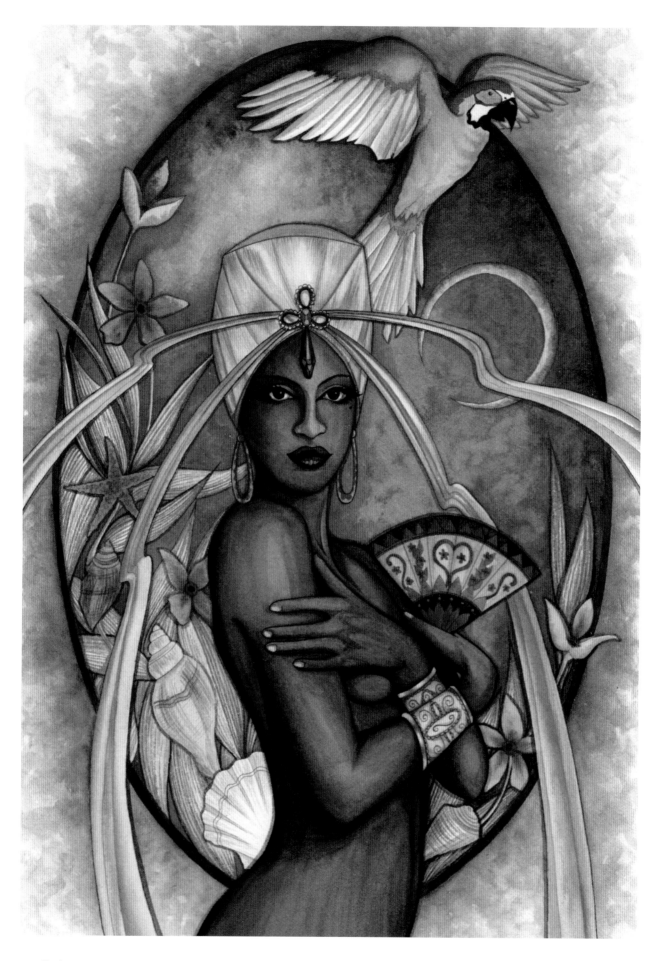

## Oshun

One of my newer goddess paintings, Oshun is a colorful rendition of the Afro-Caribbean goddess of love and beauty. I included each of her more well known symbols, including a tropical bird and foliage, a hand held fan, her jeweled headdress and trademark brass jewelry.

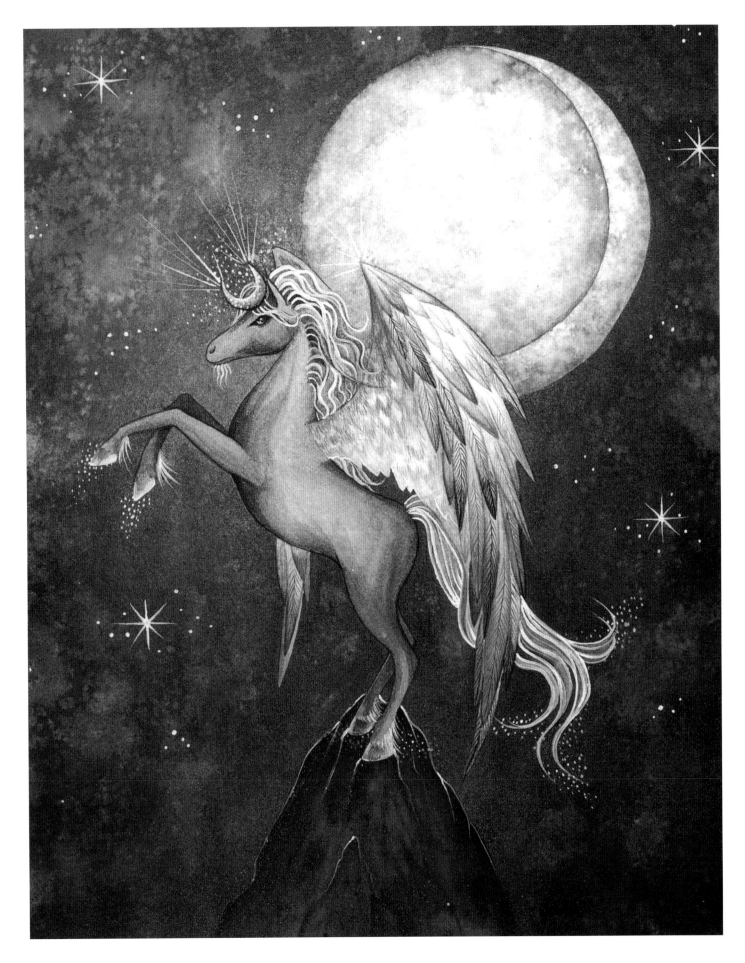

### *Pegasus*

One of my earlier works, this painting represents the winged horse Pegasus, from Greek mythology, atop a rugged peak.

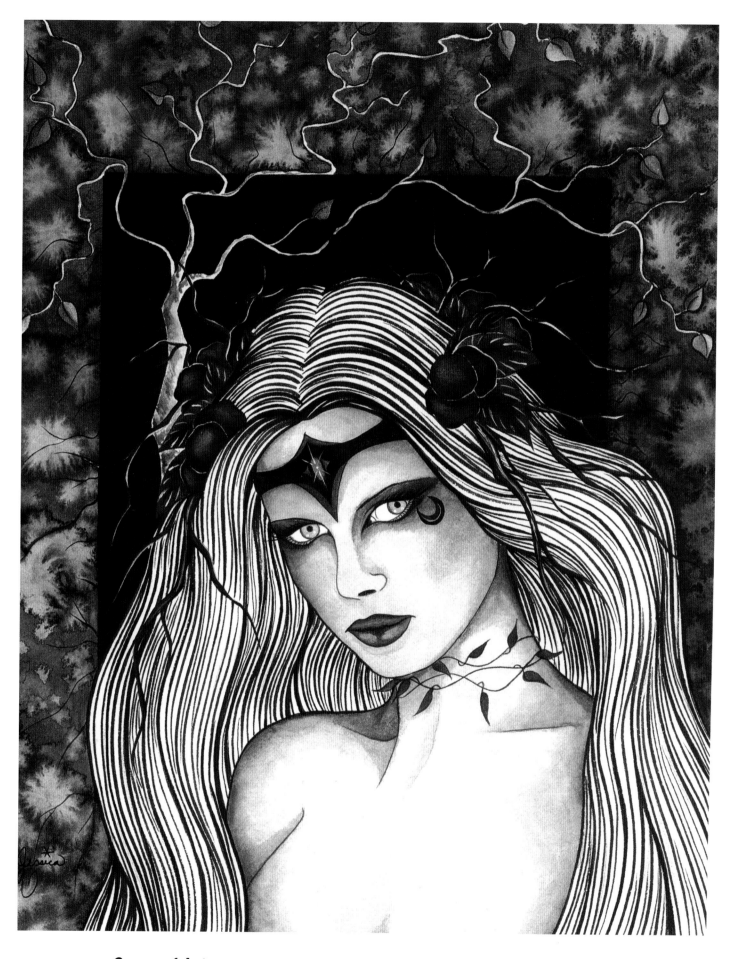

### *Queen of Autumn*

Autumn is my very favorite time of year and you'll find me revisiting the autumn theme in many paintings. This one features an autumn maiden with fall leaves and berries in her crown.

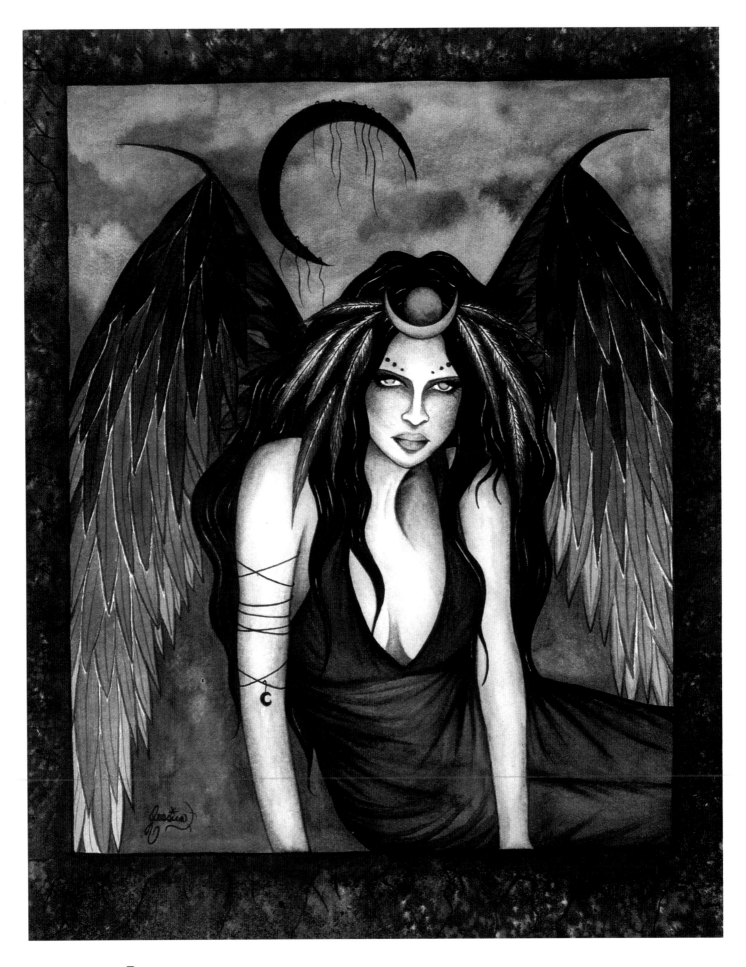

### *Raven*

In this piece, a raven-winged woman stares at the observer, with a foreboding gaze. This early work is also one of my first endeavors to paint a darker, gothic piece.

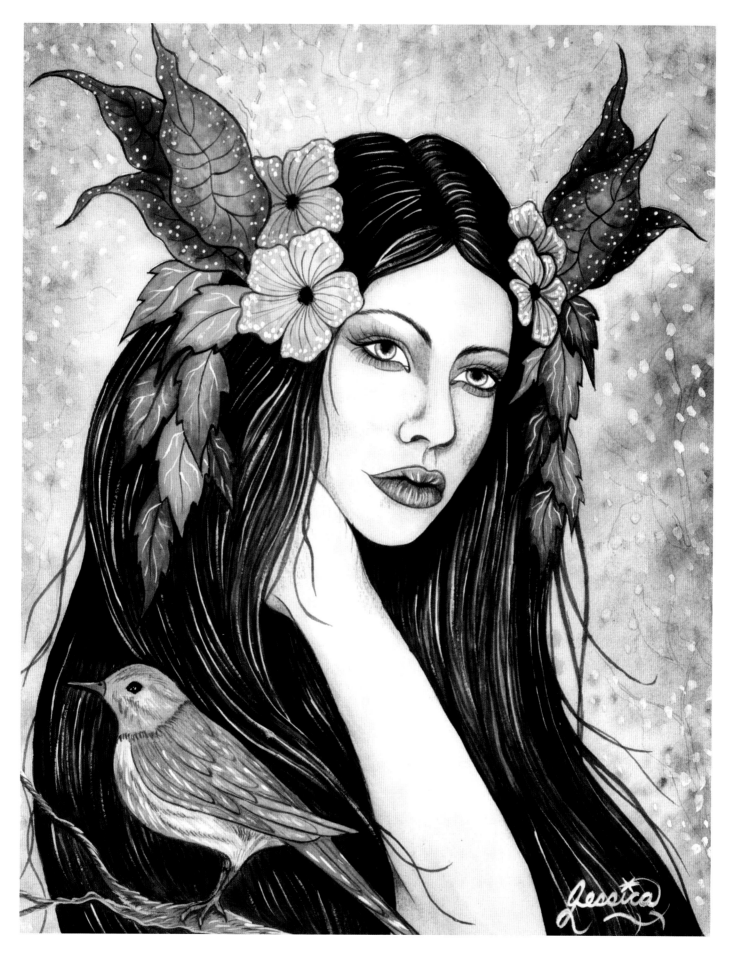

### *Rhiannon*

Also one of my early works, this is my rendition of the Celtic goddess Rhiannon who was often shown with songbirds.

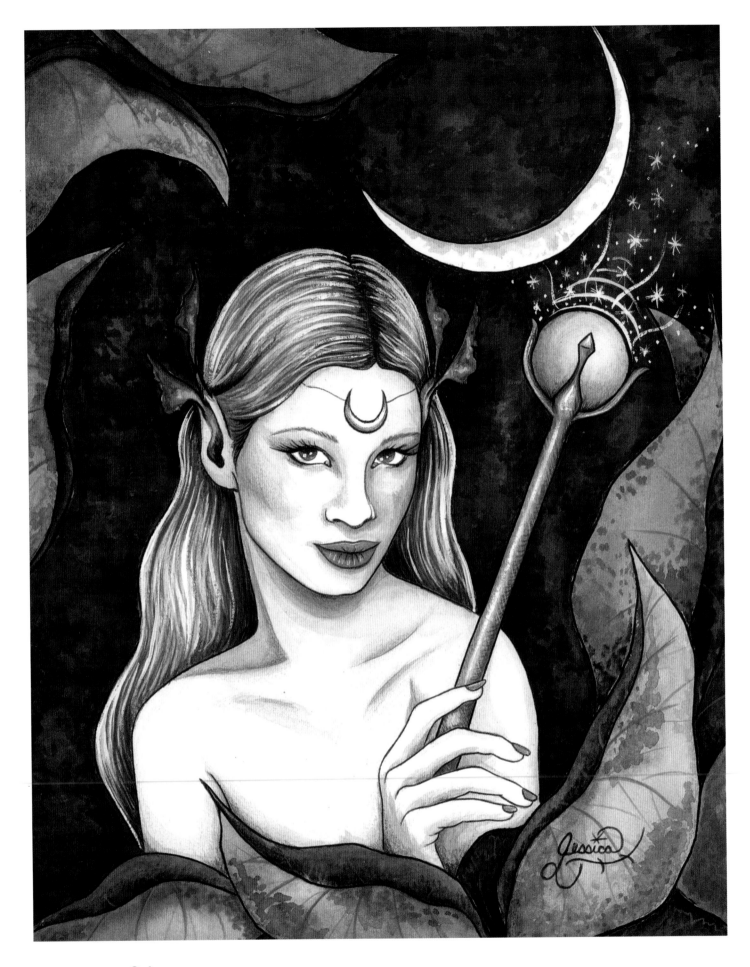

### *Selene*

Selene is another one of my very early works. Selene is a moon goddess from Greek mythology.

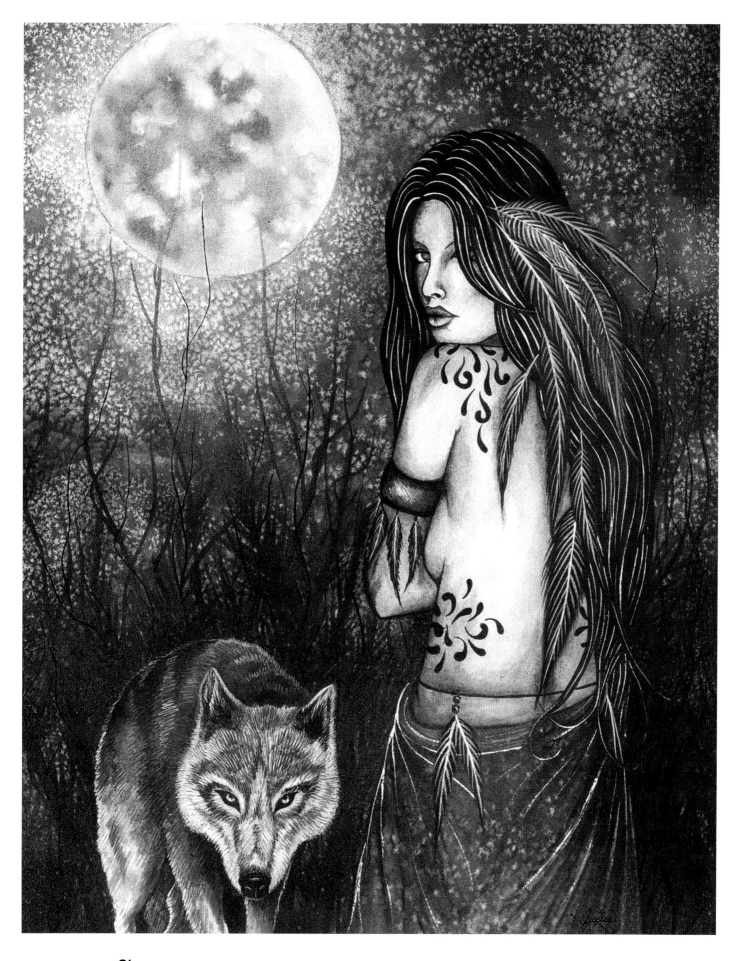

### Shamaness

My paintings that include wolves are always popular, and I try to revisit this theme often. In this painting, a beautiful female Shaman stands with her wolf companion.

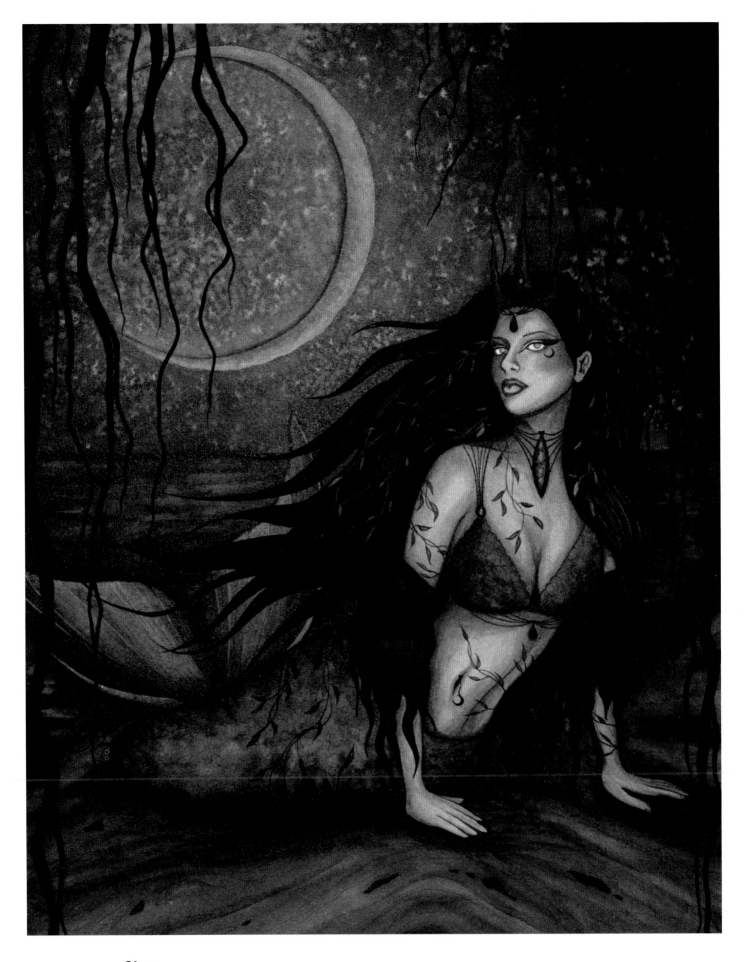

### Siren

Resting on rock, with her raven locks flowing, a dark mermaid sends a haunting song out into the night.

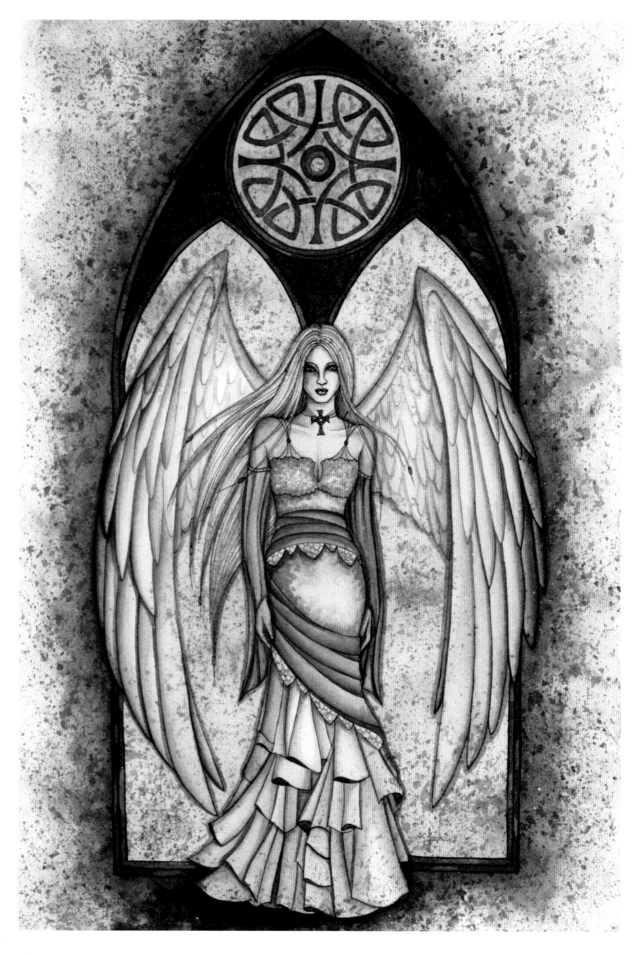

### *Spirit of Imbolc*

This icy colored angel represents the late winter Celtic holiday of Imbolc. I gave her a bit of a gothic flair for some added excitement.

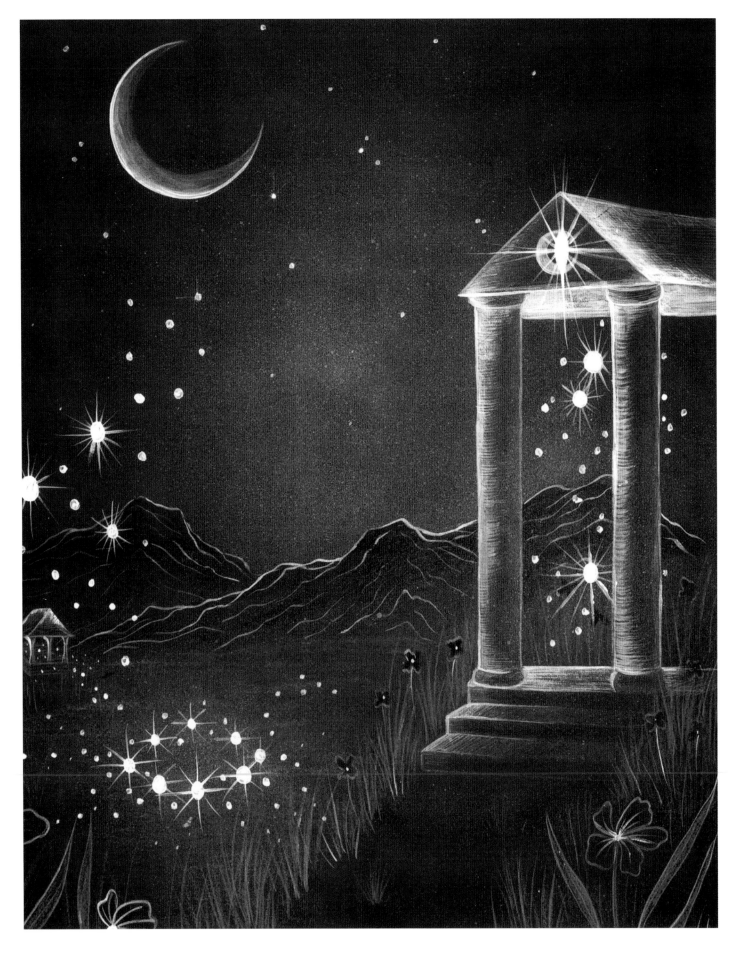

### Temple of the Moon
I went through a short phase where I was painting mystical scenery instead of figures.

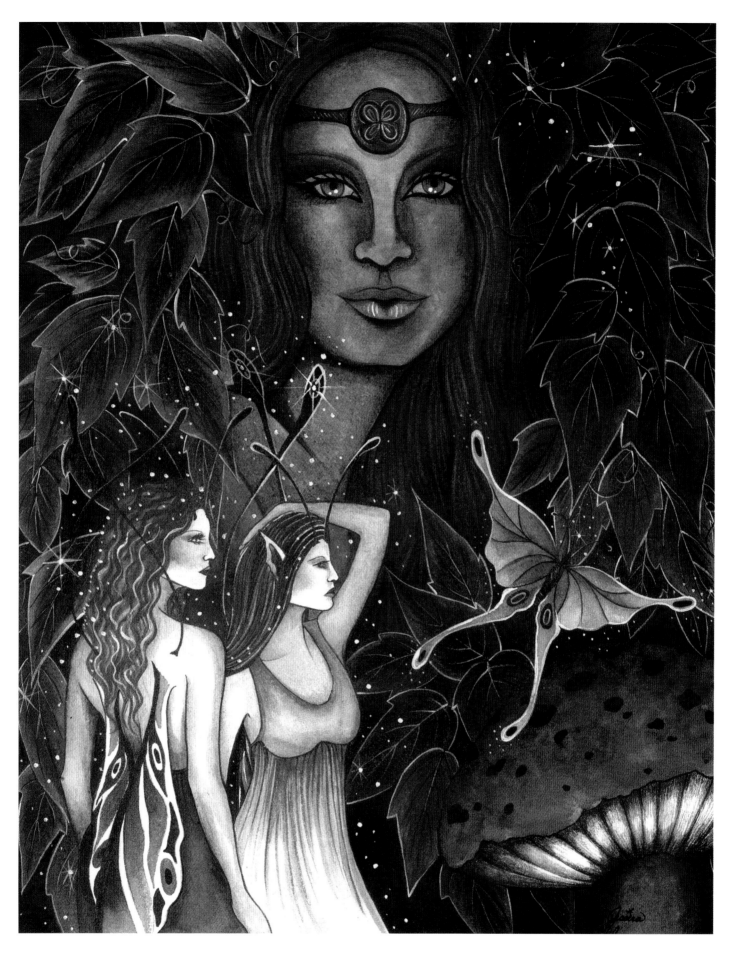

### *Tuatha de Danann*
This piece features faery folk frolicking beneath the watchful eye of the Celtic mother goddess Danu. It is one of my more detailed pieces.

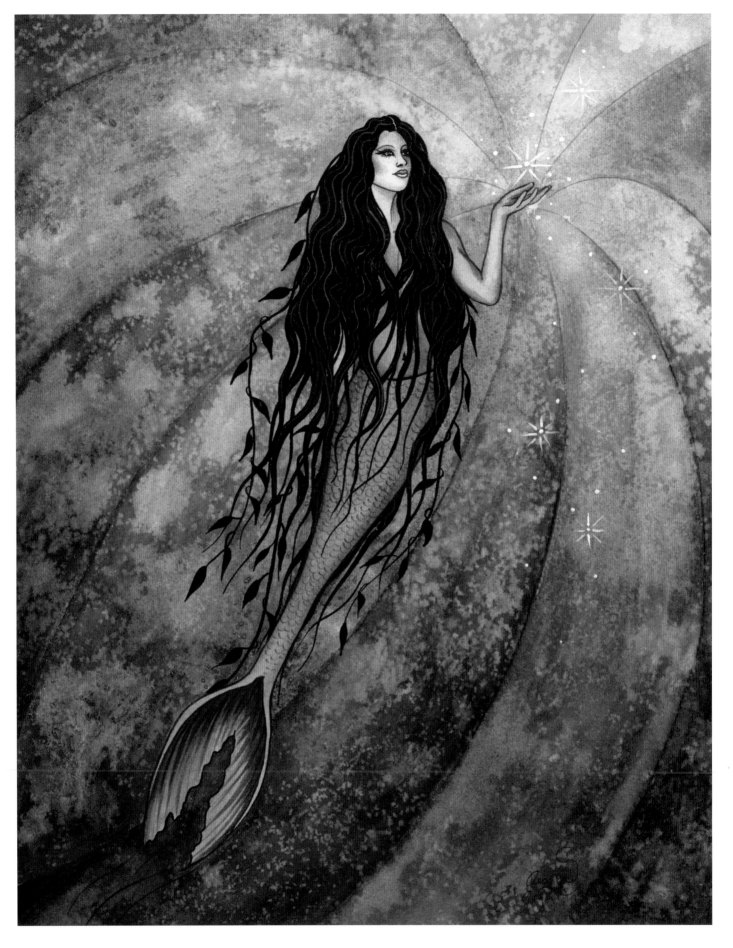

### *Turquoise Seas*
A beautiful dark haired mermaid propels herself through turquoise seas.

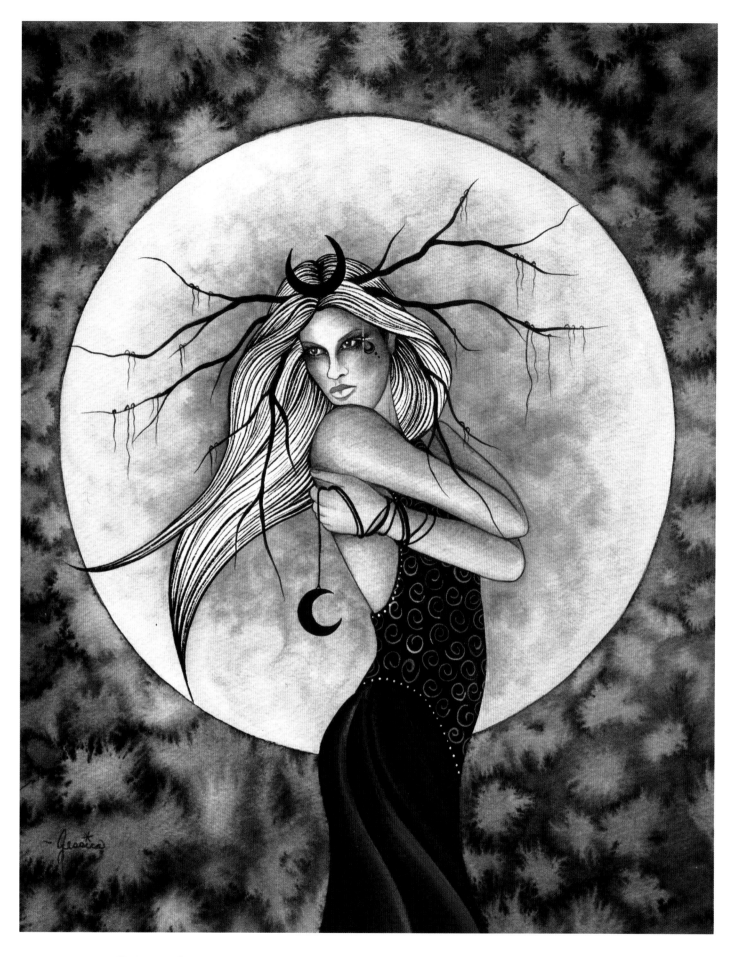

### *Twist of Shadows*

I named this painting of a dark enchantress beneath a full moon, after one of my favorite songs by a band called Xymox.

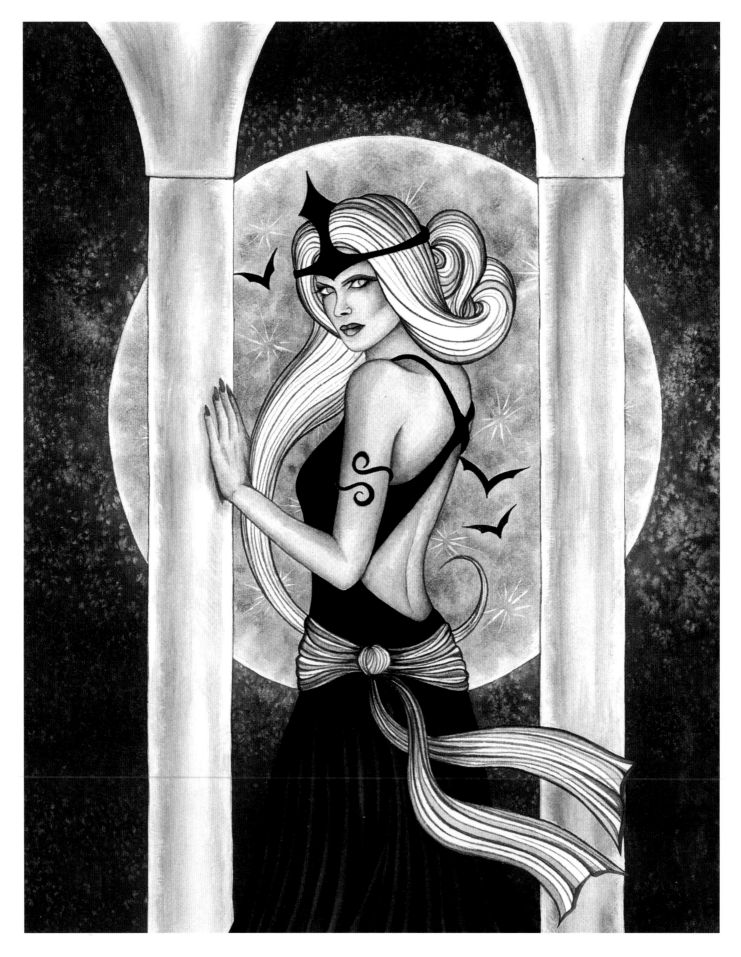

### *Vampiress*
I was inspired to paint this female vampire after reading one of my many Anne Rice books.

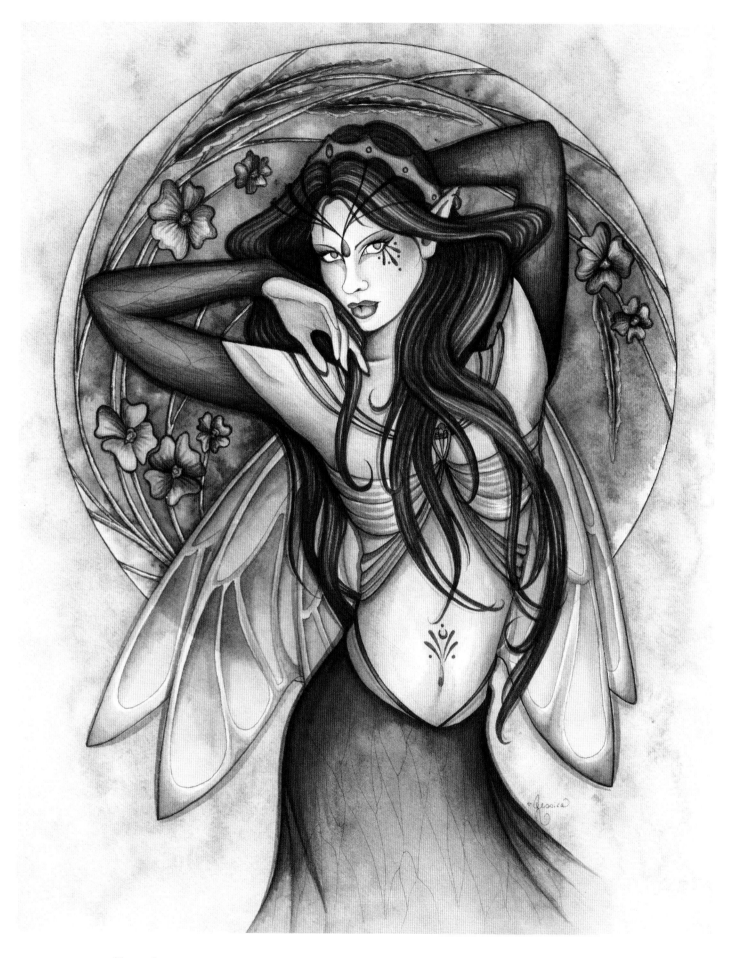

### *Vervain*

I read about the herb vervain, it is considered an enchanted plant connected with the faery realm. After that the vervain faery begged to be painted in all her seductive glory.

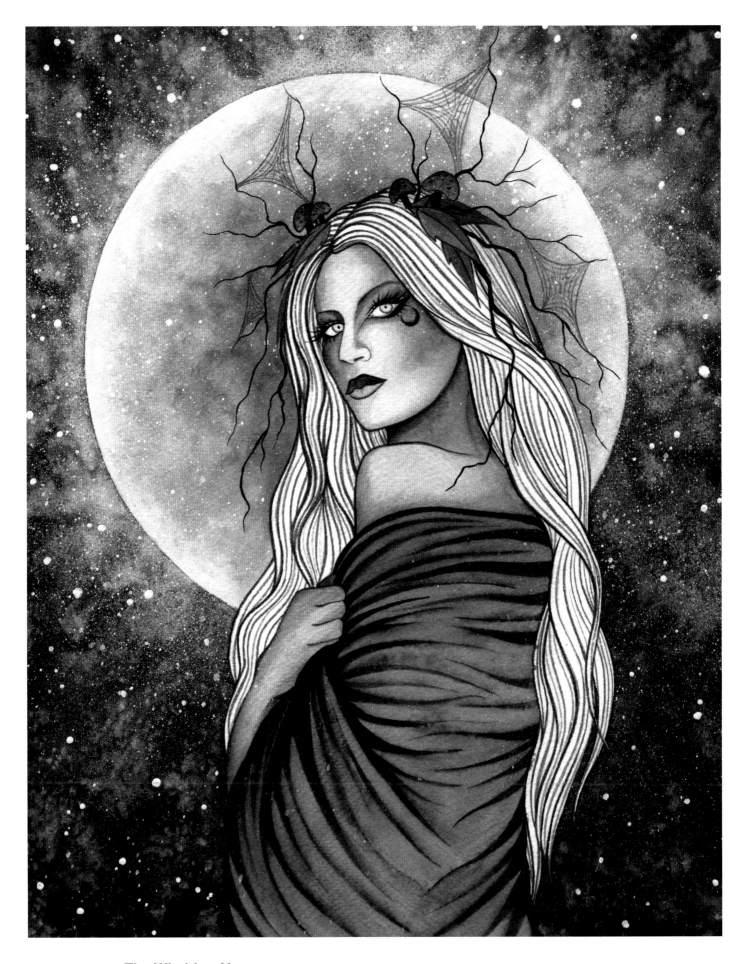

### *The Witching Hour*

At the midnight hour beneath a full moon, a witch flashes a piercing gaze over her shoulder.

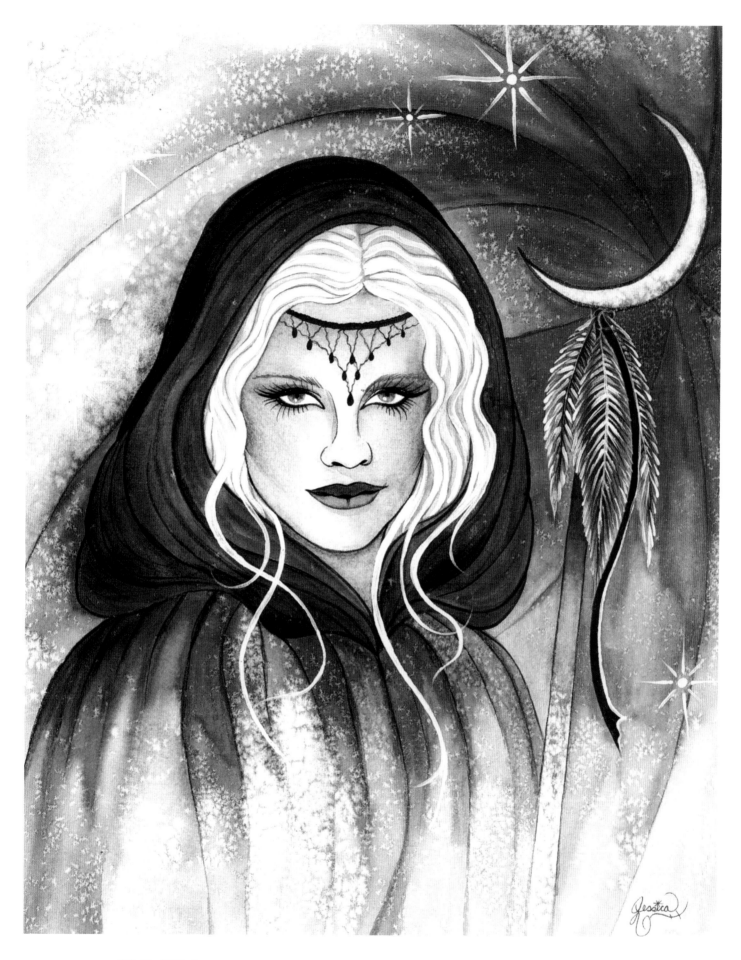

### White Witch

One of my few paintings done entirely in pastel colors, the White Witch remains a
favorite with my customers. I utilized a technique called the salt effect, in the
background and on her robes, to get that crystallized look.

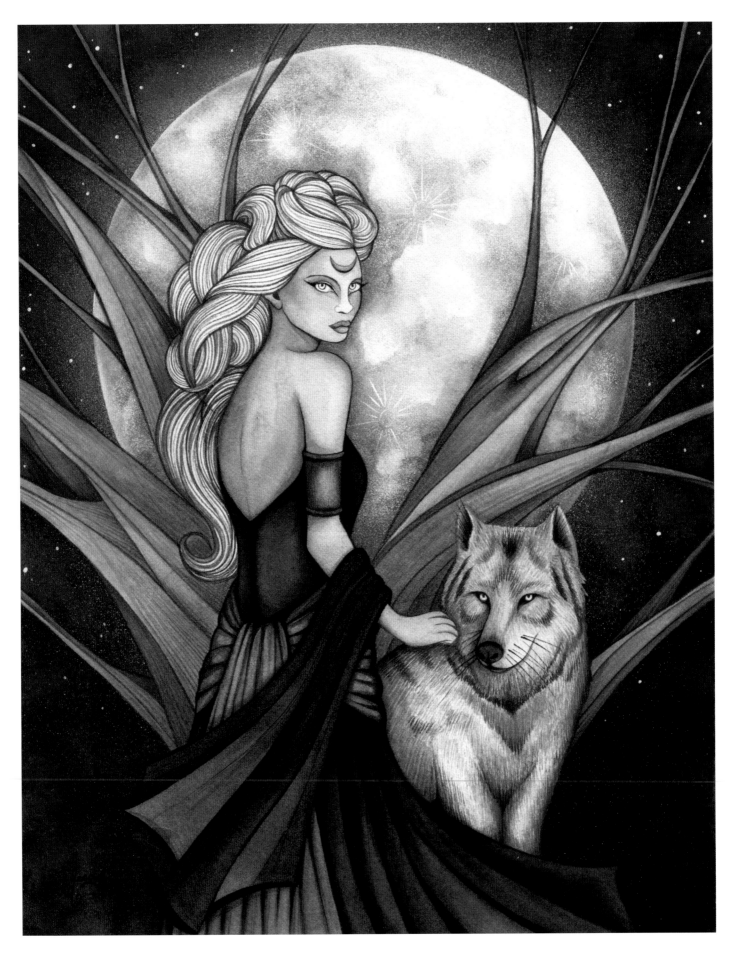

### *Wolf Maiden*

A beautiful maiden stands with her wolf companion beneath a glowing full moon. Her gaze is seductive.

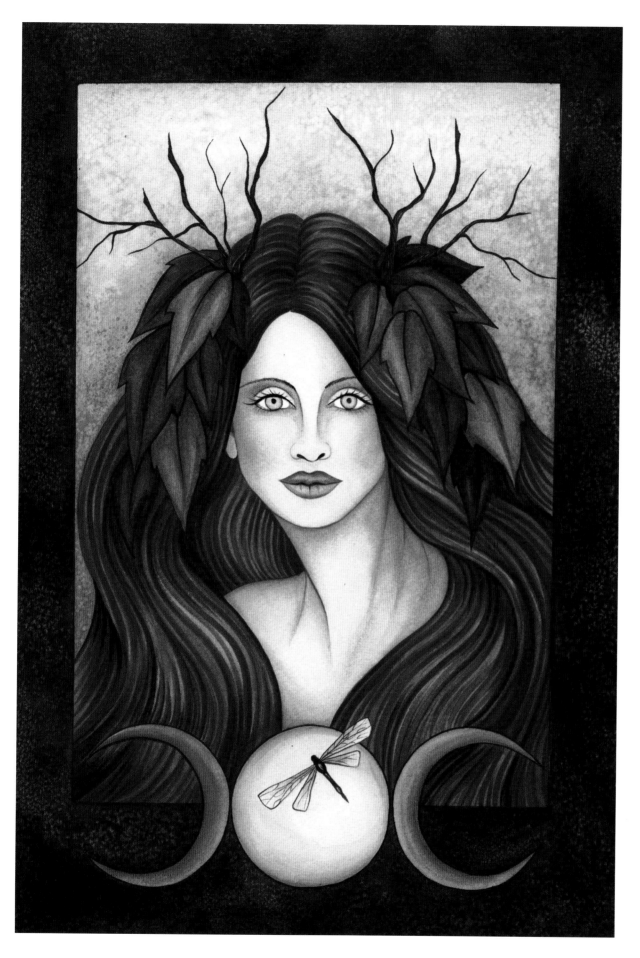

### *Wood Nymph*

With this piece, I used a palette of earth tones to create a portrait-style rendition of a beautiful wood nymph

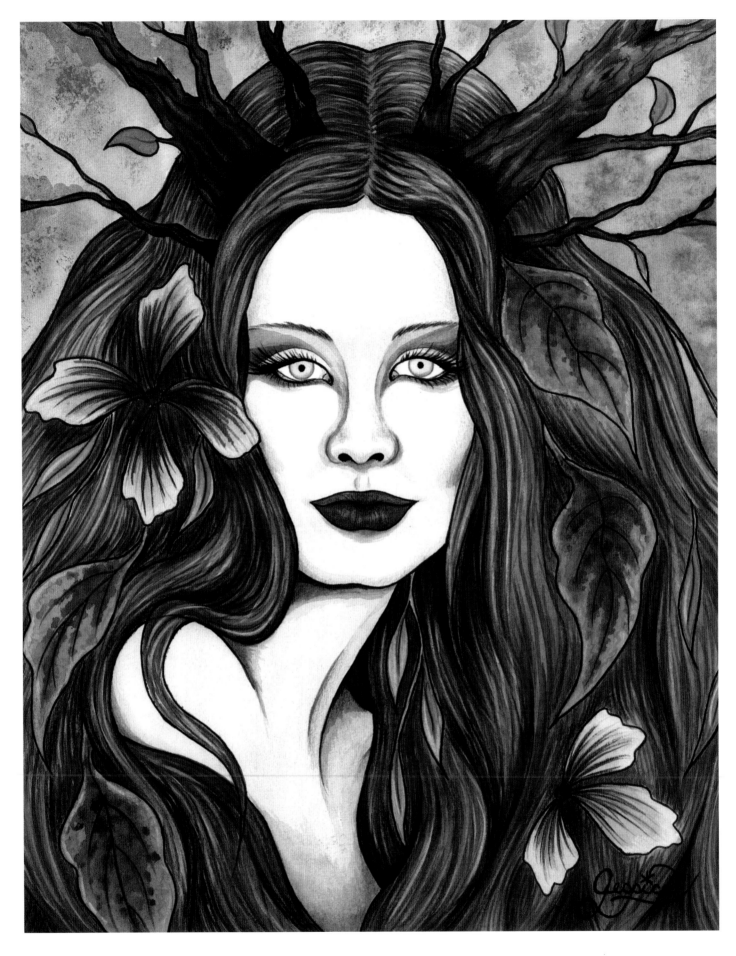

### *Wood Witch*

Believe it or not, this very early painting remains my favorite to this day. A print of this image hangs in my own painting studio for inspiration, and I swear her haunting green eyes follow me around the room.

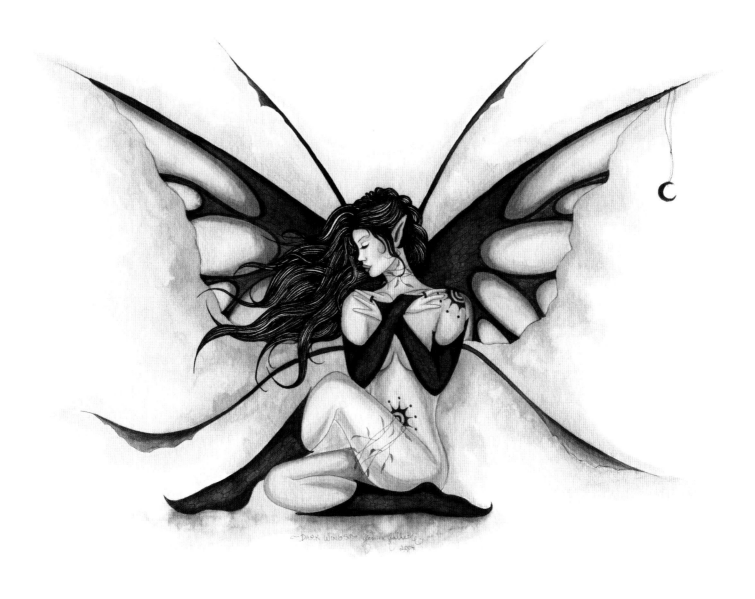

## *Dark Wings*

This delicate faery has a simple plain background and dark wings outstretched behind her. Her long black hair blows in the wind and she wears only a few twining vines.

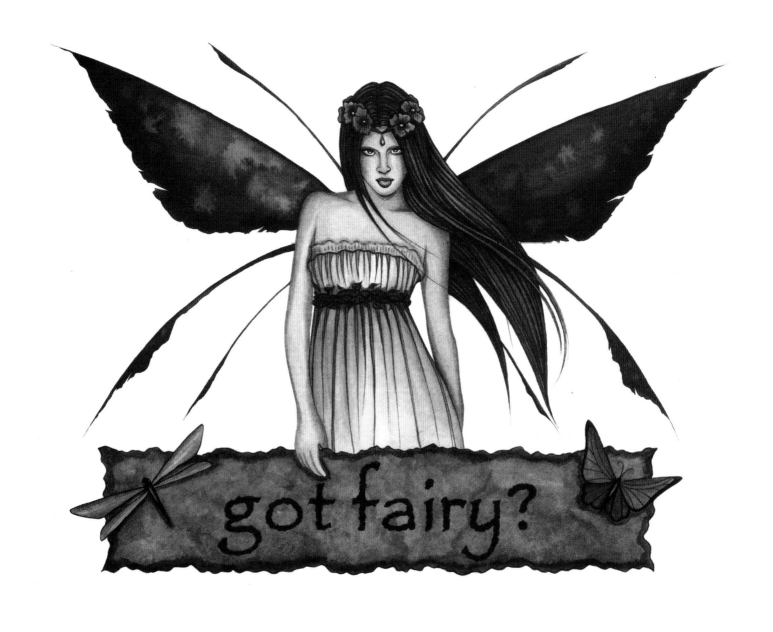

### *Got Fairy*

This was my attempt at a bit of faery humor. This sassy little faery asks the all important question… "Got Fairy?"

### *Epona*

This is my rendition of the Celtic goddess of horses, Epona. She was thought to have long white hair and is pictured with a white mare.

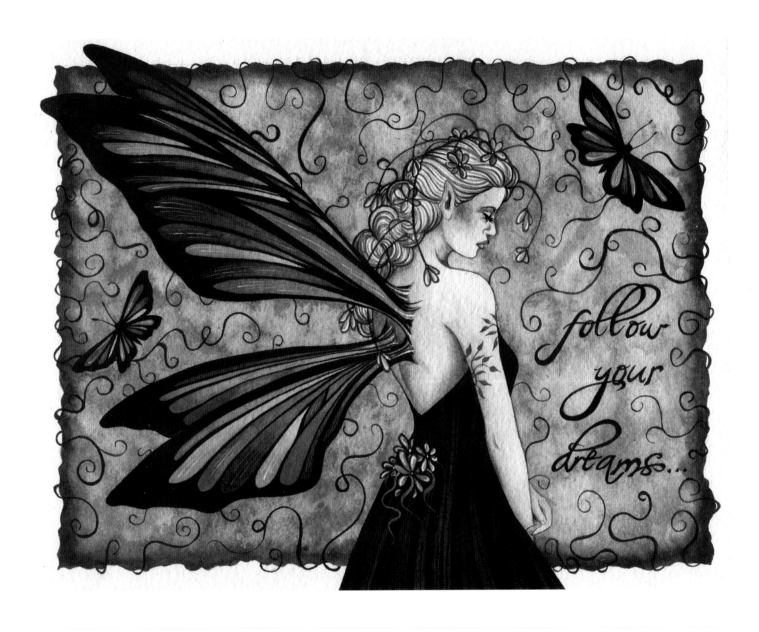

### Follow Your Dreams
This painting features a faery against a parchment background that contains my favorite inspirational quote… "Follow Your Dreams"

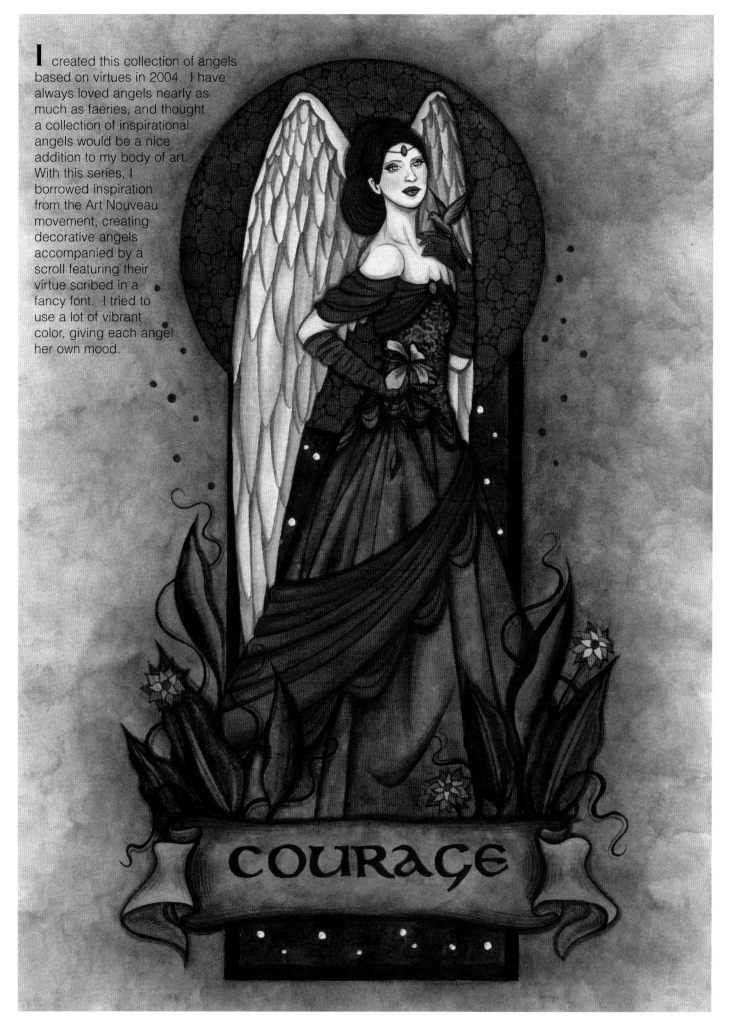

I created this collection of angels based on virtues in 2004. I have always loved angels nearly as much as faeries, and thought a collection of inspirational angels would be a nice addition to my body of art. With this series, I borrowed inspiration from the Art Nouveau movement, creating decorative angels accompanied by a scroll featuring their virtue scribed in a fancy font. I tried to use a lot of vibrant color, giving each angel her own mood.

COURAGE

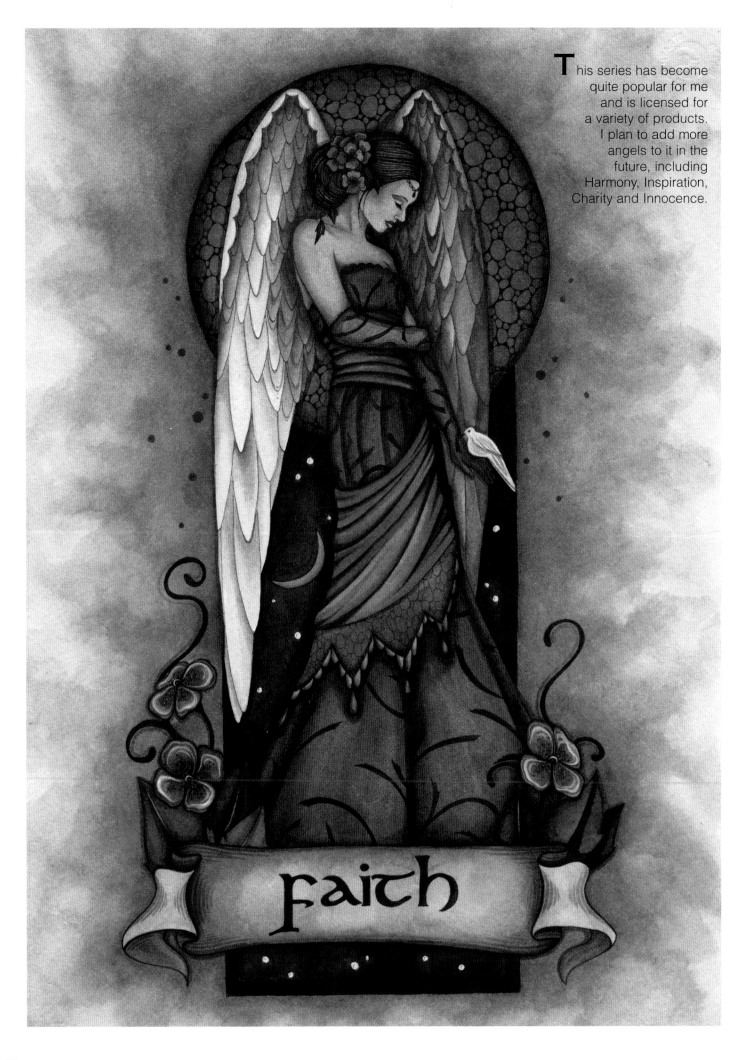

ANGEL VIRTUES COLLECTION

This series has become quite popular for me and is licensed for a variety of products. I plan to add more angels to it in the future, including Harmony, Inspiration, Charity and Innocence.

faith

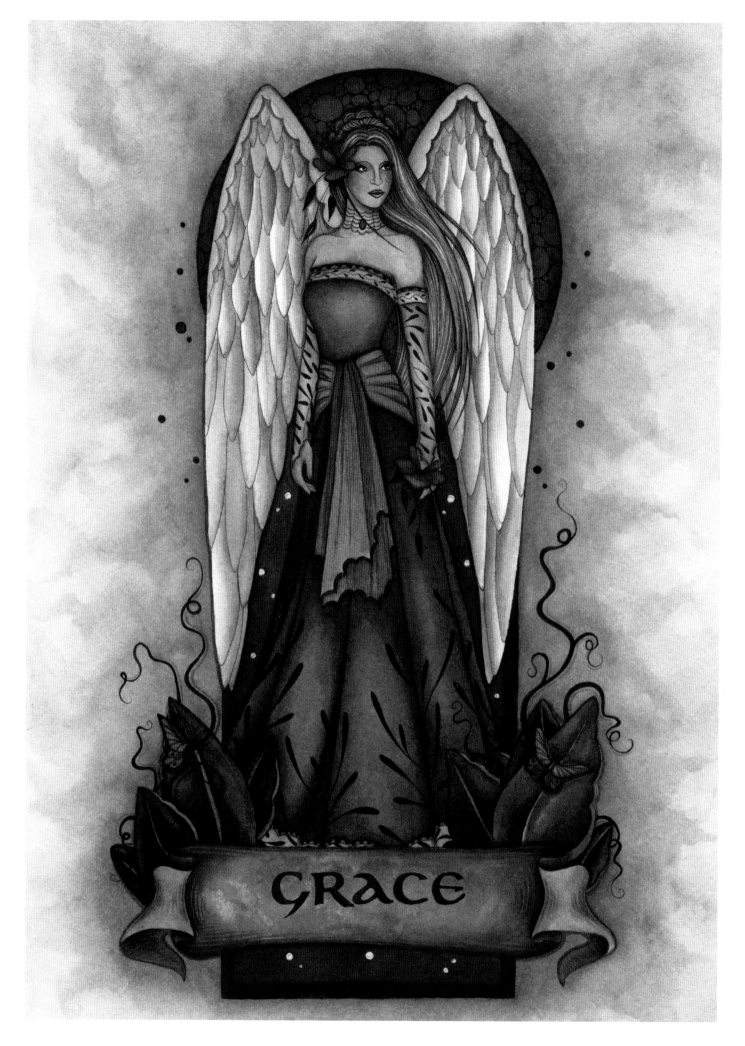

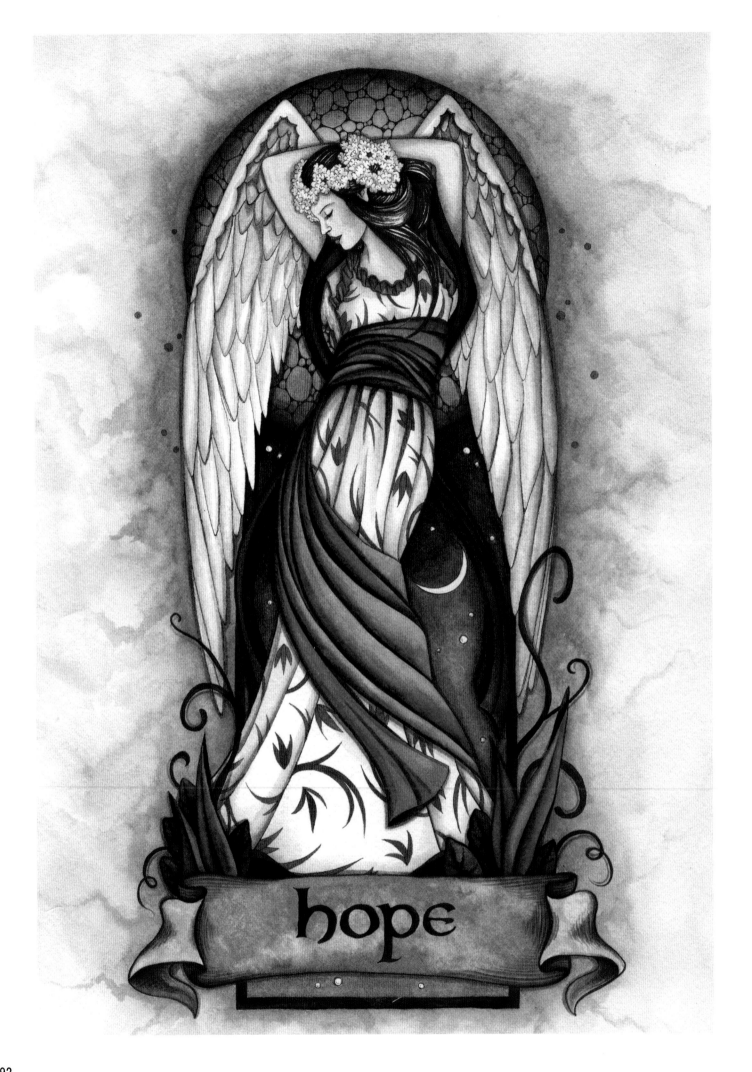

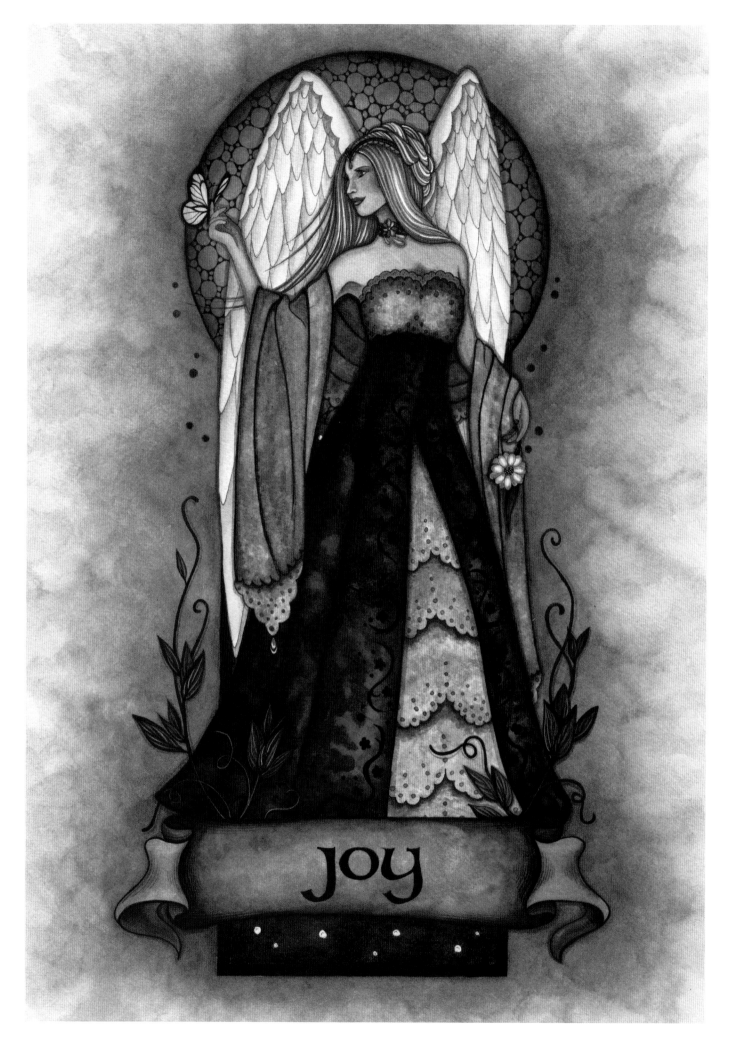

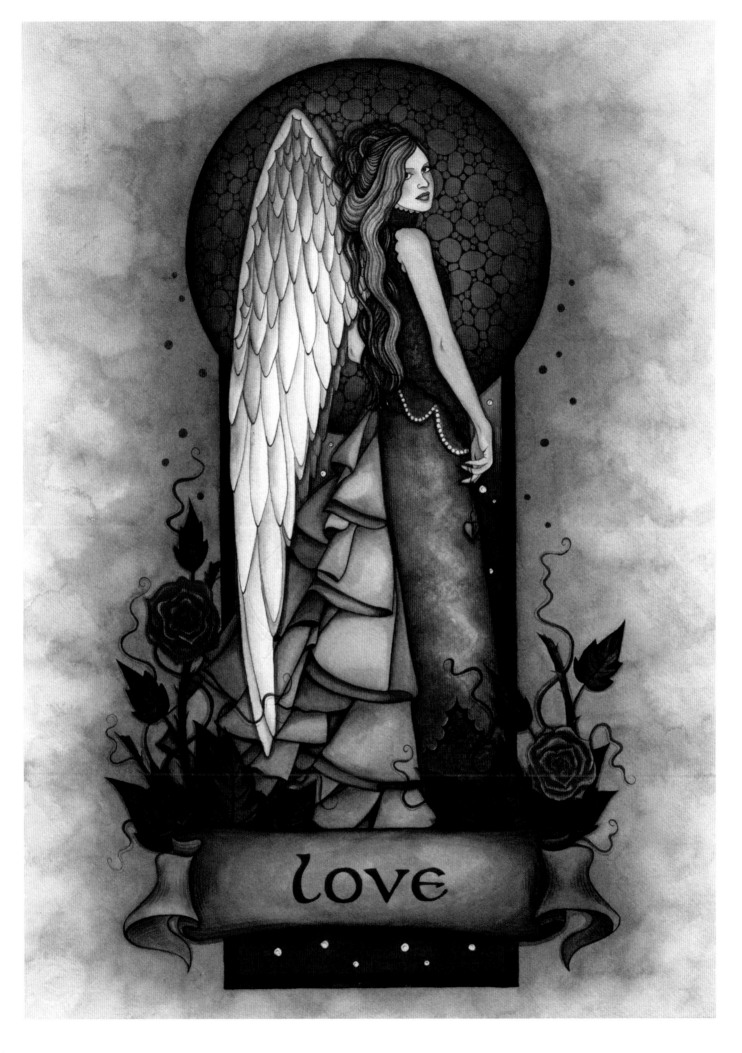

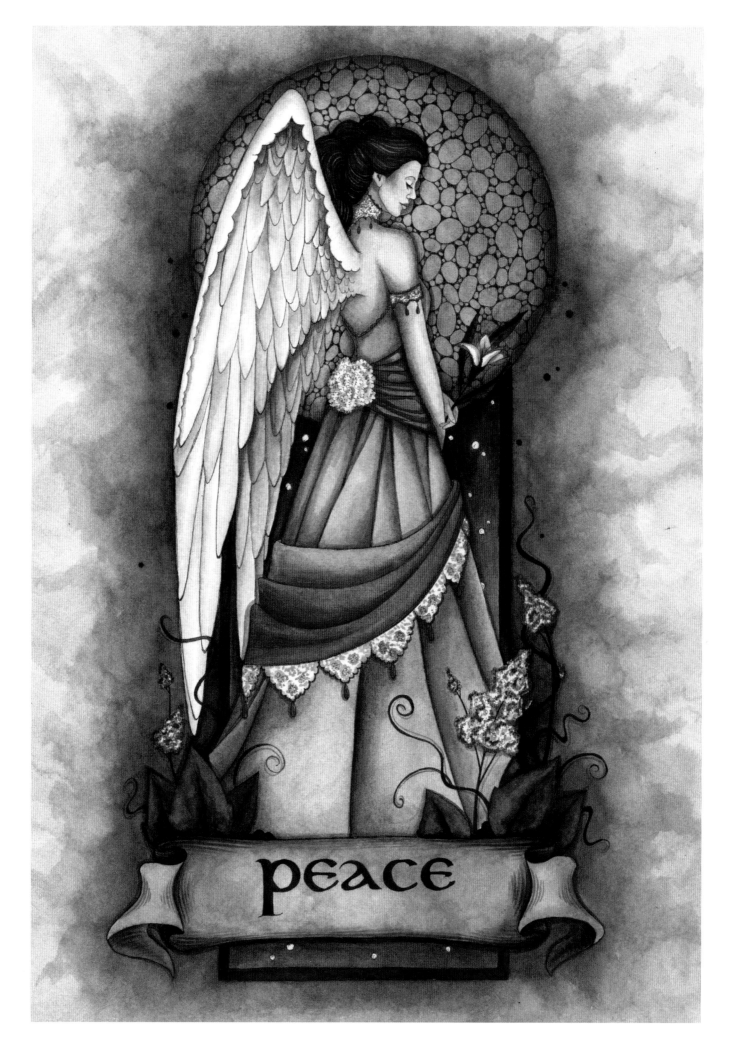

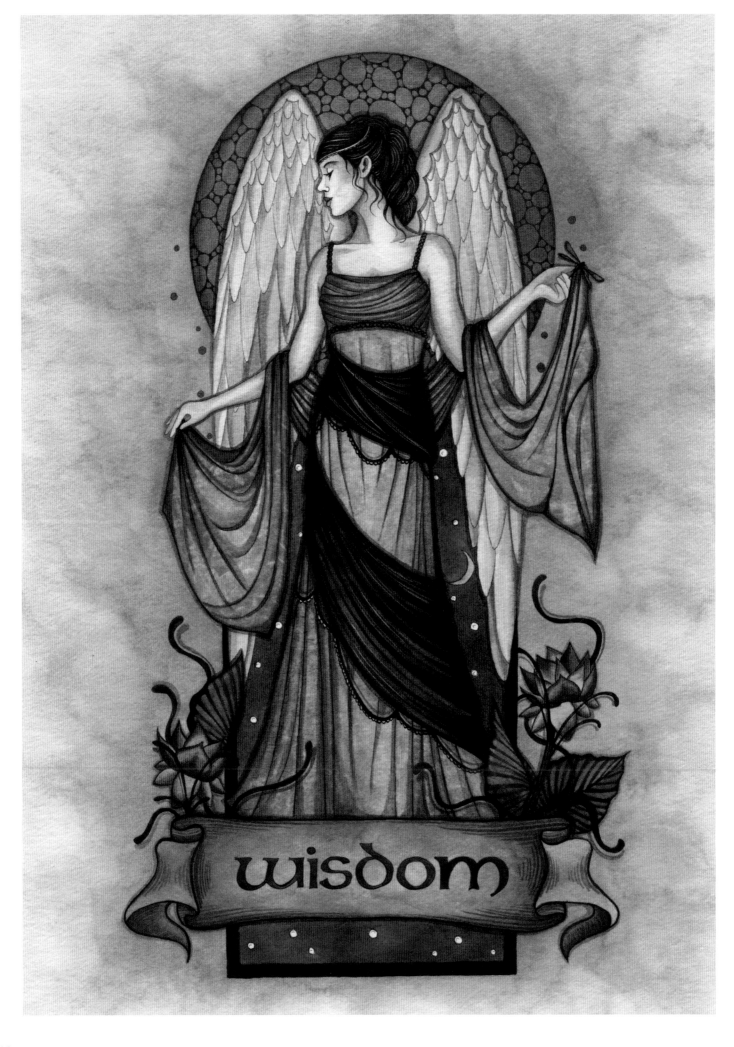

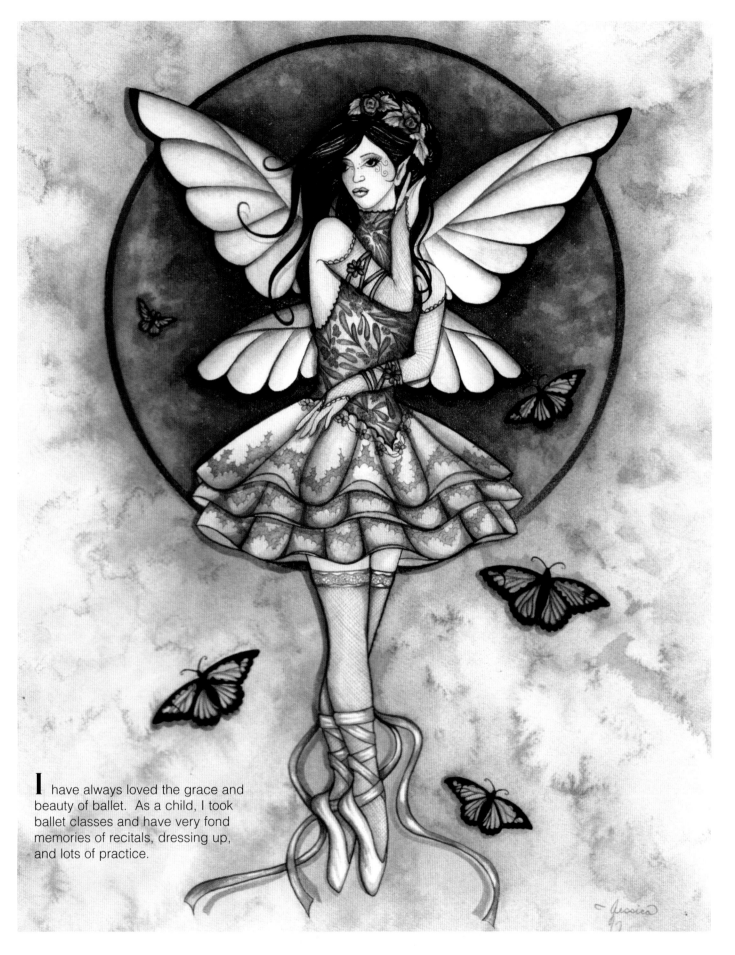

I have always loved the grace and beauty of ballet. As a child, I took ballet classes and have very fond memories of recitals, dressing up, and lots of practice.

*Blue*

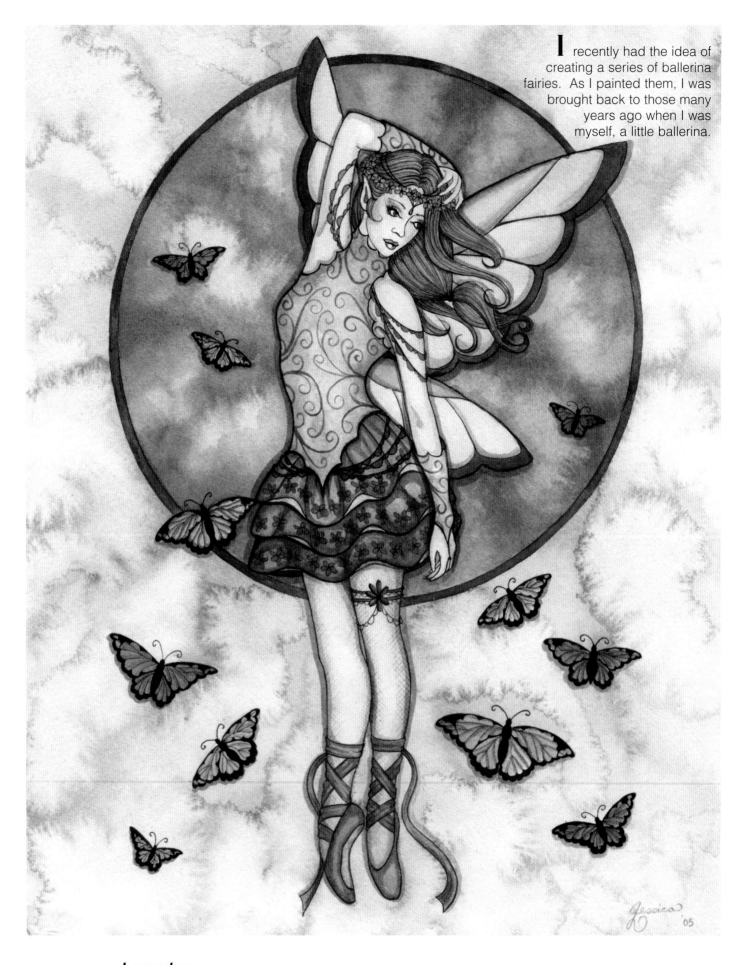

I recently had the idea of creating a series of ballerina fairies. As I painted them, I was brought back to those many years ago when I was myself, a little ballerina.

*Lavender*

98

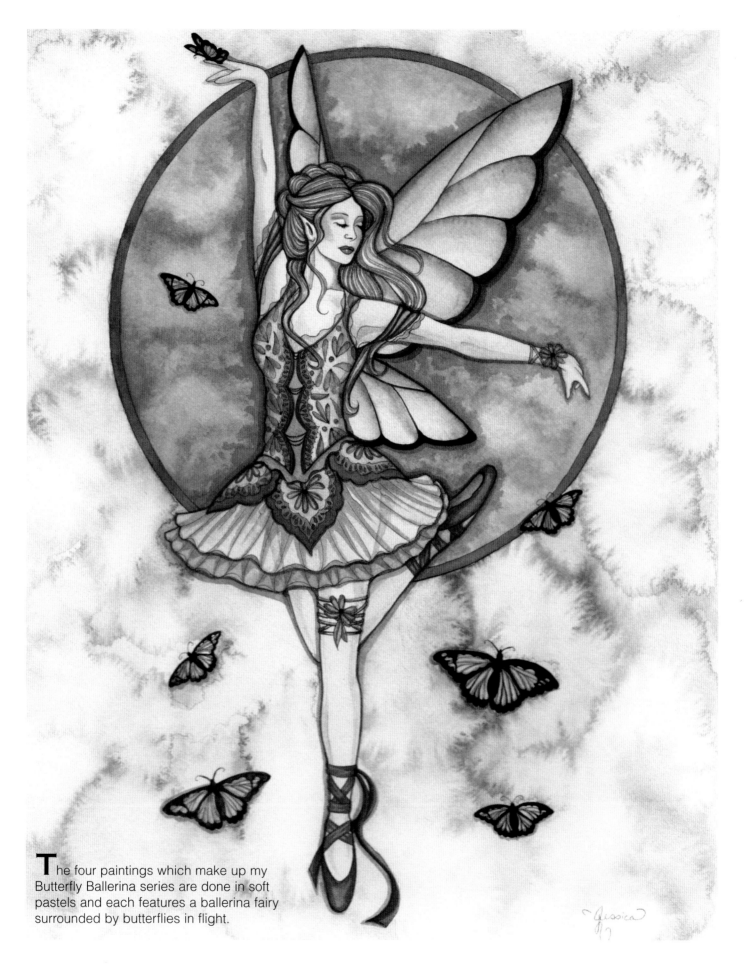

The four paintings which make up my Butterfly Ballerina series are done in soft pastels and each features a ballerina fairy surrounded by butterflies in flight.

**Mauve**

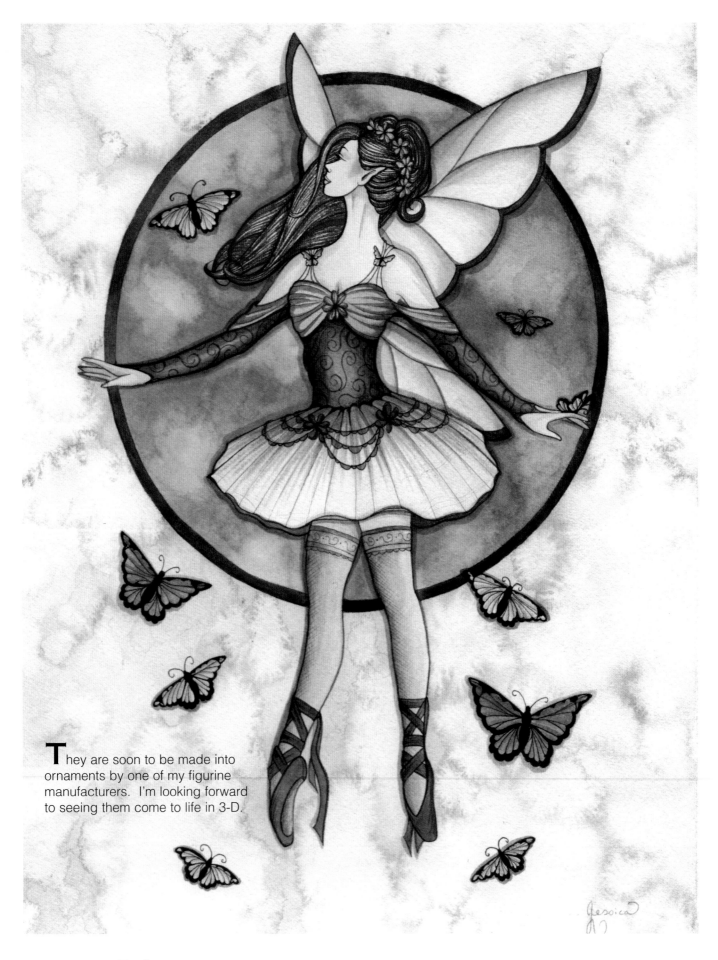

They are soon to be made into ornaments by one of my figurine manufacturers. I'm looking forward to seeing them come to life in 3-D.

*Teal*

100

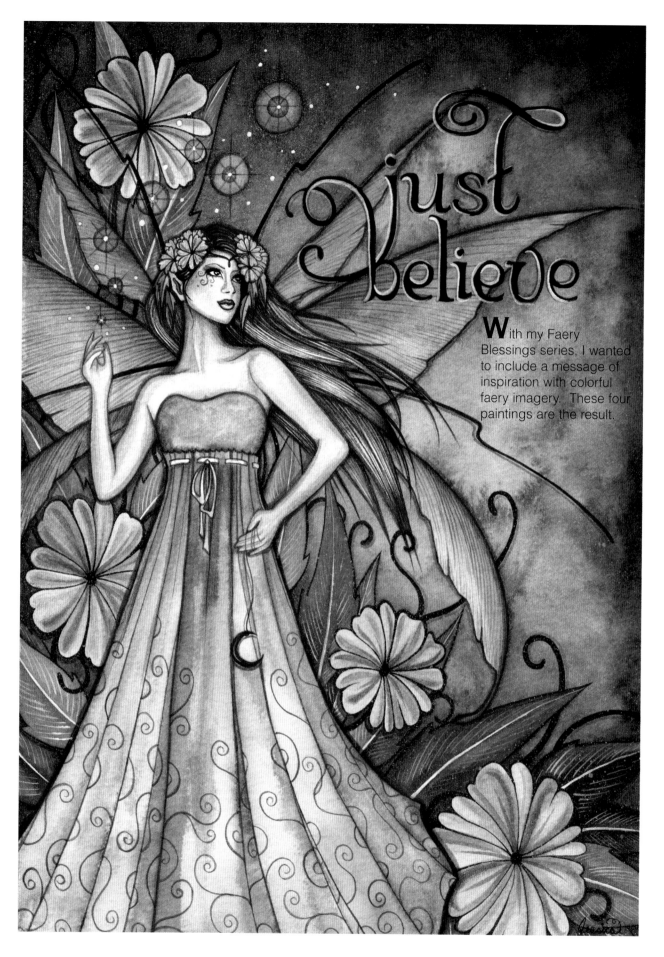

# Just Believe

**W**ith my Faery Blessings series, I wanted to include a message of inspiration with colorful faery imagery. These four paintings are the result.

*Just Believe*

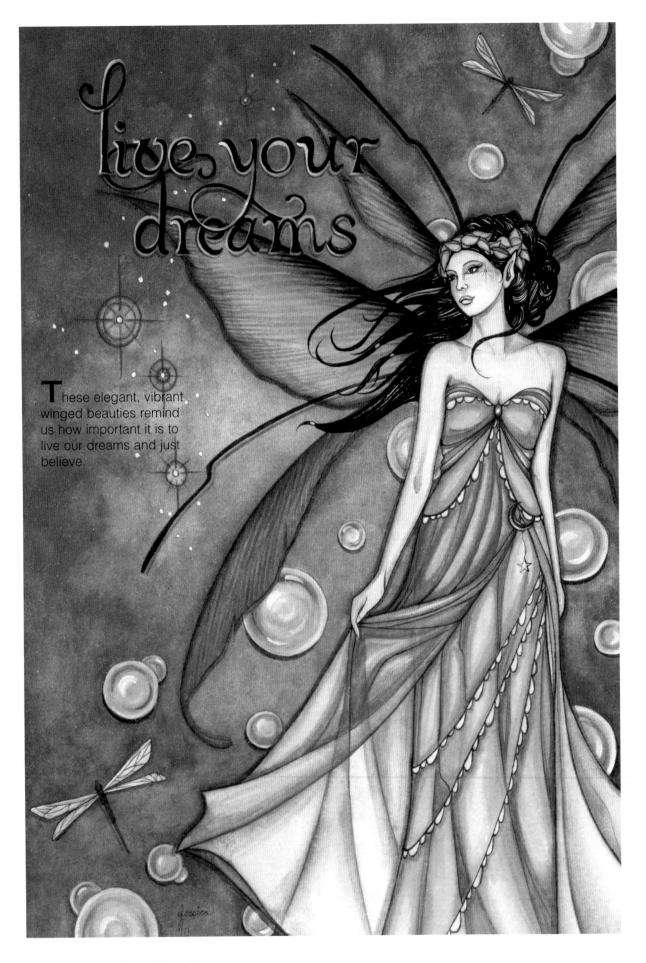

These elegant, vibrant winged beauties remind us how important it is to live our dreams and just believe.

**Live Your Dreams**

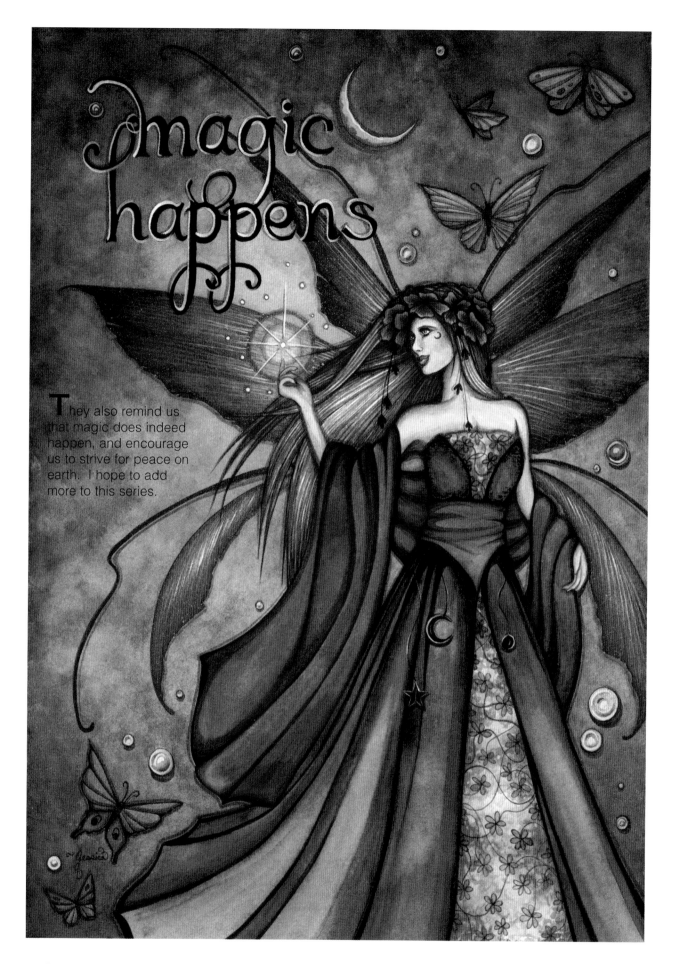

They also remind us that magic does indeed happen, and encourage us to strive for peace on earth. I hope to add more to this series.

**Magic Happens**

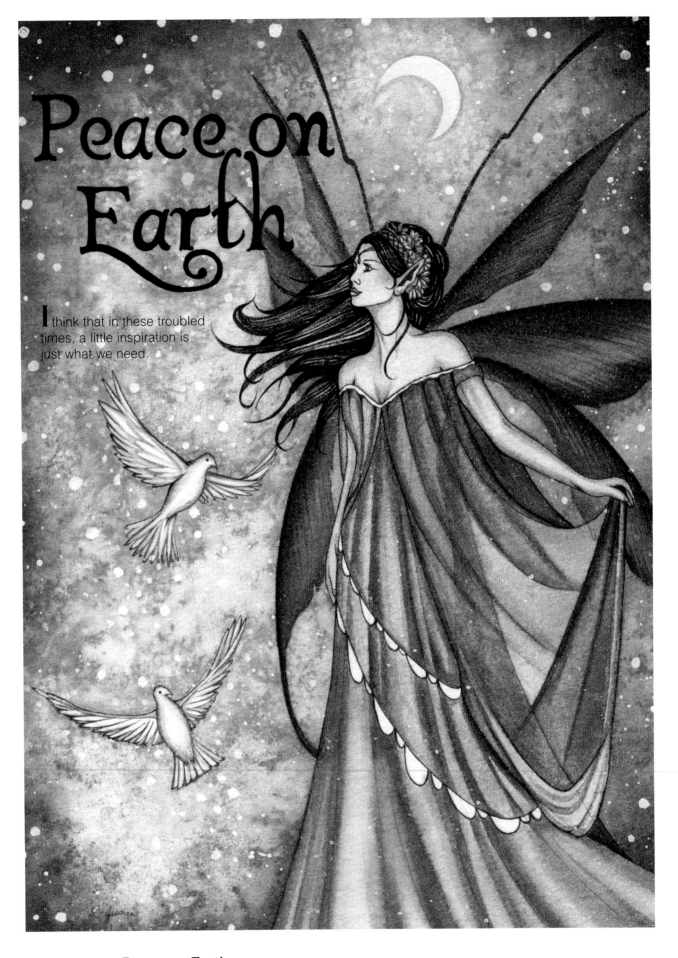

# Peace on Earth

I think that in these troubled times, a little inspiration is just what we need.

**Peace on Earth**

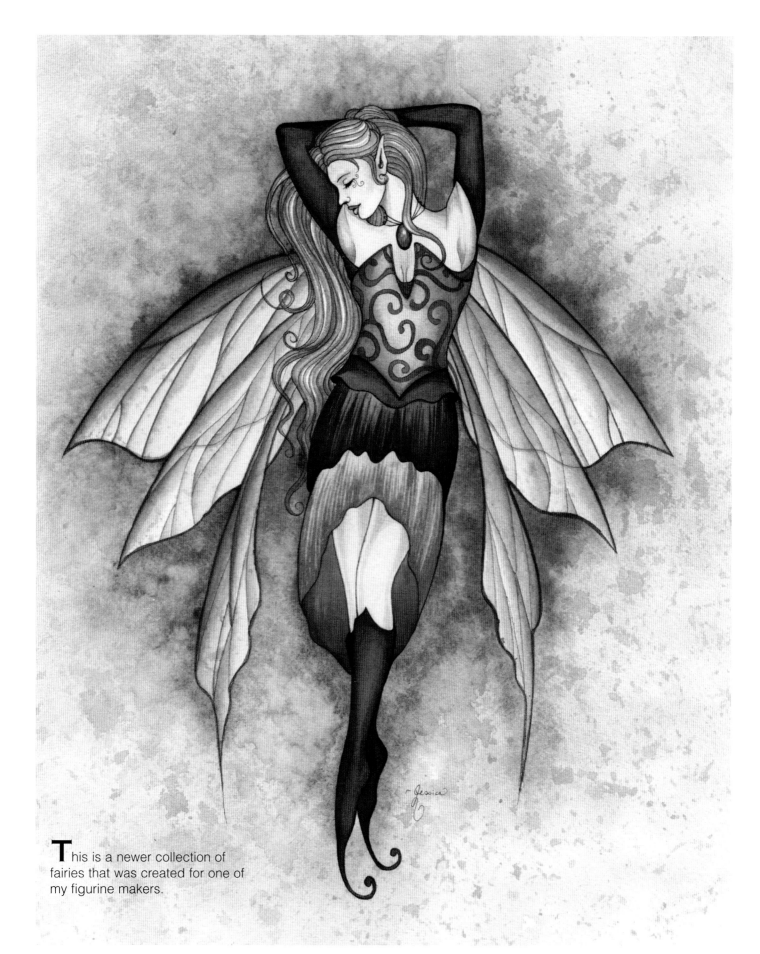

This is a newer collection of fairies that was created for one of my figurine makers.

### Amber

Amber a warm yellow-orange gemstone, is actually petrified tree sap. It acts as a spiritual purifier and cleanser, allowing one to reach their full creative potential, while promoting self confidence.

105

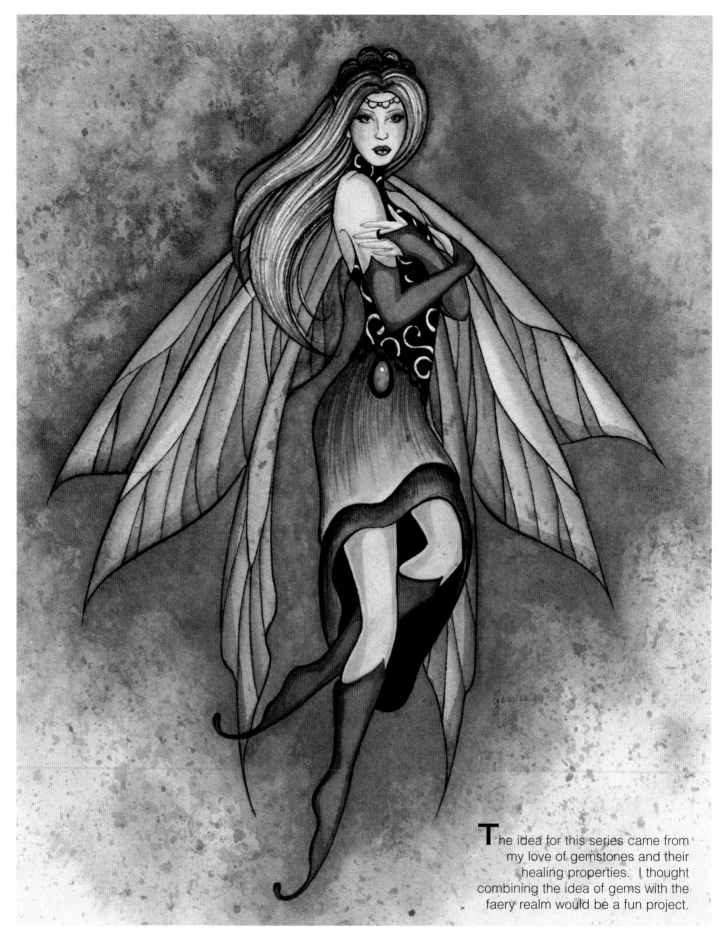

The idea for this series came from my love of gemstones and their healing properties. I thought combining the idea of gems with the faery realm would be a fun project.

### *Amethyst*

Amethyst, a lavender-purple gemstone, is known as the spirituality and transformation gemstone. It promotes calmness and clarity of mind and encourages intuition and awareness.

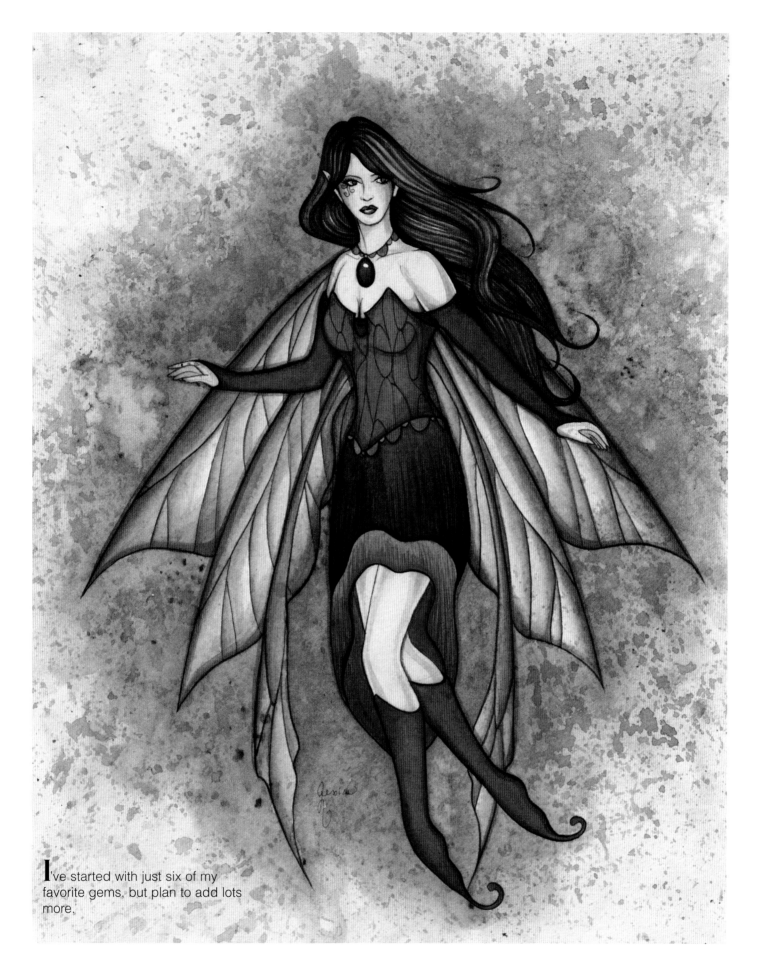

I've started with just six of my favorite gems, but plan to add lots more.

### Garnet

Garnet, a deep red gemstone is known as the gemstone of love and friendship. It also promotes balance in all areas of life and encourages passion, energy, and desire.

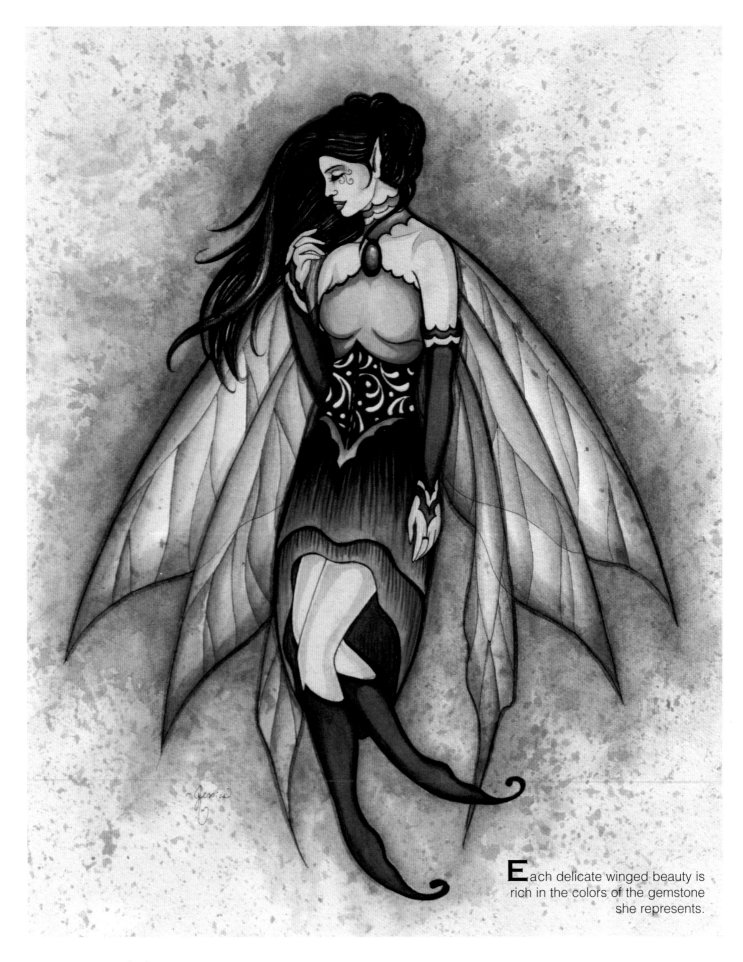

Each delicate winged beauty is rich in the colors of the gemstone she represents.

### Jade

Jade, a cool green gemstone is known as the gemstone of hope, healing, and serenity. It encourages peace of mind and is also known to bring good luck and prosperity.

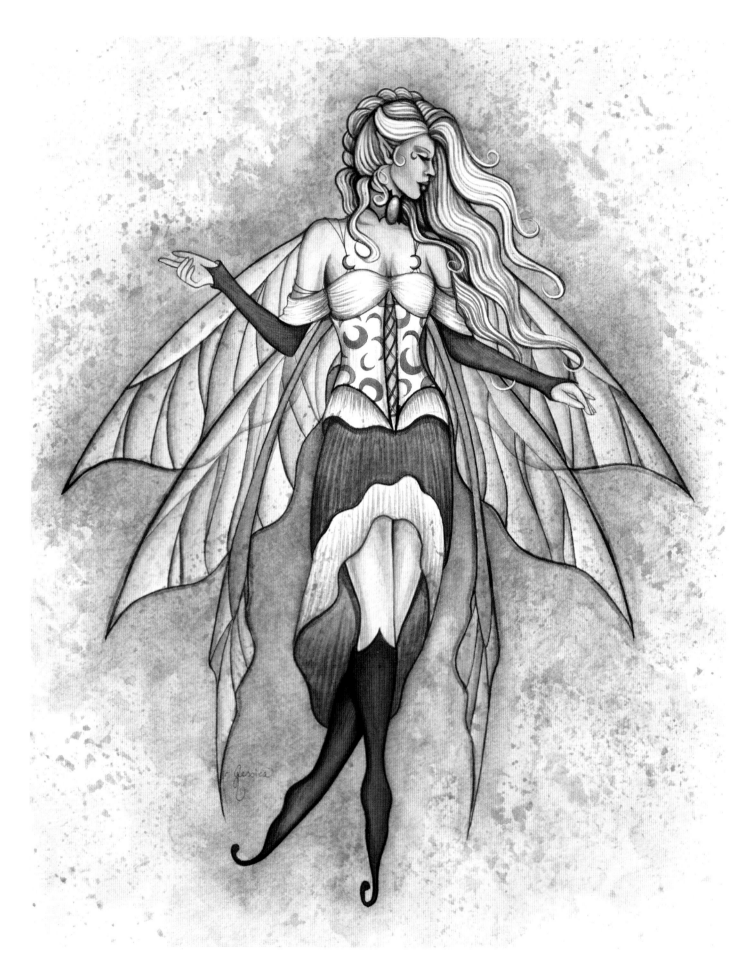

### *Moonstone*

Moonstone, an opaque blue gemstone, acts to increase one's spiritual awareness by embracing the power of the moon. It is also a wishing stone, associated with the fairy realm and increases psychic powers.

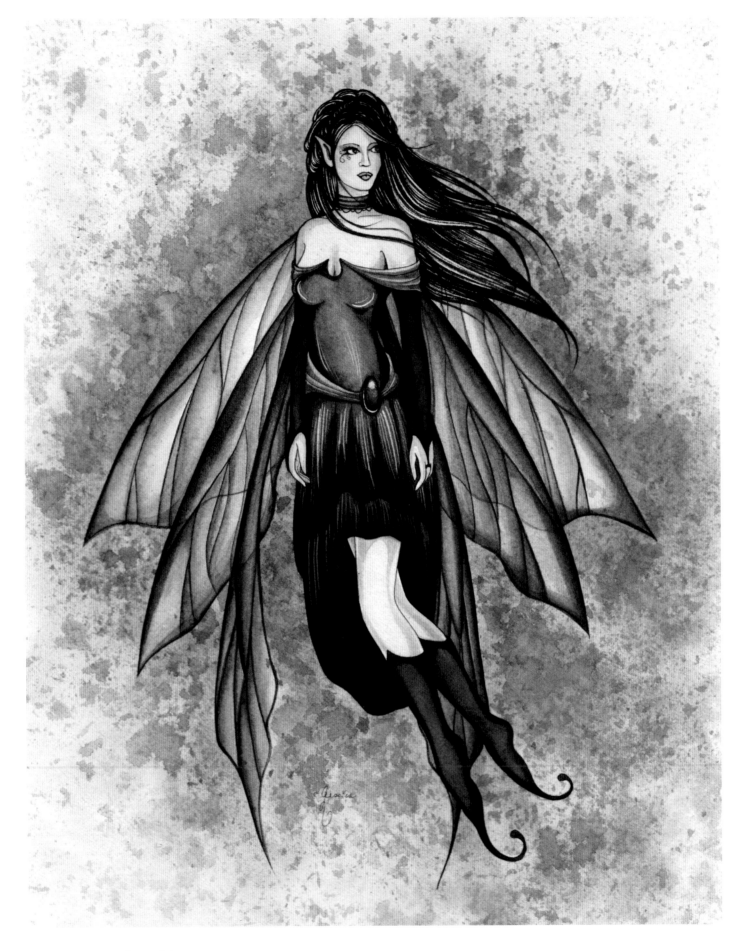

### *Sapphire*

Sapphire, a deep royal blue gemstone is known as the gemstone of truth, faith, and honesty. It promotes healing in all physical and mental areas and encourages sincerity, divine favor, and higher intelligence.

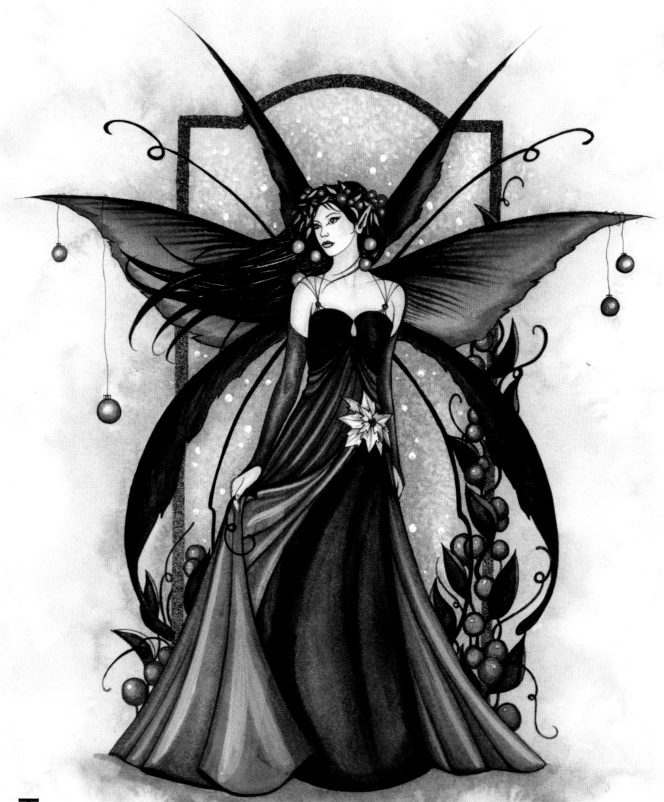

**T**hese four winter holiday faeries were definitely a project to remember! My greeting card licensor, Tree Free, mentioned they'd like to do a holiday tin set of notecards for me and wondered if I had any winter faeries. I didn't, but offered to paint some. They said, great – we'll need them Monday! I literally painted one of these per day for four days straight. Needless to say I didn't get much sleep. But, the holiday tin sets came out beautifully and these elegant wintry faeries seem to be popular with faery enthusiasts.

### *Holiday Splendor*

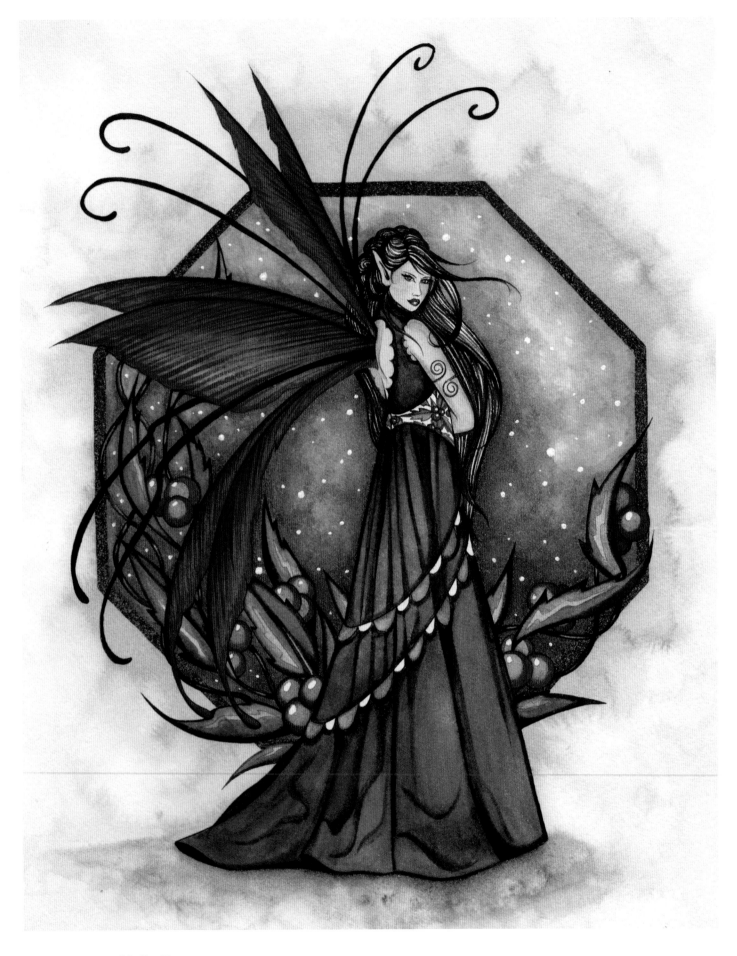

*Holly Faery*

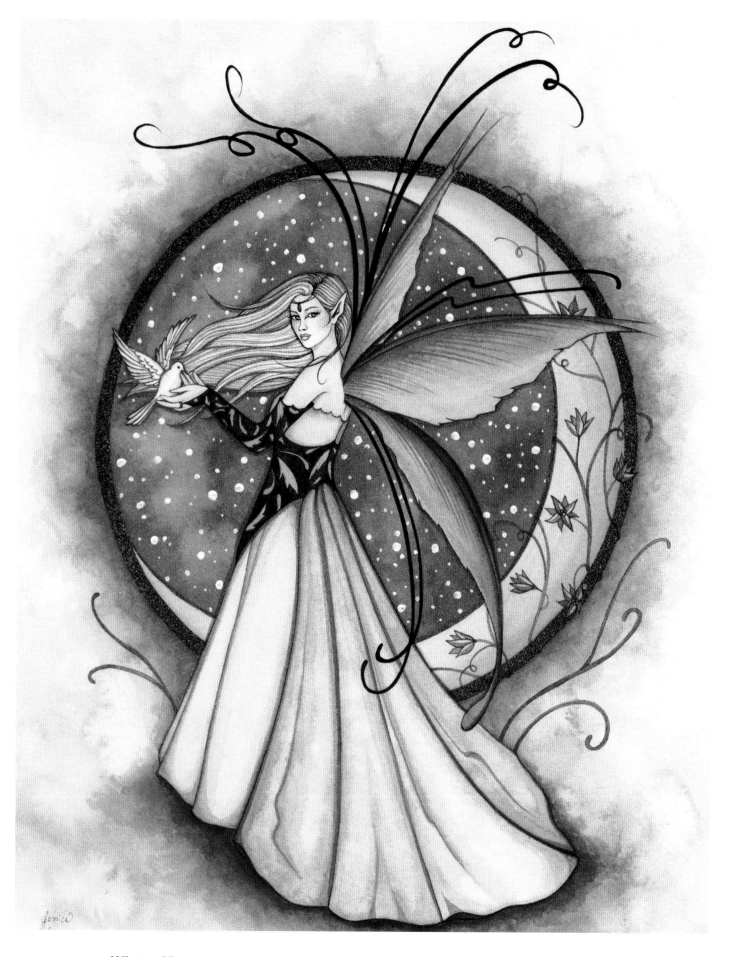

**Winter Moon**

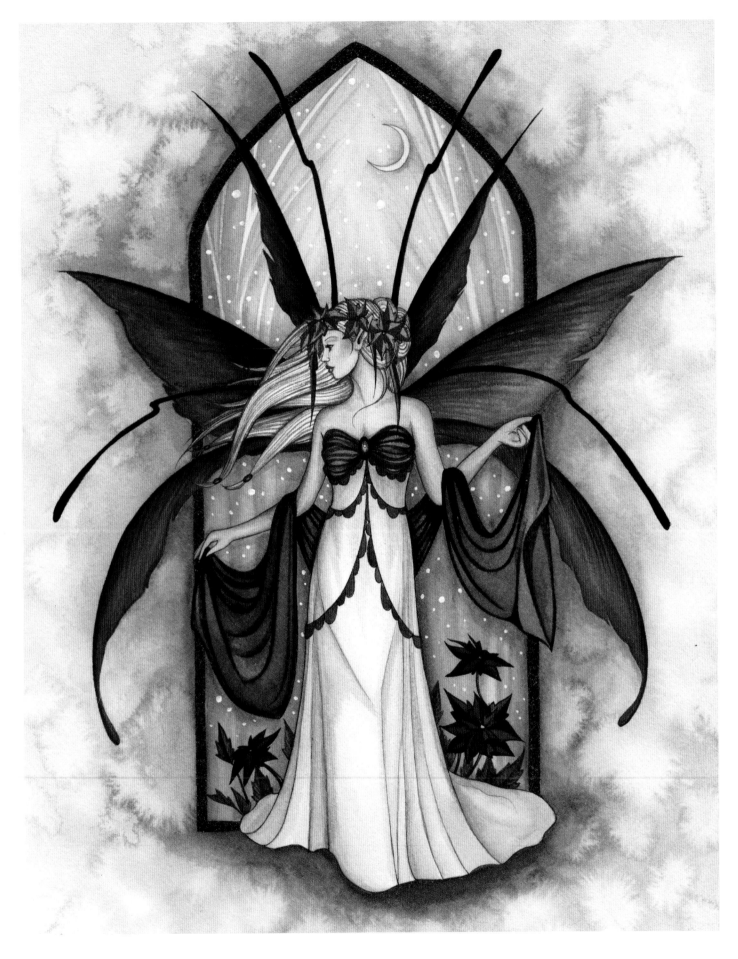

*Yule Faery*

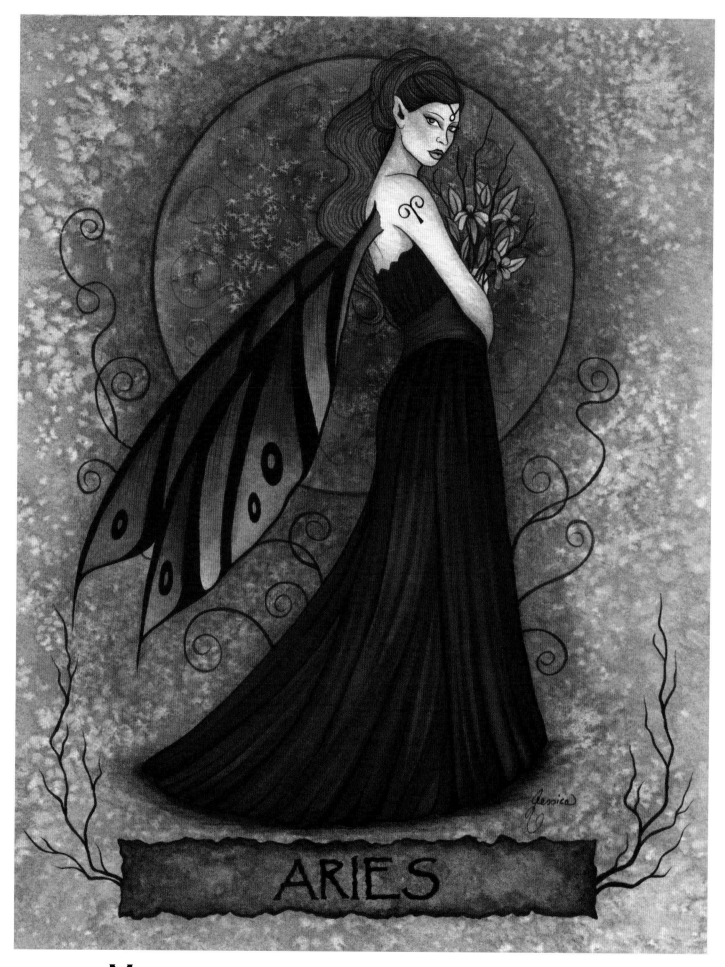

ARIES

**M**y Zodiac Fairies remain my most popular collections to date. I had actually had this idea years ago, but it took me a while to buckle down and get ready to do a series of twelve paintings. I tend to lose interest if I do something for too long so this took a lot of focus for me! I'm so glad I finished it though, because it has been a really popular and successful collection.

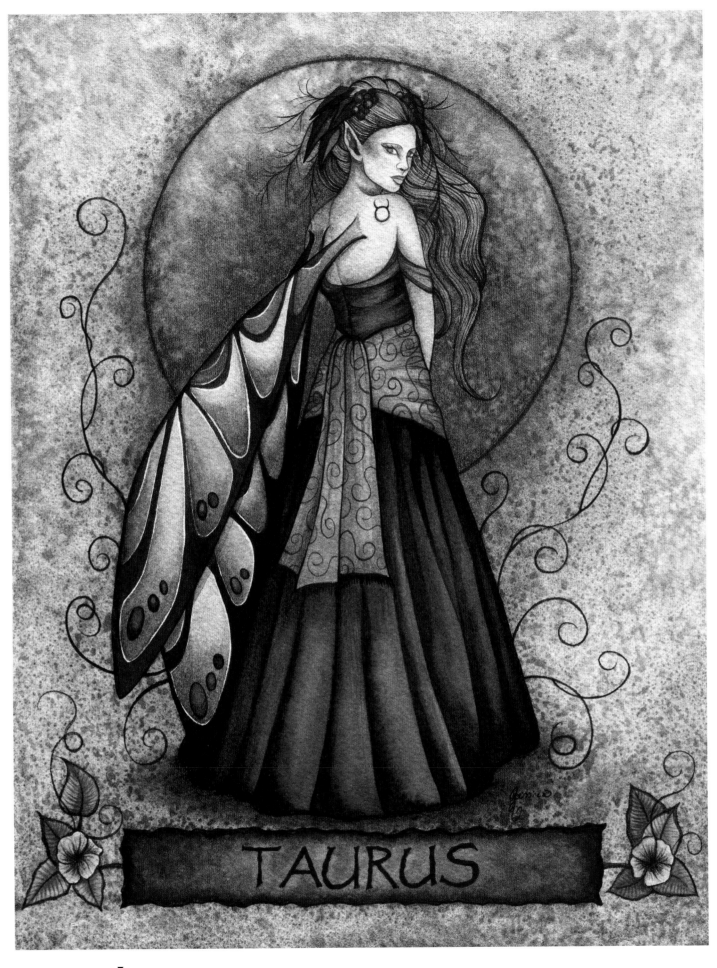

TAURUS

**A**lways having an interest in astrology, I researched the different Zodiac signs extensively before setting out to paint each faery. With each, I used the appropriate colors, flowers, gemstones and symbols associated with that sign. I also felt it important to script the name of the sign on a banner in the composition.

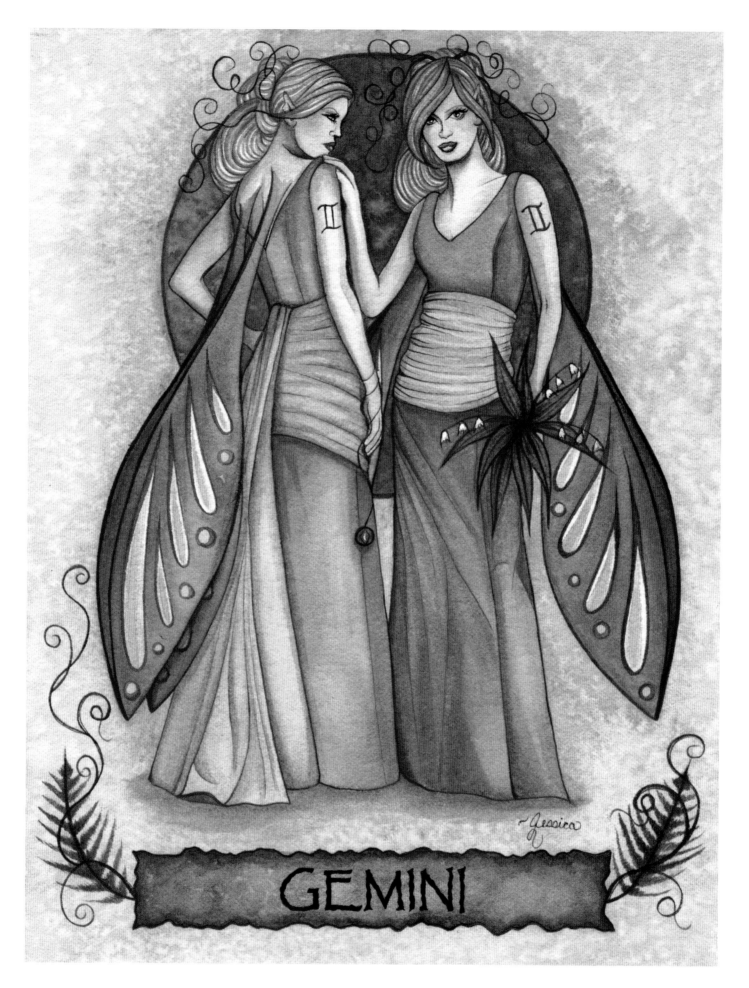

GEMINI

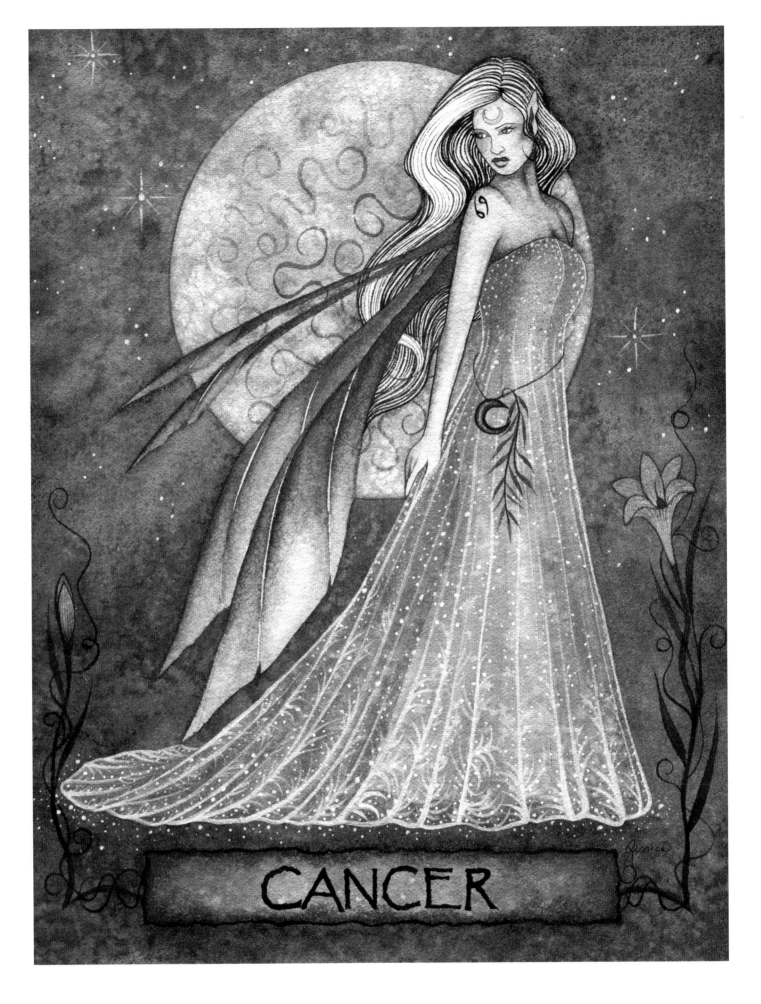

CANCER

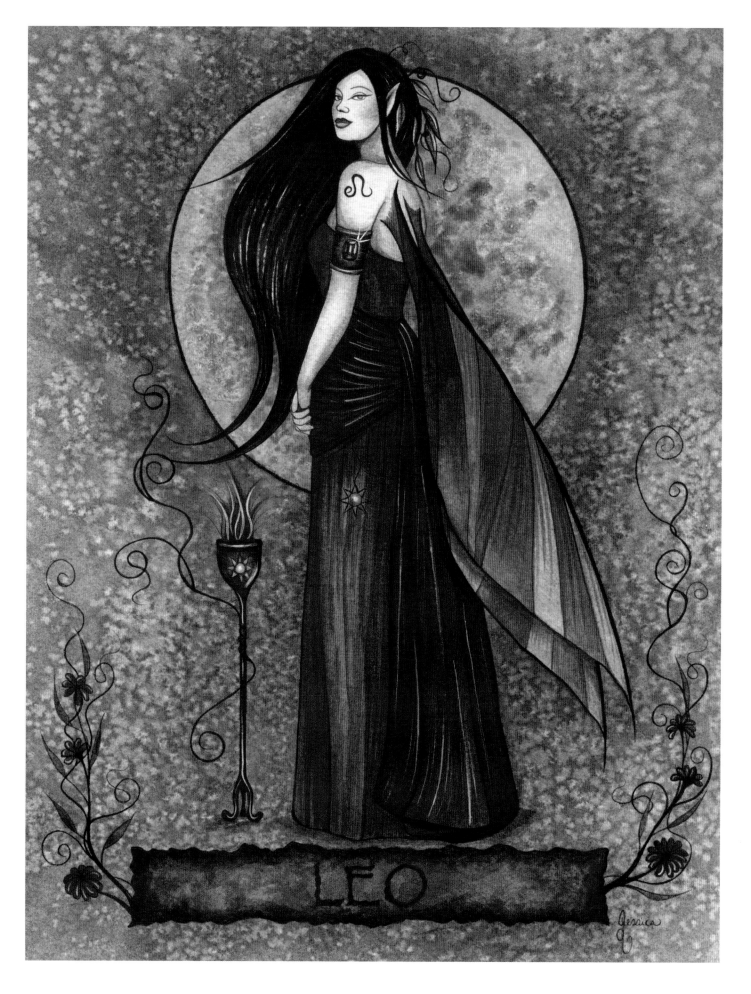

LEO

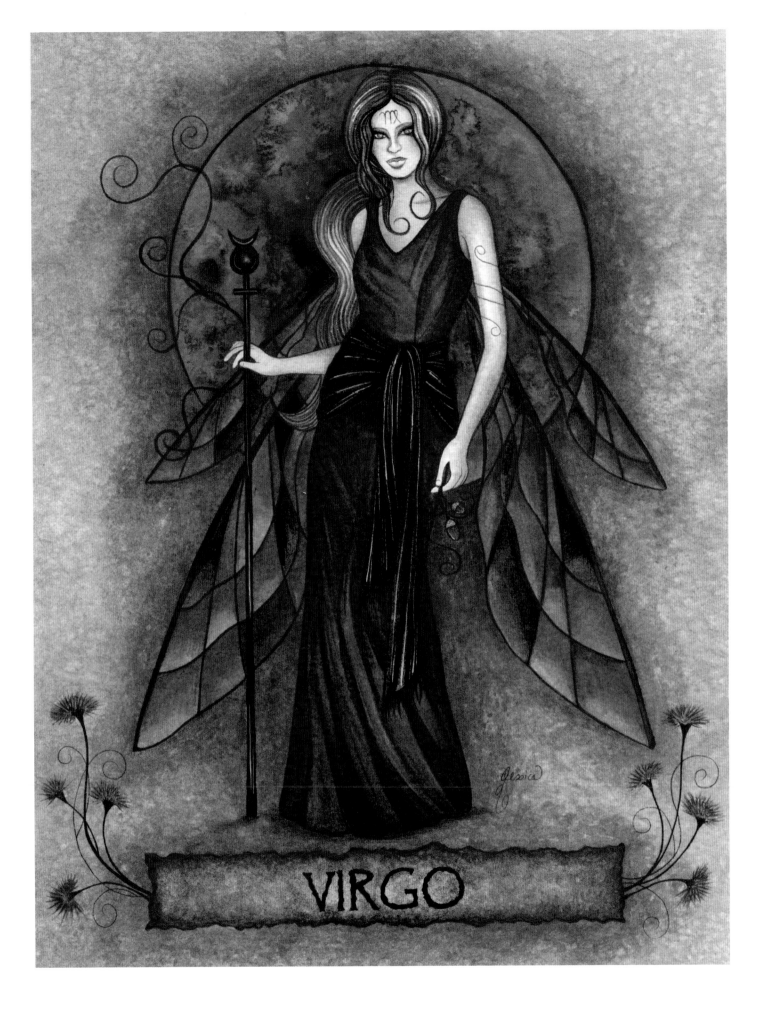

VIRGO

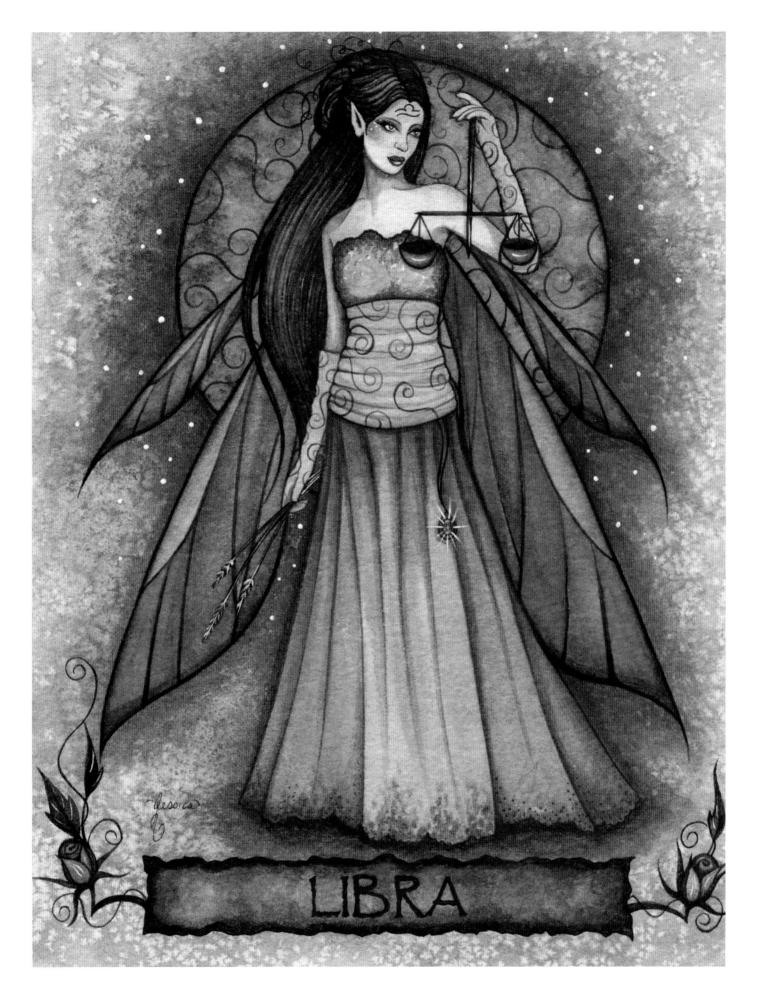

LIBRA

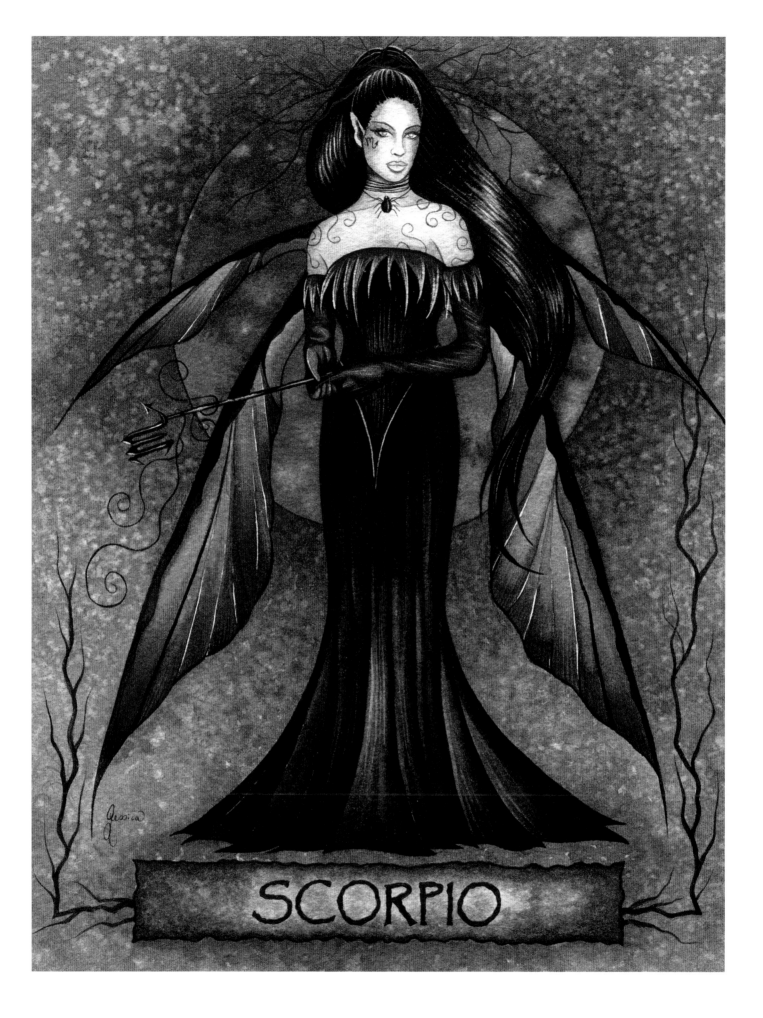

SCORPIO

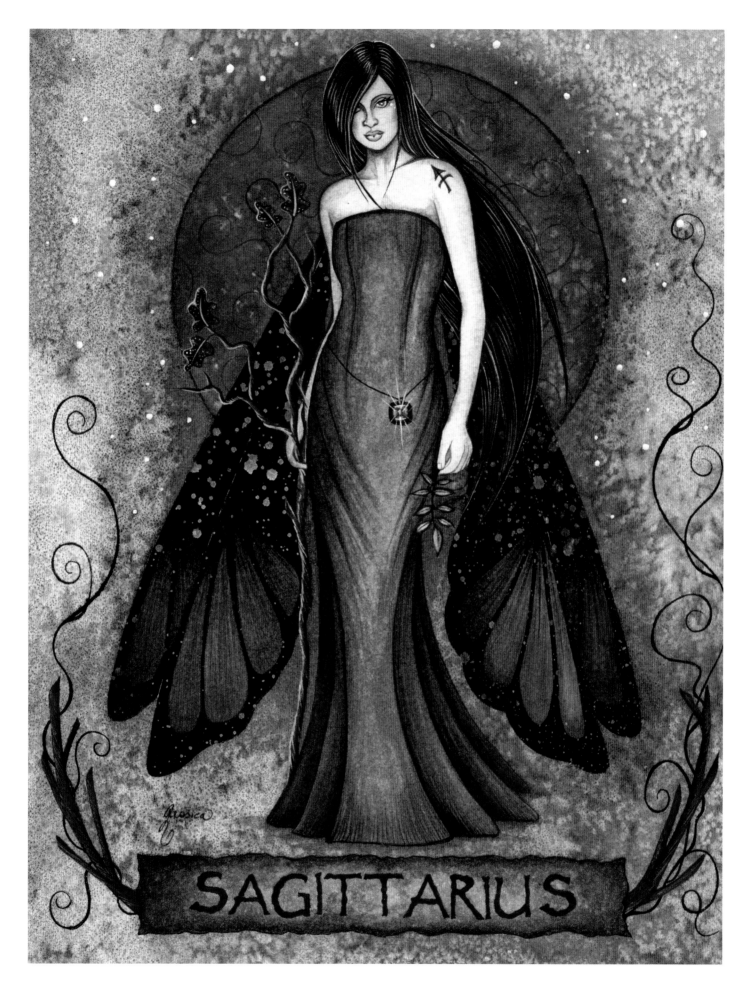

SAGITTARIUS

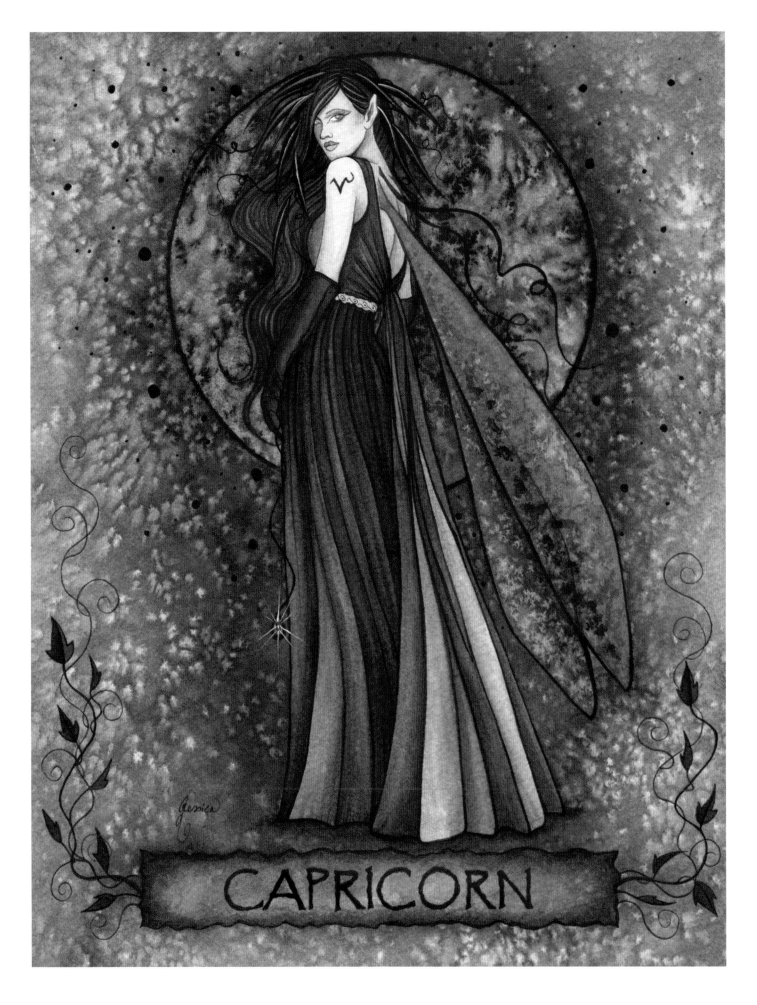

CAPRICORN

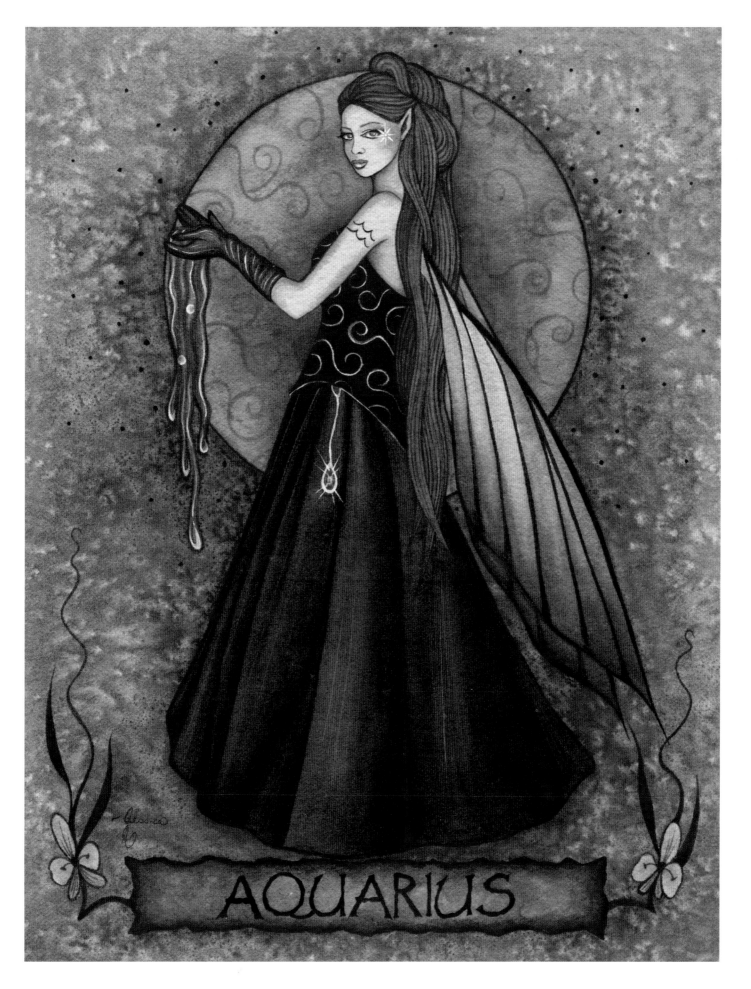

AQUARIUS

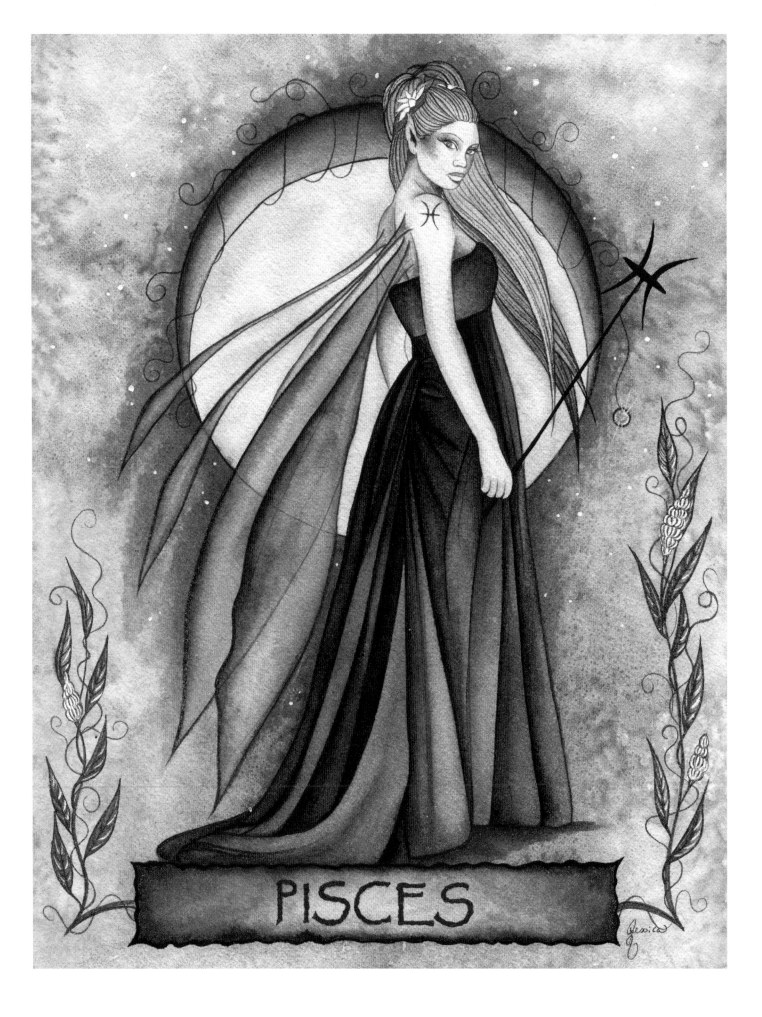

PISCES

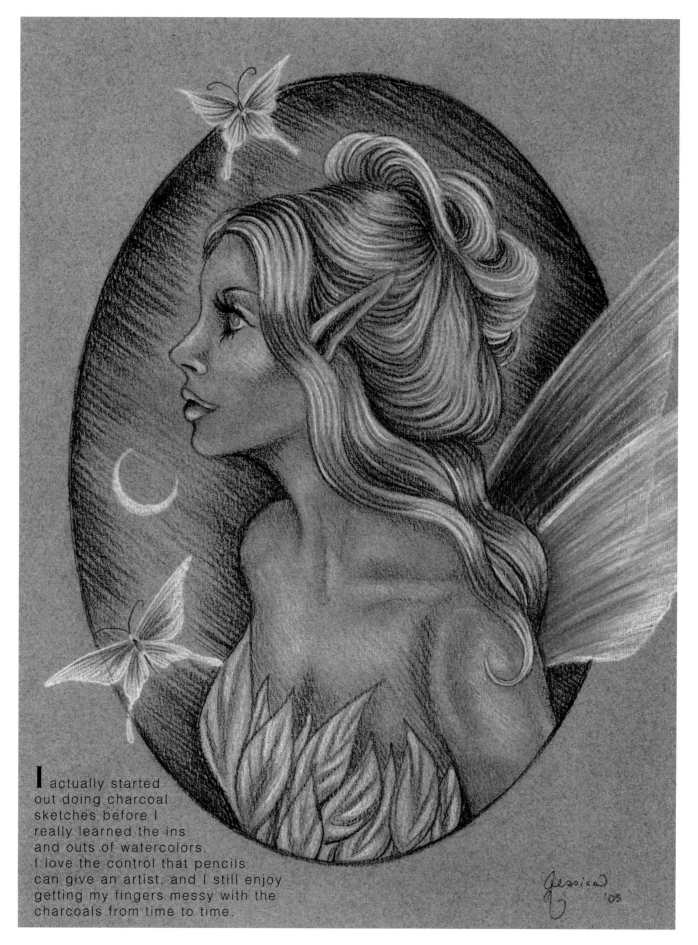

I actually started out doing charcoal sketches before I really learned the ins and outs of watercolors. I love the control that pencils can give an artist, and I still enjoy getting my fingers messy with the charcoals from time to time.

**Anu, The Faerie Queen**

When I'm getting burned out from painting, which happens from time to time, I get out my charcoals and start sketching away.

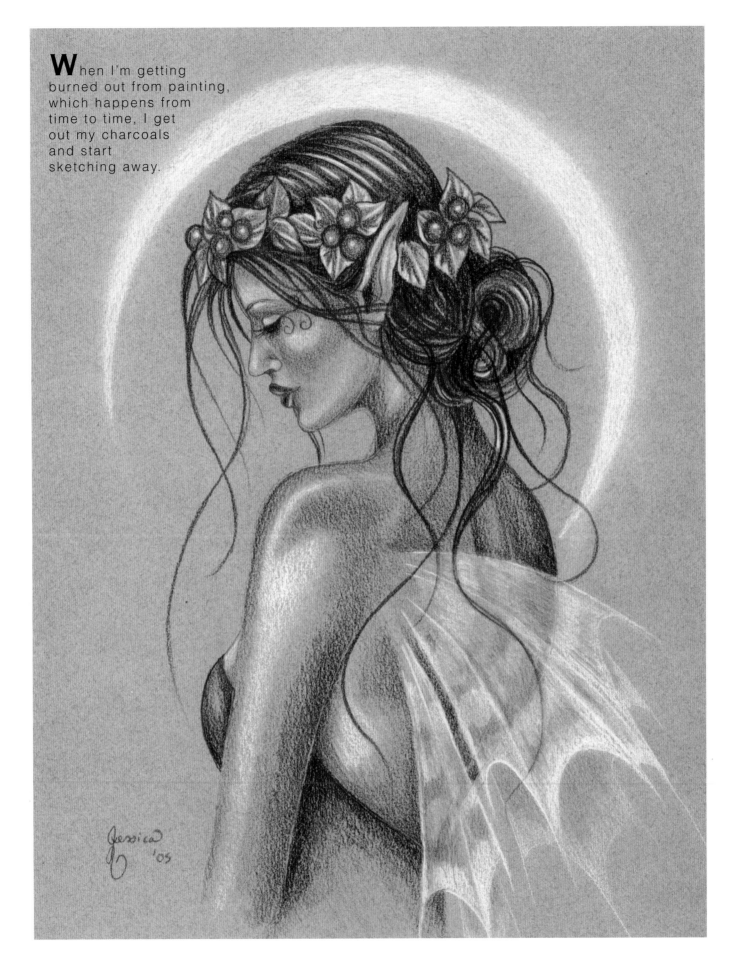

**Auburn Fantasy**

This collection features some of my
more recent sketches. Each is done with
black and white charcoal pencils
on textured, tinted
charcoal paper.

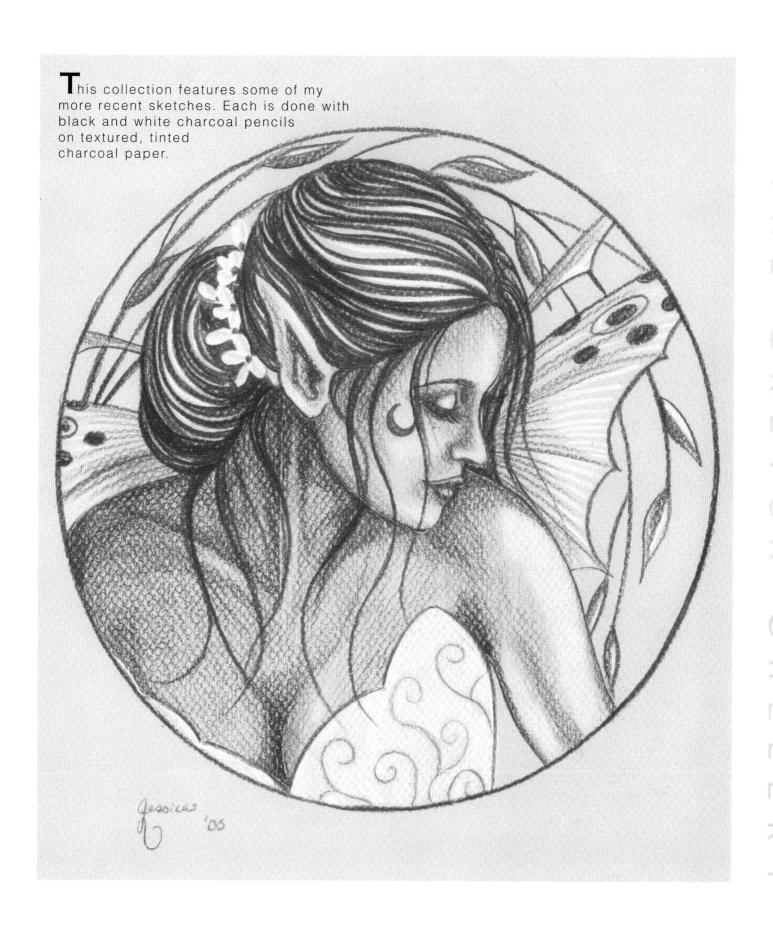

**Day Dreams**

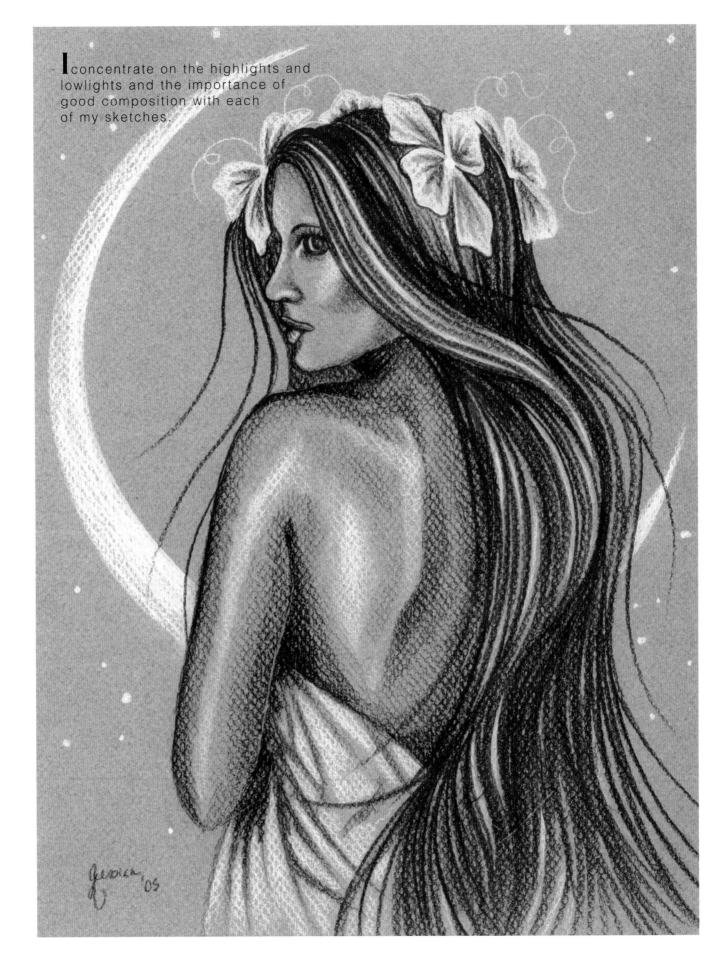

I concentrate on the highlights and lowlights and the importance of good composition with each of my sketches.

*Dreaming of Avalon*

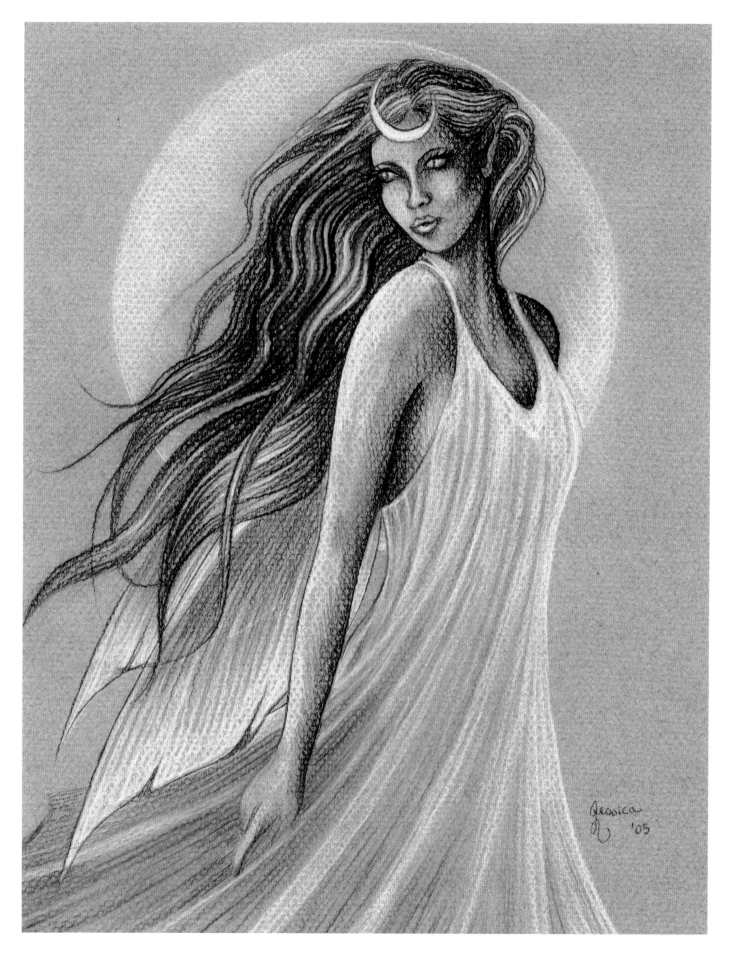

**Lunar Spirit**

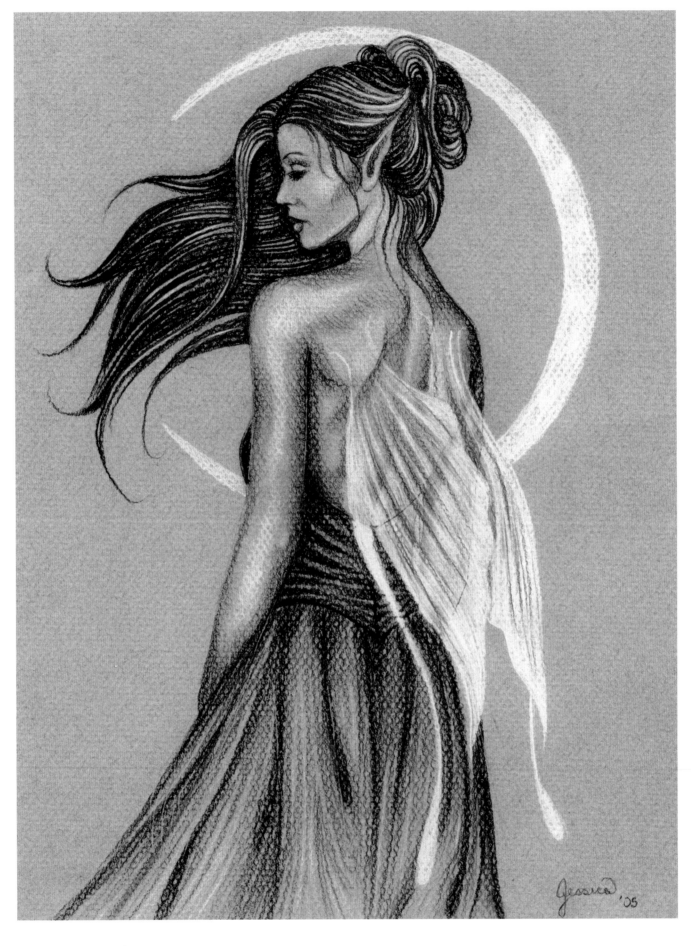

*Moon Daughter*

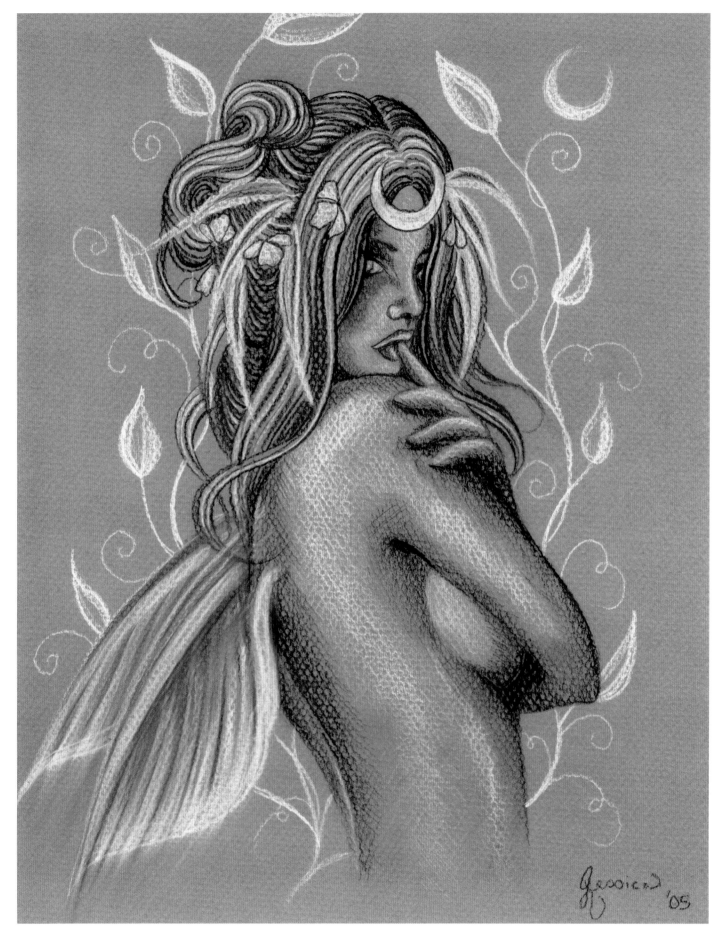

*Moon Deva*

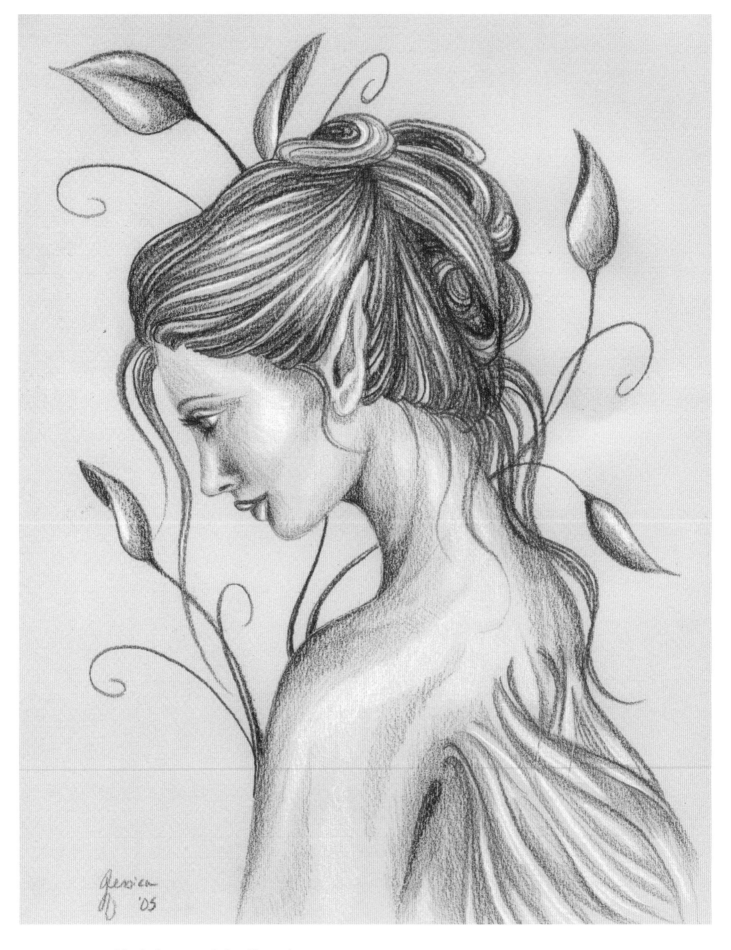

**Nari, Queen of the Nymphs**

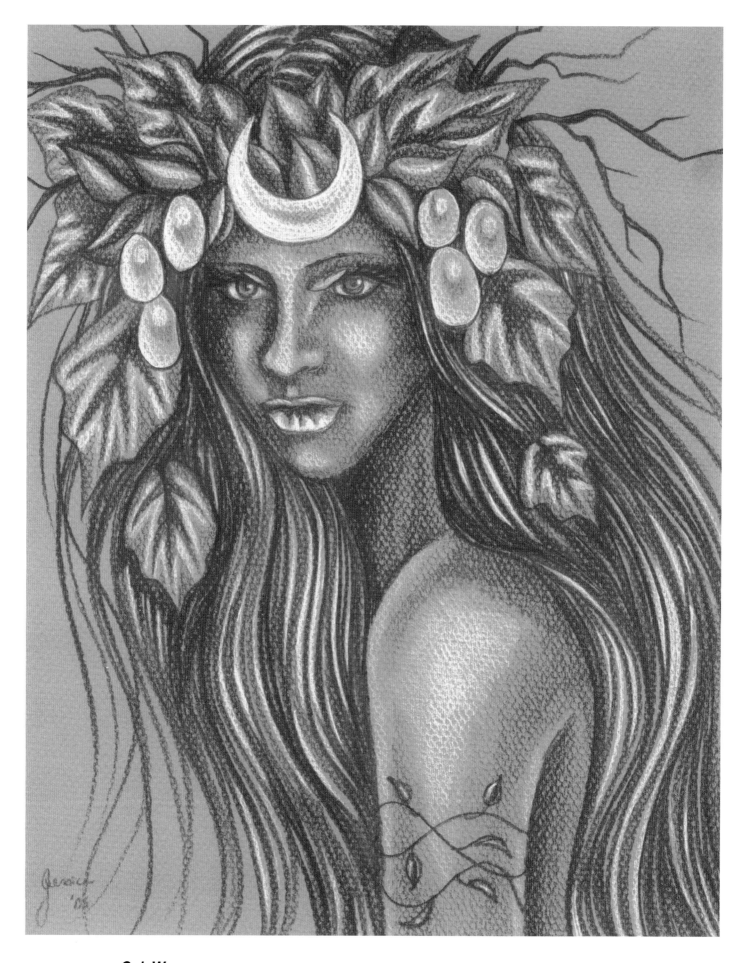

*Oak Woman*

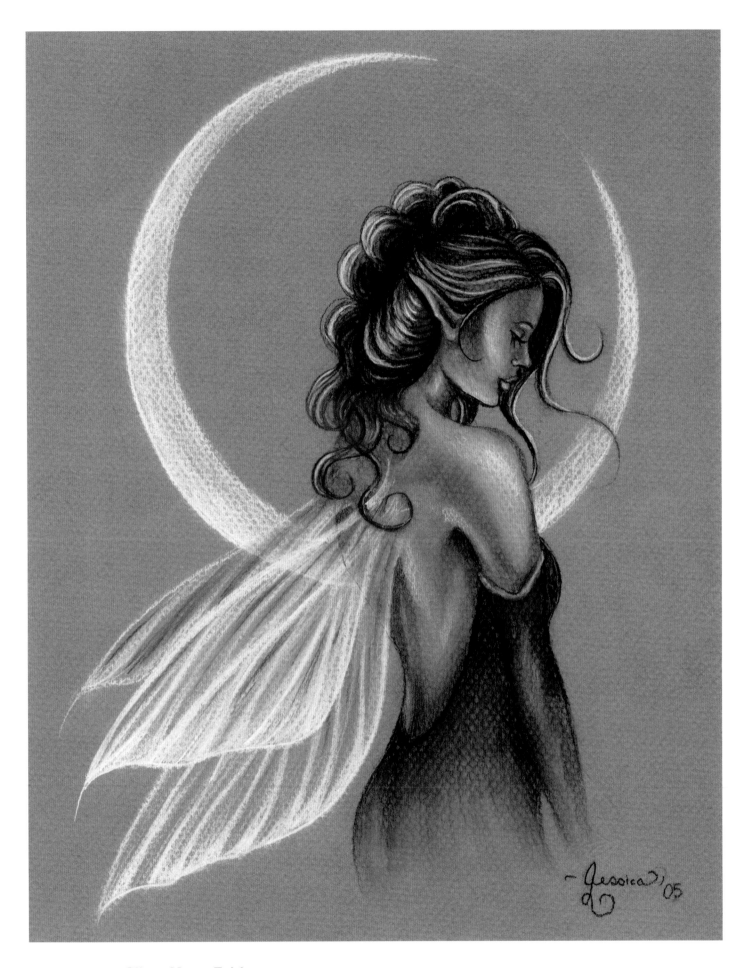

*Silver Moon Fairie*

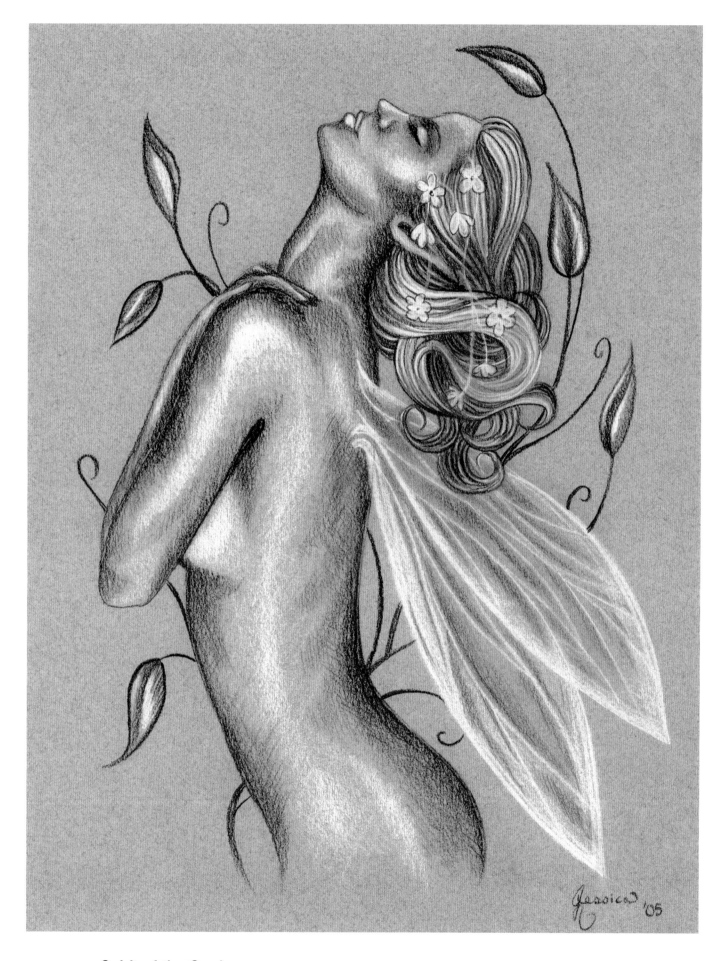

*Spirit of the Garden*

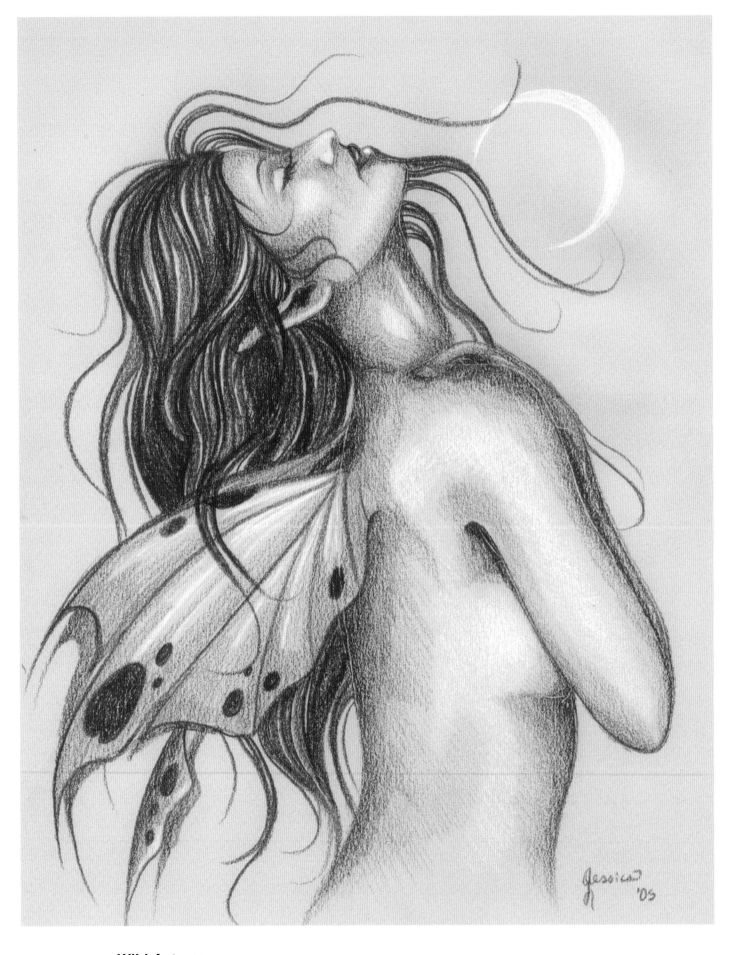

*Wild Autumn*

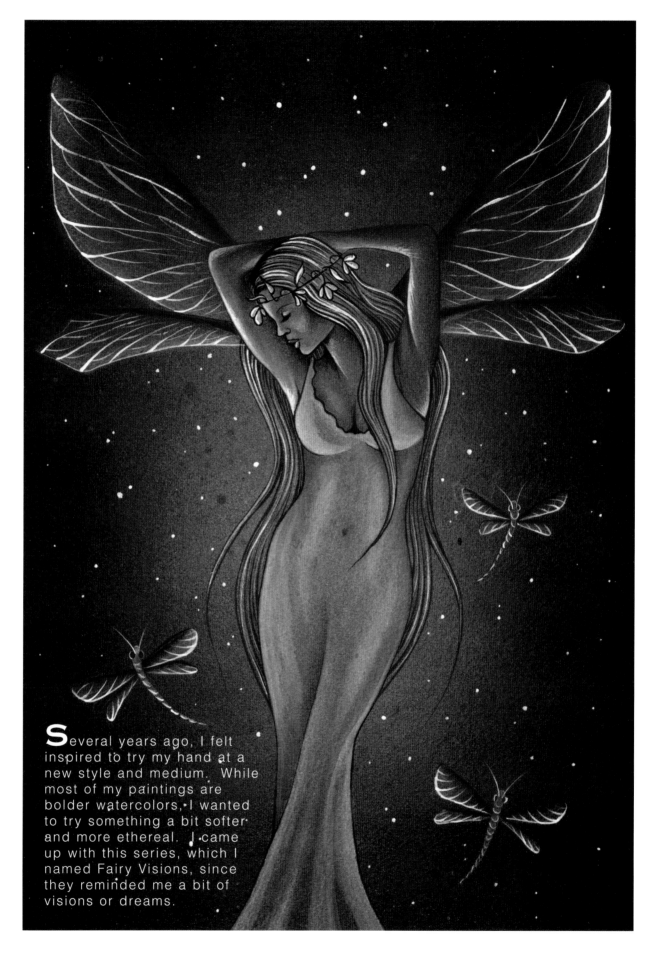

**S**everal years ago, I felt inspired to try my hand at a new style and medium. While most of my paintings are bolder watercolors, I wanted to try something a bit softer and more ethereal. I came up with this series, which I named Fairy Visions, since they reminded me a bit of visions or dreams.

### *Dragonfly Queen*

With head bowed and eyes closed, the beautiful queen of the dragonflies stands with long hair flowing as her subjects flit and fly around her.

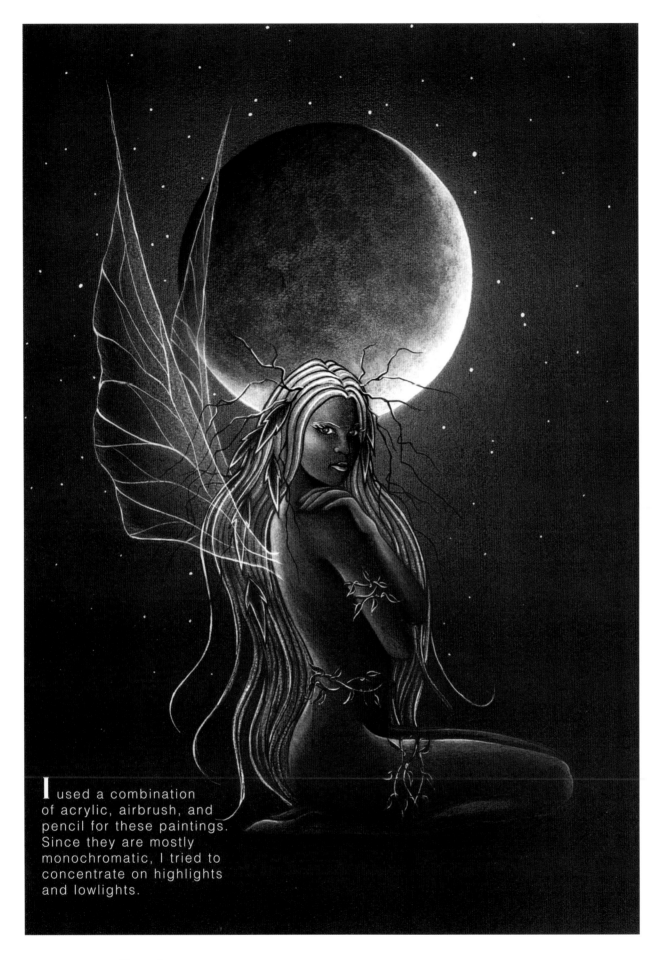

I used a combination of acrylic, airbrush, and pencil for these paintings. Since they are mostly monochromatic, I tried to concentrate on highlights and lowlights.

### *Dryad*

Carefully poised beneath an enchanted moon, eyes filled with the wisdom of the woodlands, a beautiful Dryad beckons you to come closer.

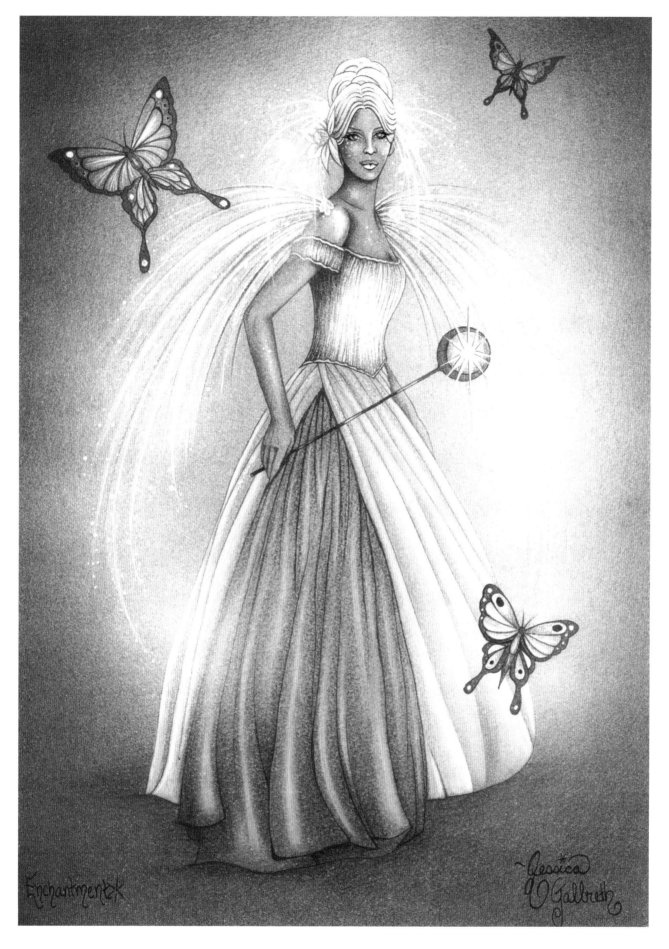

Enchantment

### Enchantment

In full fairy regalia, a fairy princess clutches her magical wand as delicate butterflies surround her in a shower of magic and enchantment.

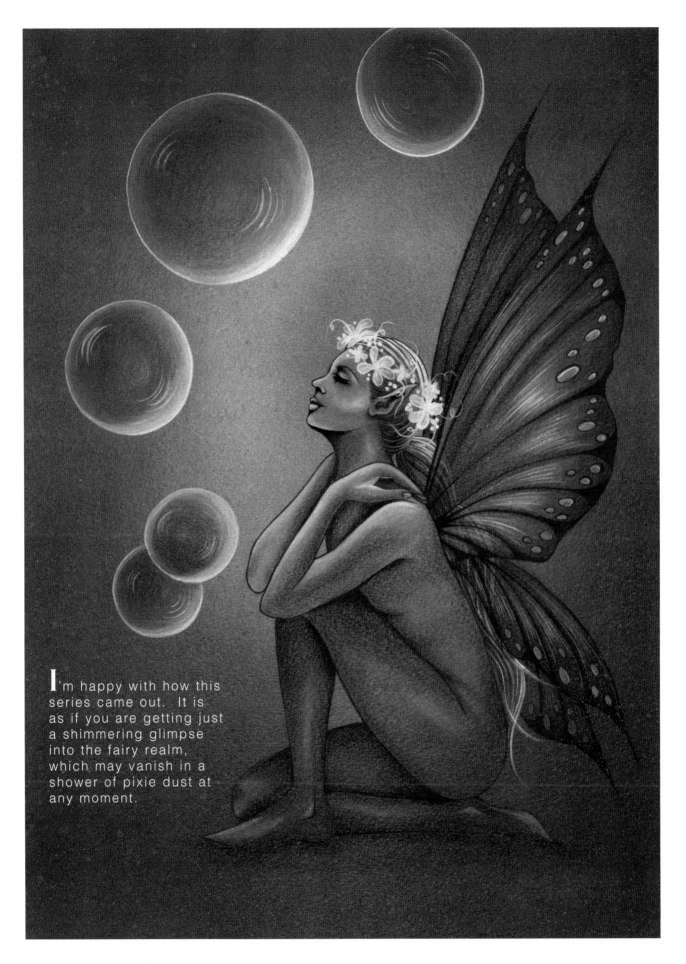

I'm happy with how this series came out. It is as if you are getting just a shimmering glimpse into the fairy realm, which may vanish in a shower of pixie dust at any moment.

### Fairy of Dreams

With eyes closed and head raised in prayer, the fairy of dreams offers her blessings upon the rising and swirling bubbles filled with the hopes and wishes of mortals.

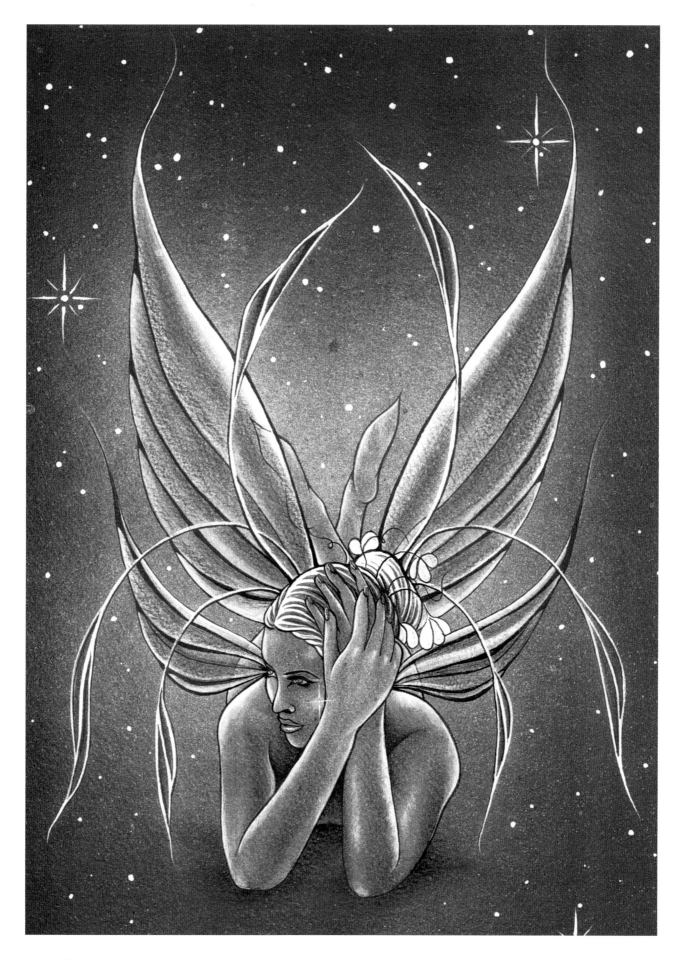

### *Fairy of Inspiration*
This playful and serene fairy is resting in a comfortable pose with gossamer wings stretched out above her, offering inspiration to artists and poets throughout the world.

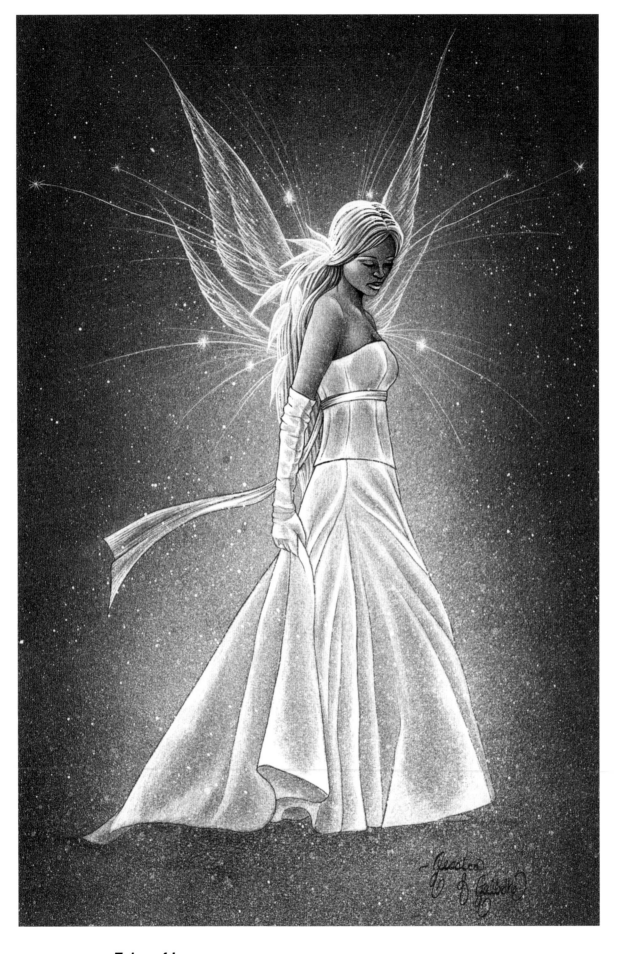

### *Fairy of Innocence*
Dressed in her finery, a shimmering fairy princess stands with head bowed. She represents all that is innocent in our world.

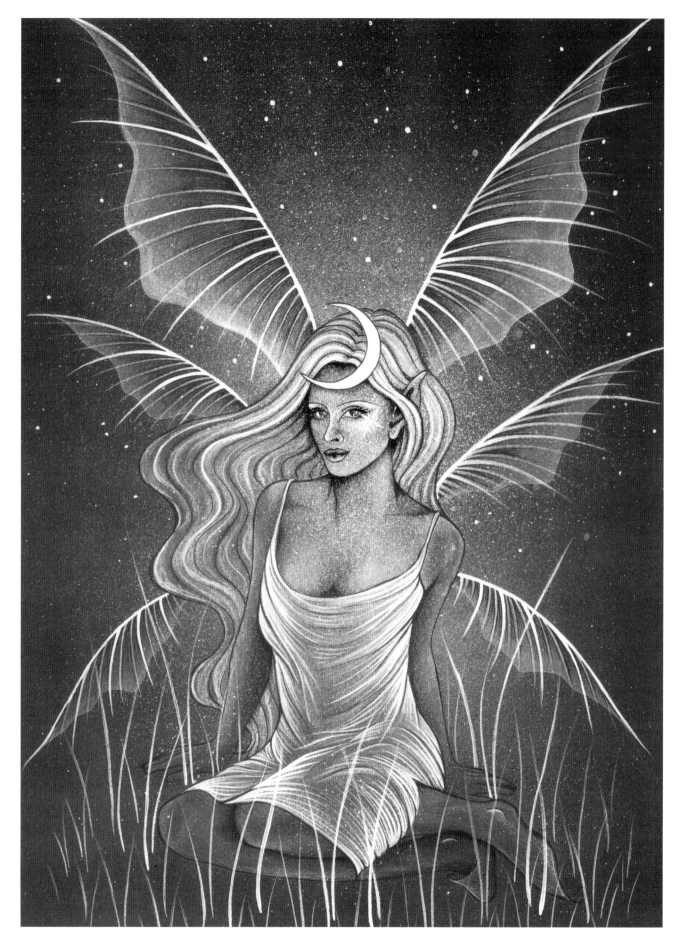

### *Fairy of Light*

Wearing a moon crown and a dress of gossamer silver threads, the fairy of light appears as a beacon of love and hope.

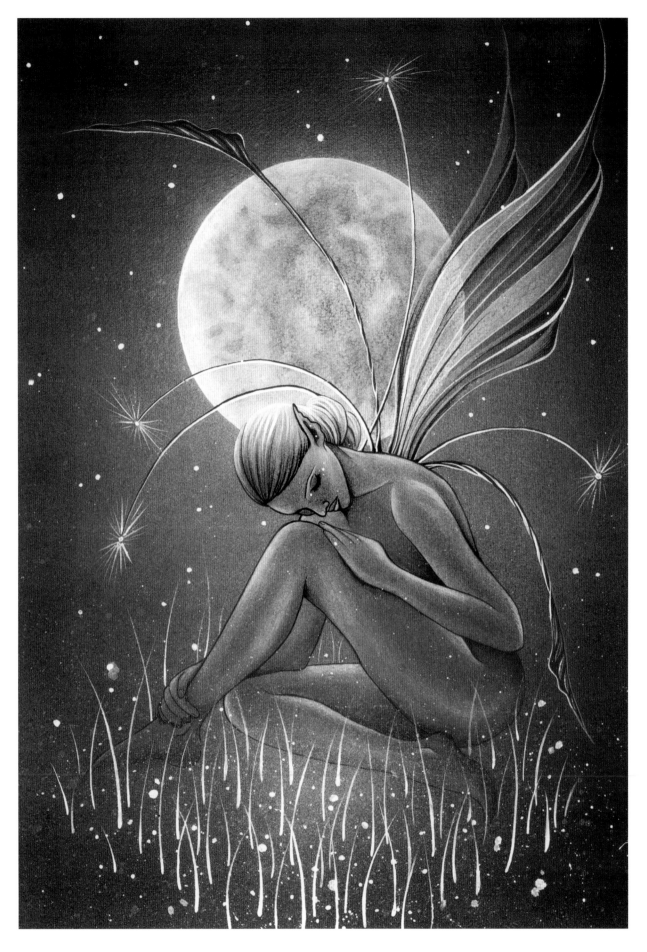

### *Moon Petal*

In a shower of purple fairy dust...a delicate lunar fairy rests beneath a full moon, her head bowed in a serene meditation.

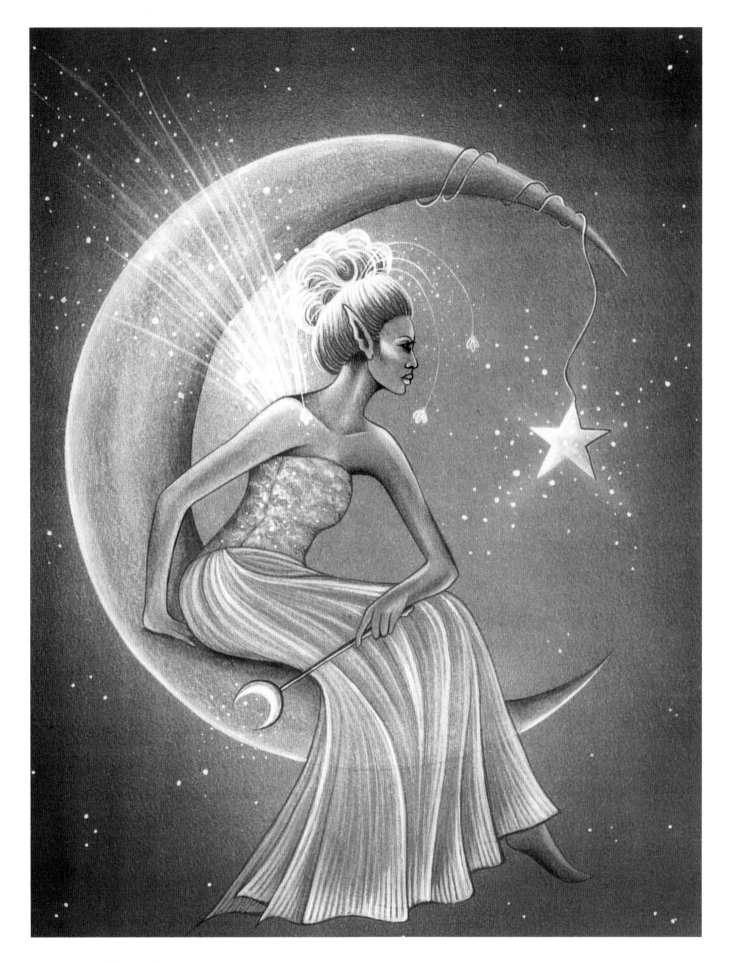

### Moon Queen

Resting on her crescent moon throne, the Moon Queen fairy gazes over the heavens and contemplates the universe.

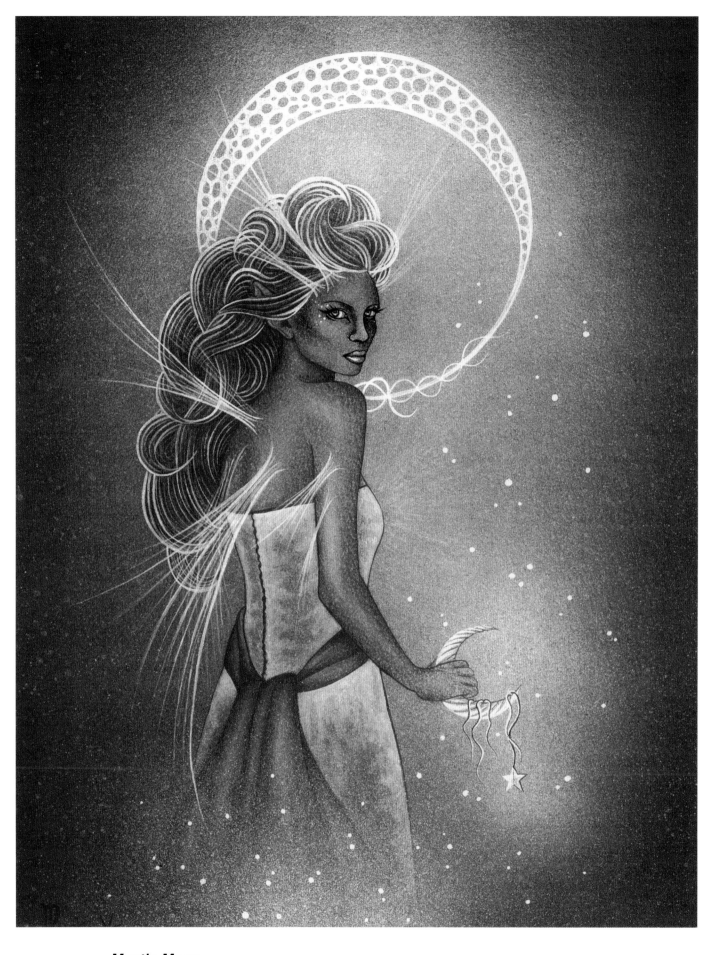

### *Mystic Moon*
As if in an enchanting dream, a mystical fairy materializes beneath a fanciful moon. Emerging from the mists, she flashes an intense gaze.

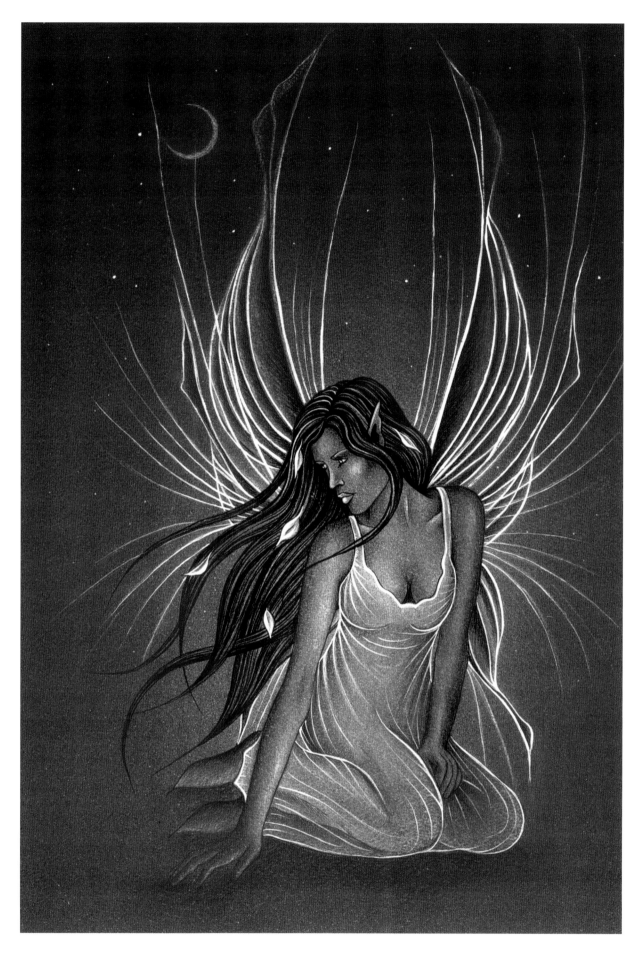

### *Night Fairy*

With a crescent moon shining distantly, a visionary fairy rests with her long locks blowing gently in the cool night winds.

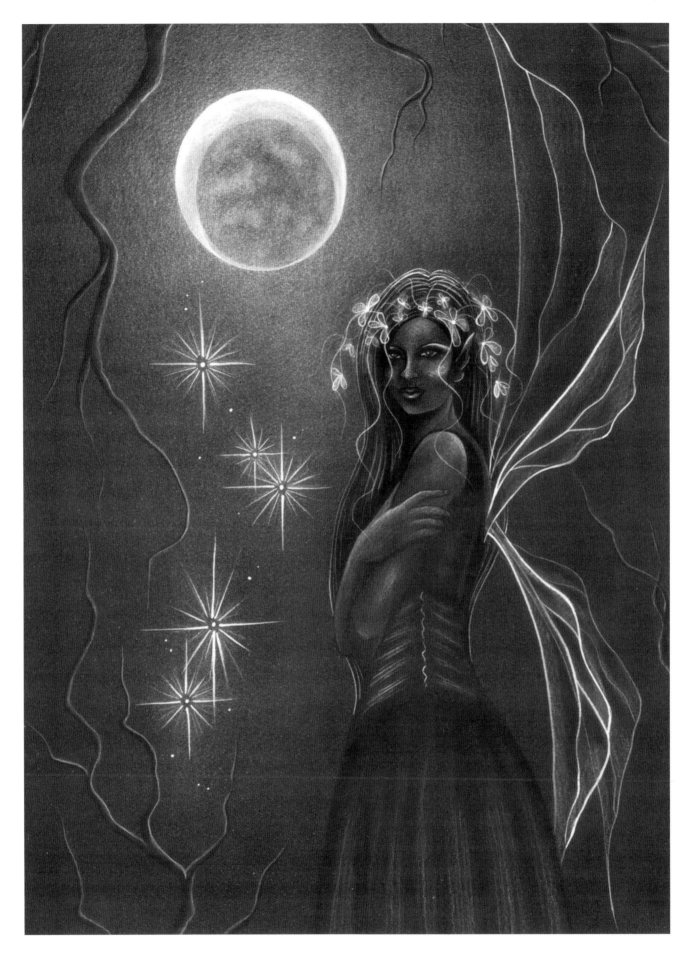

### Night Shade

Barely visible in the dark night mists, a fairy stands beneath the faint glow of a distant moon as the shadows close in around her.

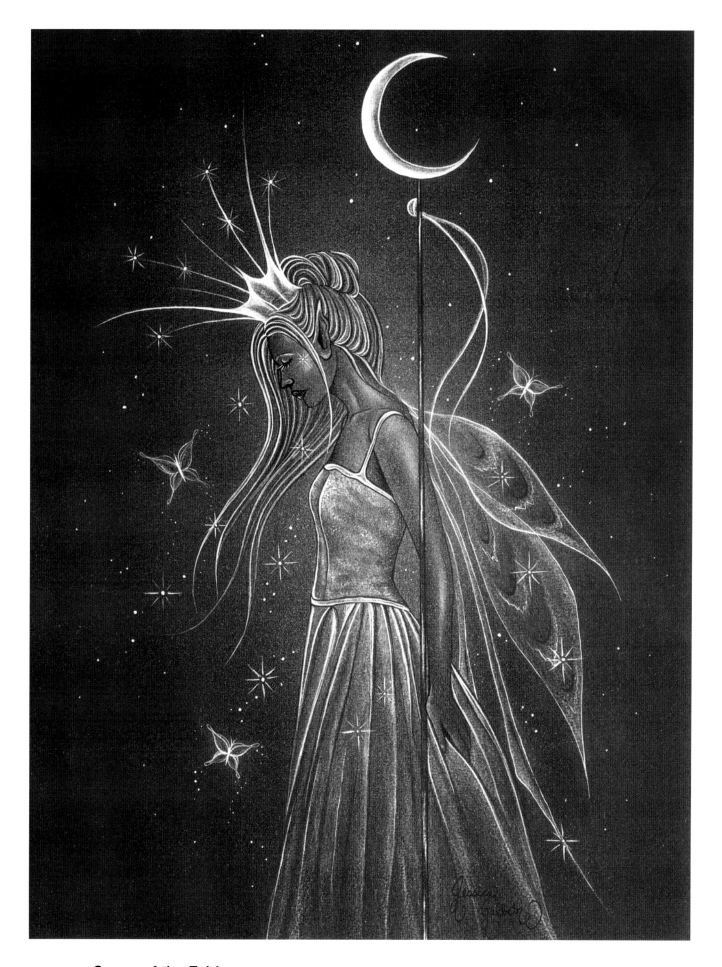

### *Queen of the Fairies*

The beautiful queen of the fairies walks through her enchanted forest, surrounded by a procession of shimmering butterflies.

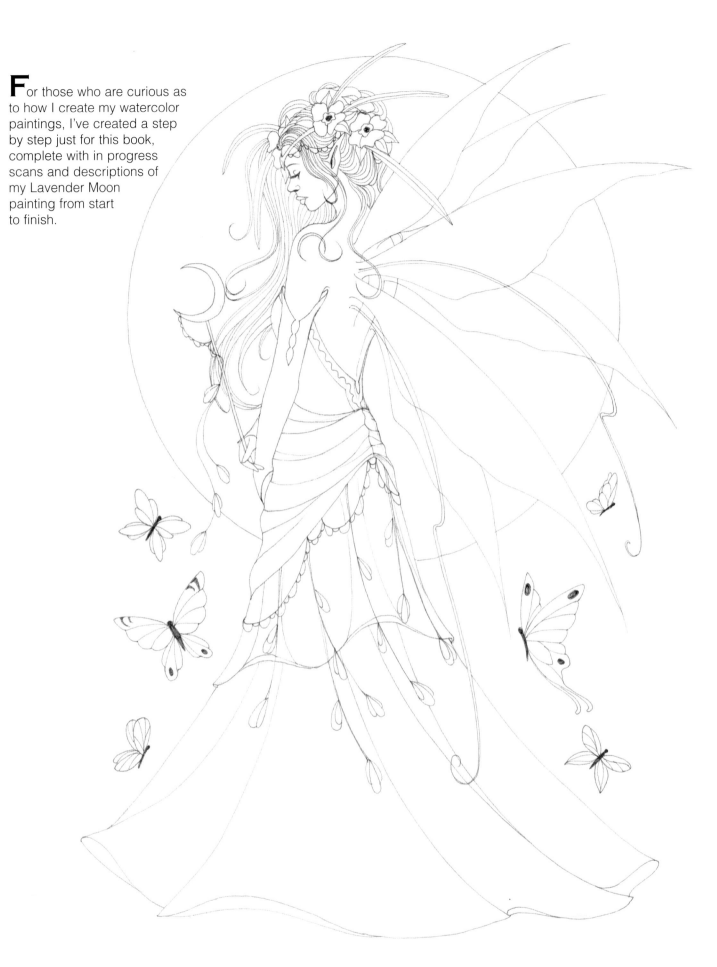

**F**or those who are curious as to how I create my watercolor paintings, I've created a step by step just for this book, complete with in progress scans and descriptions of my Lavender Moon painting from start to finish.

### *Lavender Moon Step One – The Sketching and Inking Process*

Using a piece of 300 lb. coldpress watercolor paper (I prefer Strathmore), I lightly sketch out the composition using a fine point, light pencil. Then, using a rapidograph fine point drawing pen filled with sepia toned permanent ink, I go over the pencil lines of the entire image.

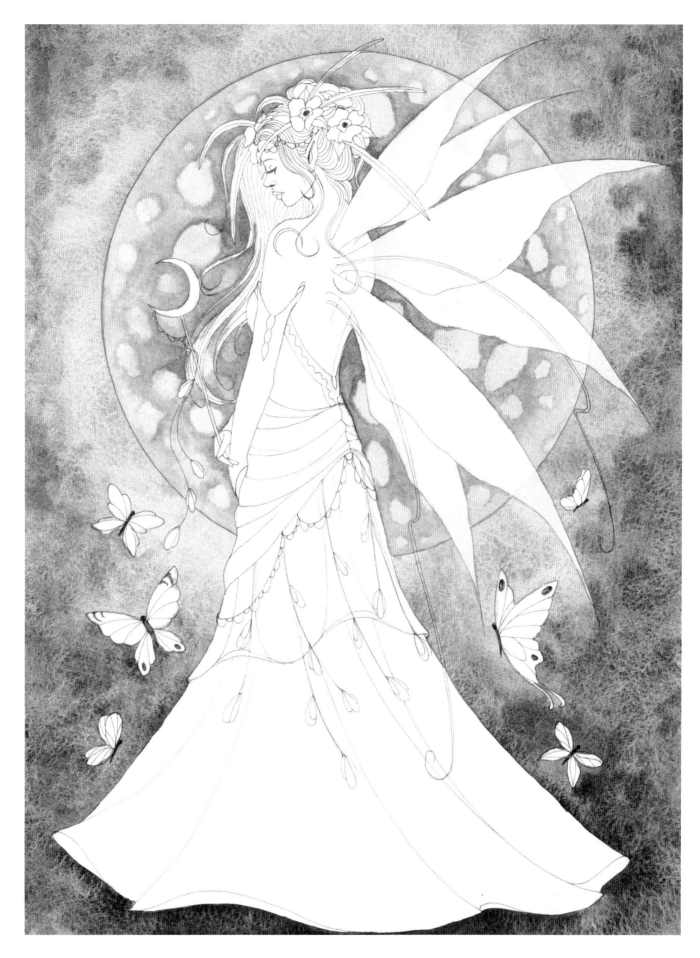

### *Lavender Moon Step Two – Painting the Background*

Now for the fun part – I'm ready to paint!  Using washes of blue and purple watercolors, I paint the moon in light lavender hues, and then paint the sky in shades of indigo blue.  I dilute the wash around the moon to give it a bit of a glow.

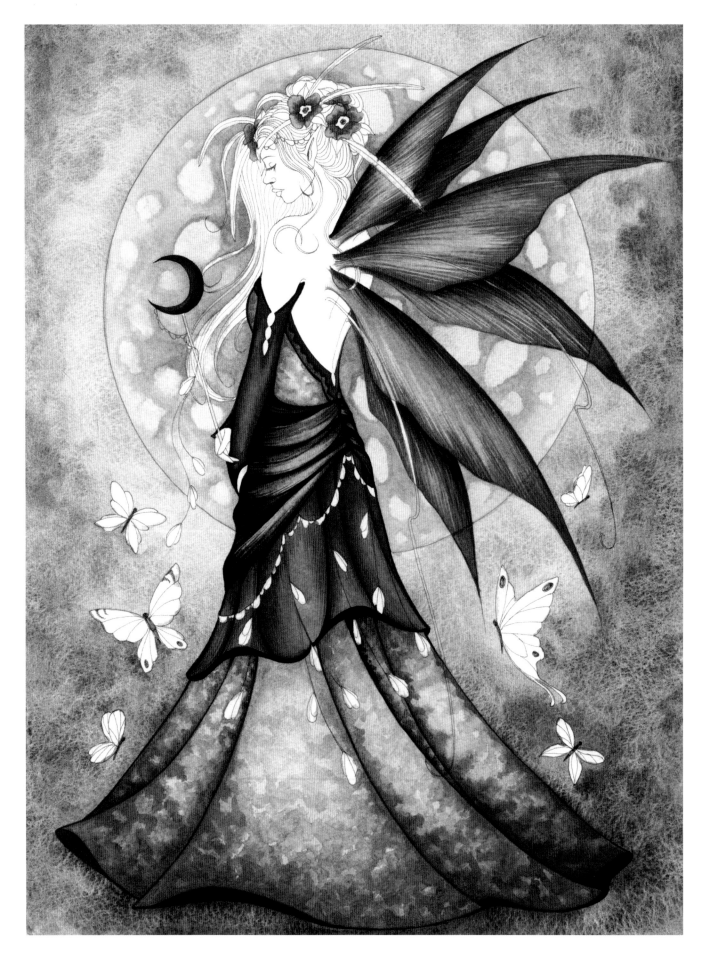

### *Lavender Moon Step Three – Dress and Wings*

With thicker washes for deeper colors, I continue on with the lavender and indigo blue color scheme to carefully paint her dress and wings. Shading is important at this point, and I've tried to create some interesting textures in the fabric of her dress.

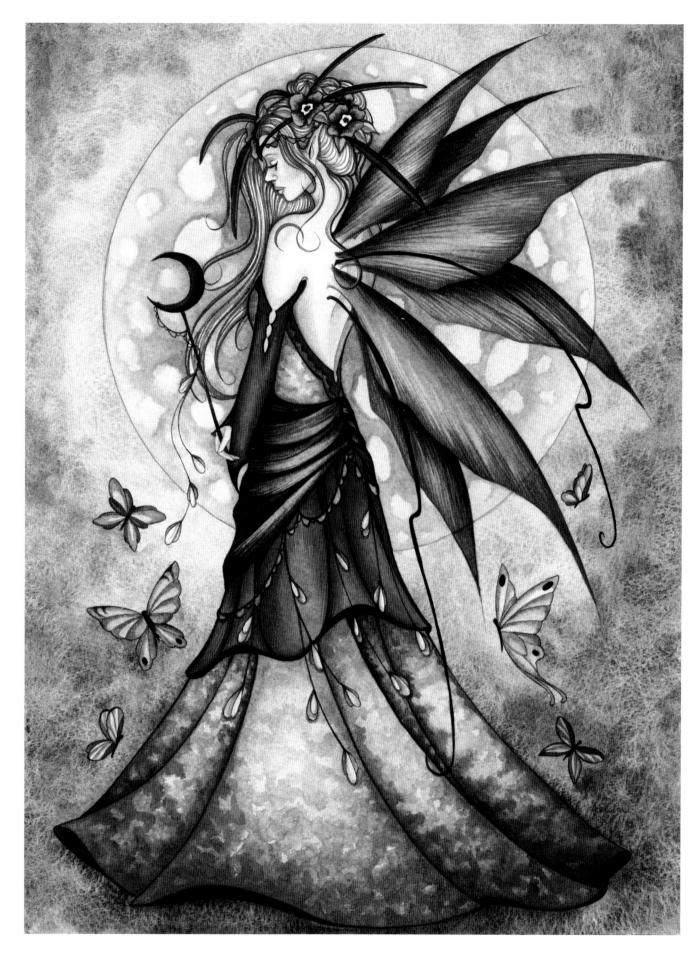

### *Lavender Moon Step Three – Finishing Up*

Last, but certainly not least, I paint her skin tone, facial features and hair while paying very close attention to the little details. When I'm happy with how she's come out, I finish up by painting the butterflies in the background.

# INDEX